Unseen Ayckbourn: Illustrated Edition

Simon Murgatroyd is Alan Ayckbourn's archivist and the creator and administrator of the playwright's official website www.alanayckbourn.net. He has written extensively about the playwright for a number of publications - including articles for the world premiere and West End productions of Alan Ayckbourn's plays - and administered Ayckbourn-related events since 2002.

He has been working with the Ayckbourn Archive since 2005 and oversaw the transfer of the archive to the Borthwick Institute at the University of York in 2011 following its acquisition for the nation. He continues to collect new material for the Archive as well as maintaining an extensive digital archive in conjunction with the playwright and the website.

Simon has also created and runs two subsidiary websites, *Scarborough In The Round* (www.theatre-in-the-round.co.uk) which looks at the history of theatre in the round / the Stephen Joseph Theatre in Scarborough. Alongside Dr Paul Elsam, he co-founded the website *Stephen Joseph & The Library Theatre* (www.stephen-joseph.org.uk), which offers an insight into Alan Ayckbourn's most significant influence and mentor. He also maintains The Bob Watson Archive at Alan Ayckbourn's home venue, the Stephen Joseph Theatre.

Unseen Ayckbourn was named as one of The Stage's best theatre books of 2013.

His own website can be found at www.simonmurgatroyd.co.uk.

All rights reserved
© Simon Murgatroyd 2016

The right of Simon Murgatroyd to be identified as author of this work has been asserted in accordance with Section 77 of the Copyright, Designs and Patents Act 1988.

No part of this book may be reproduced in any form or by any electronic or mechanical means including information storage and retrieval systems, without permission in writing from the author.

Printed in the United Kingdom
Second Edition: December 2016 (corrected)

ISBN 978-1-326-82086-2

Book design by Simon Murgatroyd
Cover Design by Simon Murgatroyd

All cover images are copyright of Alan Ayckbourn except where noted.
The front cover images are taken from the world premiere productions of: Standing Room Only; Christmas V Mastermind; Meet My Father (copyright: Scarborough Theatre Trust); The Square Cat; Dad's Tale (copyright: Alan Ayckbourn)
The back cover portrait of Alan Ayckbourn is by and copyright of the photographer Andrew Higgins.

Unseen Ayckbourn
Illustrated Edition

by Simon Murgatroyd

Dedication

To Mo Thwaites,
my soulmate and best friend.
You have changed my life.

And my girls, Kate & Sarah,
for just being fantastic.

And to
Alan Ayckbourn & Heather Stoney.

Simon Murgatroyd, December 2016

Contents

Foreword	7
Additions to the new edition	8
Guide to *Unseen Ayckbourn*	9
Unseen Ayckbourn	10
Inside The Archive	141
Appendix I: Definitive play-list	161
Appendix III: People and places	166
Acknowledgments	169
Endnotes	170

Foreword

It was never my intention to publish updated editions of *Unseen Ayckbourn*. Naively, I assumed there would never been enough new material to warrant such a thing. I should have known better when dealing with an author so prolific as Alan Ayckbourn. Since the first edition was published in 2009, Alan has written eight full-length plays, three one act plays, an eight hour long vocal narrative, an interactive 'party' and several miscellaneous pieces. He has also conceived and discarded numerous other ideas, altered several existing plays, imagined different play-titles and also brought to this author's attention much previously unknown ephemera relating to past works.

With each previous edition of *Unseen Ayckbourn*, I have attempted to differentiate them by including bonus material exclusive to each edition - largely essays or interviews. For this edition, I've delved into the archives and am delighted to be able to publish 20 archive illustrations, such as the playwright's own notes for concepts for both well-known plays and abandoned ideas. I hope they prove to be of interest and offer a new insight into the archival material from which most of the information in the book is drawn.

Unseen Ayckbourn has always strived to draw attention to works and ideas which have either never - or rarely - been in the public eye or have long since been withdrawn from public consumption and which are unlikely to ever be made public outside of the archives in which they are currently held. The material within this book is drawn from the Ayckbourn Archive at The Borthwick Institute at the University of York, The Bob Watson Archive at the Stephen Joseph Theatre in Scarborough, Alan Ayckbourn's personal archive and the digital archive held by his official website www.alanayckbourn.net.

As with previous editions, you must forgive the author's broad remit and penchant for taking slight liberties with the title. Some of the plays within have been seen; albeit not by significant numbers of people. The unifying thread is these are ideas, works or variants of works which have largely been ignored by other authors and, all but unseen, have found a home within these pages.

Unseen Ayckbourn celebrates an extraordinary playwriting career, illustrating the road to this enormous success is paved with so much more work and ideas than we are ever made privy to, but which can be glimpsed here.

Simon Murgatroyd

December 2016

Additions to The New Edition

This is the fourth edition of *Unseen Ayckbourn* and readers of previous editions may appreciate being able to head straight to the substantive new content. These are listed below, although many of the previous entries have also been updated and illustrations of archival material have been included following the main body of the book.

Barnstairs Syndrome
The 'Blizzard' Play
A Case Of Missing Wives
Communicating Doors (revised)
The Divide
Foreseeable Futures
GamePlan (revised)
Henceforward... (revised)
The 'Hotel' Play
House & Garden (fête)
In Future
Incommunicado
Intimate Exchanges (variation)
IOU
IOU: The Novelist
IOU: The Teacher
IOU: The Star
IOU: The Nightclub
Isn't It Romantic?
Joking Apart (concept)
The Karaoke Theatre Company
Neighbourhood Watch
One Day In Spring
Order Of Appearance
Past Tense
Roundelay (early drafts)
Roundelay (4 act)
Satisfaction Guaranteed
Sugar Daddies (revised)
The Waiter
Where's My Seat?
Where's Peter Rabbit?

Guide to Unseen Ayckbourn

Every entry in *Unseen Ayckbourn* is placed into one of the following categories to provide a basic context.

Abandoned
A play begun by the playwright, which has either been re-written or abandoned altogether.

Title - Alternative
An alternative title for a canon play

Title - Discarded
An early unused title for a canon play.

Concept
An idea or concept for an unwritten play or an early substantially different idea for an actual written play.

Ephemera
A play or piece of writing that has not been officially acknowledged or which does not fit into any other category.

Grey Play
An acknowledged play which is not part of the official canon, but which has been produced and then withdrawn.

Screenplay
A screenplay or a treatment for an unwritten screenplay.

Unproduced
A completed play which has either not been produced to the best of the author's knowledge or may have just had a single non-professional performance.

Variant
An alternative version of a play within the acknowledged canon.

Withdrawn
A full-length play which is considered to be part of the official play canon, but which has been withdrawn.

A Note On Canon

When the term 'canon' is used, this refers to one of Alan Ayckbourn's 81 full-length plays (as of 2017), a full list of which can be found in the appendix.

A Note On Sources And Manuscripts

Although much of the content of *Unseen Ayckbourn* concentrates on unwritten plays and ideas, manuscripts do exist for a number of the plays mentioned. Where these exist and have been quoted and referenced, they have predominantly been drawn from the Ayckbourn Archive held in the Borthwick Institute for Archives at the University of York.

Further Research

Unseen Ayckbourn makes reference to many of Alan Ayckbourn's acknowledged works. Further information and in-depth discussion of all the playwright's canon plays and other acknowledged writing can be found on his official website www.alanayckbourn.net.

The website also contains detailed biographical information about Alan Ayckbourn as well as many other features dedicated to the playwright and his career in theatre.

Unseen Ayckbourn

Absent Friends
Description: Concept

Having written his ambitious trilogy *The Norman Conquests* in 1973, Alan Ayckbourn decided he would write something on a more intimate scale for his next play in 1974. This would be *Absent Friends*, a play set in one location running in real time and directly inspired by a scene from *The Norman Conquests*.

> "At the beginning of the second act of *Living Together* [*The Norman Conquests*] the whole action pulled up with a jolt and the family sat and talked and read magazines. I'd never done that sort of thing before, with people just sitting and talking about themselves. Writing it, I felt nothing was actually happening; and it was wonderful to get it onto the stage and find a response coming off the audience. So I went back to Scarborough and attempted to write something that would involve the audience in an afternoon."[1]

The structure of *Absent Friends* was ground-breaking for Alan, being the first play he had written where the same amount of time passed on stage for the characters as for the audience watching; in essence it is an extreme close-up of two hours of these characters' lives. However, the earliest notes for the play survive in the Ayckbourn Archive and do not utilize this structure, although the basic premise appears to have been the same.

This early concept is centered on Sunday dinner or lunch with two of the acts (the play is described in both three and four act versions) being the same event, the dinner, but viewed entirely from the point of view of each sex: the three women in one-act followed by the three men in the next. The final act would see all the characters brought together, presumably highlighting the different perspectives and experiences of the preceding dinner. Although an intriguing idea, the fact that there are no other surviving notes relating to anything other than the structure of the play suggests Alan abandoned this idea early in the writing process.[2]

Absent Friends
Description: Title - Alternative

Within the Ayckbourn Archive, there are a number of hand-written notes relating to early concepts for what would eventually become the

play *Absent Friends*. Amongst them is a list of titles which Alan considered for the play - at the time set around a dinner party - which not only include *Absent Friends* but also *A House Divided...*, *According To Taste...* and *Dividing Line*.³

Absurd Person Singular

Description: Concept

Much ingenuity and effort has been exhausted over the years attempting to decipher the meaning of the title of one of Alan Ayckbourn's most popular plays, *Absurd Person Singular*. Unfortunately for all concerned the title has absolutely nothing to do with the play; it was intended for an entirely different work which was either abandoned or never begun - Alan has never been specific as to its fate.

No details are known about the prototype *Absurd Person Singular*, although it seems likely the play had an entirely different concept to the finished piece.

> "*Absurd Person Singular* - the title was originally intended for a play I didn't write and subsequently, because I rather cared for it, given to the play I did write."⁴

Given this statement originated just five years after he wrote *Absurd Person Singular* it should be given credence. However, it is notable that the existence of an earlier unwritten play is rarely mentioned in more recent interviews.

In platform events in both 2008 and 2010, Alan mentions the title was something he just thought up and decided to keep for the appropriate occasion.

> "We were in a lift up to [the producer] Michael Codron's office and I suddenly said '*Absurd Person Singular*. That's a good title.' I hadn't got a play!"⁵

Absurd Person Singular

Description: Concept

There are times when Alan Ayckbourn admits he got it wrong - often with plays regarded as classics of his extensive playwriting canon. Perhaps the most famous example of this is the original draft of *Absurd Person Singular* which was set in the living rooms of three couples over three Christmas celebrations.

Having completed the first act, Alan realised the play was not fulfilling its potential.

"I like to have a problem, because I think it takes care of one aspect of the play. Take *Absurd Person Singular*. I had the theme of the ascendancy of one couple and the decline of the other two, set it in the sitting room, started off as normal, and I think in terms of content it was quite interesting - you know, I'd got the couples sketched rather well. But there was an edge missing off it and by transferring it into the kitchens - setting it backstage, as it were - one got an additional angle on it, which made it much more interesting. I think it lifted it from being a reasonable play into a better play."[6]

Candidly admitting that the play got "desperately boring very quickly"[7] in the living room, Alan duly relocated the play to the couples' kitchens and began writing the play afresh.

There were two memorable off-shoots of this alteration: firstly, by moving the action to the kitchen it removed the need for some of the less interesting aspects of parties.

"As a footnote: since I was writing about parties and guests arriving, it also relieved me of the tedium of all that hallo-how-are-you-good-bye-nice-to-see-you business."[8]

The second - and by far most wide-reaching - alteration was the inadvertent creation of two of the most monstrously memorable of Alan Ayckbourn's off-stage characters, Dick and Lottie Potter.

As originally conceived, Dick and Lottie were a fourth couple present on stage in the living room and there can be little doubt they would have dominated proceedings. By relocating the action to the kitchen and confining the Potters to the living room, Alan was to create two of his most renowned off-stage characters.

"I was halfway through the act before I realized that I was viewing the evening from totally the wrong perspective. Dick and Lottie were indeed monstrously overwhelming, hearty and ultimately very boring, and far better heard occasionally but not seen. By a simple switch of setting to the kitchen, the problem was all but solved, adding incidentally far greater comic possibilities than the sitting room ever held. For in this particular case, the obvious offstage action was far more relevant than its onstage counterpart."[9]

Little reported is Dick & Lottie also make a brief 'appearance' in another Ayckbourn play, *Bedroom Farce*.

Kate: And who else is there. Ken and Margaret, of course. And John and Dorothy and Wilfred and Gareth and Gwen and Mike

and Dave and Carole and Dick and Lottie. Gordon and Marge, of course and - er - Susannah and Trevor...[10]

Keen Ayckbourn fans will also note the mention of Gordon and Marge from *Absent Friends*, whilst Ken and Margaret are a little Ayckbourn in-joke referring to Ken and Margaret Boden, the long-serving theatre manager and box office manager of the Library Theatre in Scarborough.

According To Taste

Description: Title - Discarded

One of several proposed titles for *Absent Friends* which Alan Ayckbourn had written in his early notes for the play.

Am I Famous Yet?

Description: Title - Discarded

It would be fair to say that Alan Ayckbourn has probably abandoned more titles than he cares to remember during his career as a playwright - some of which have been lost to posterity, whilst others have been recycled for entirely different plays. Most of these possible titles have been lost to time, but several examples survive.

Am I Famous Yet? was an early proposed title for the 2004 play *Drowning On Dry Land*, which deals with the phenomenon of celebrity and how people with no apparent talent achieve fame. The proposed title was inspired by a television documentary investigating the same phenomenon and "a girl on TV jumping up and down, waving her arms and asking, 'am I famous yet?' when she really hadn't done anything."[11]

As to the origin of the eventual title, inspiration often comes from the most obscure places....

> "I originally considered calling the play *Am I Famous Yet?*, but browsing through one of my dictionaries of quotations I came across an old English proverb: "It is folly to drown on dry land." Heaven knows how old or English it is, but I liked it, especially since I had chosen to set the play in a folly. Not that there's anything symbolic in that, of course. Heaven forbid."[12]

As A Sister

Description: Title - Discarded

One of several proposed titles for *Sisterly Feelings* which Alan Ayckbourn had written within early notes for the play.

Ayckbourn On Song

See *Todd On Ayckbourn On Song*

Backnumbers

Description: Grey Play

Backnumbers is best described as a greatest hits collection of songs by Alan Ayckbourn and the composer Paul Todd. It comprises two revues consisting entirely of songs drawn from the back catalogue of musicals and revues written by the pair between 1978 and 1983.

Backnumbers was originally performed as a lunchtime entertainment in the Stephen Joseph Theatre In The Round during the summer of 1983. It consists of two parts, performed separately, entitled *Backnumbers 1-10* and *Backnumbers 11-20*. There is no plot or linking material with each part consisting of ten songs taken from Alan and Paul Todd's previous collaborations: *First Course*; *Making Tracks*; *Me, Myself And I*; *Men On Women On Men*; *Second Helping*; *Suburban Strains*. There is no record of *Backnumbers* having ever been performed again.

Barnstairs Syndrome

Description: Concept

This is one of several early concepts for what eventually became the 2010 play *Life Of Riley*. Within the Ayckbourn Archive is a seven page document entitled *Barnstairs Syndrome* consisting of an introduction, character notes and a detailed bullet-point plot breakdown of significant events within the play's two acts. It was almost certainly written in 2008 at the latest, as the name Barnstairs is featured in the 2009 play *My Wonderful Day*, which was written in March of that same year.

The play centres on Monica, who has quietly left her husband Lewis for the widowed farmer Simeon. Lewis's best friend and doctor, Jack, has meanwhile discovered his friend has a rare bone disease and has only six months to live. The first act, set at Lewis's home, sees Jack discover Monica has left Lewis and his attempts to reunite the couple whilst Lewis sleeps with Jack's own partner, Tamzin. By the end of the first act, everyone but Lewis knows he has a terminal disease and Monica has left Simeon to return to Lewis.

During Act II, Lewis admits his fling with Tamzin to Monica, who is unbothered as she is aware Lewis's time is limited. Jack, however, has been told the diagnosis may not be all it's cracked up to be; his Nobel prize winning mentor, who 'discovered' Barnstairs Syndrome, has been going senile and increasingly incorrectly diagnosing the condition in a

desperate bid to prove its existence. As the friendship between the women deteriorates, Lewis finds himself accused of deceiving everyone - despite the fact he is still unaware of the 'terminal' diagnosis. All Lewis wants is a quiet life, whilst Monica wants to resume their marriage and Tamzin admits she has fallen in love with him.

The play ends with Lewis trying to unsuccessfully video-record a suicide note. Jack confronts him and blames Lewis for everything, despite the fact Jack is directly responsible for all the events which have transpired. Simeon also turns up, imploring Lewis to do the decent thing and let Monica return to him. Lewis, desperate to not be at the centre of a situation he never wanted nor planned, scribbles a note, grabs his suitcases and leaves, still unsure of what his future holds.

Although *Barnstairs Syndrome* does share some basic plot points with *Life Of Riley* - and several names - the play differs substantially from what was eventually written; not least because the terminally ill Riley never appears in *Life Of Riley*. Within that play we see the repercussions of Riley's relationships with three women play out through their relationships with each other and their own partners.[13]

'Bath' play

Description: Concept

Having set plays in practically every other room in the suburban house by the end of the 1970s, Alan Ayckbourn declared in an interview in 1981 he was actively considering setting a play in the bathroom. Alas, the play was never written although a bathroom would eventually come to play a major part in *A Small Family Business*, where deceit, murder and drug-taking are prevalent in the smallest room, but where no-one is seen taking a bath.

As to his idea for a bathroom-set play, the inspiration appears to have come from the 1970 movie *Lovers And Other Strangers*.

> "[A play] where no one actually has a bath, runs any water or uses the bathroom as a bathroom. I once saw a very funny film with Gig Young getting rid of his mistress in the bathroom. She was sitting on the loo seat and he was on the side of the bath, and it was all very incongruous."[14]

Bedroom Farce

Description: Concept

Alan Ayckbourn has written five plays which are intended for end-stage performance (the plays being *Bedroom Farce*, *A Small Family Business*, *Haunting Julia*, *Things We Do For Love* and *Virtual Reality*);

although Alan has also directed two of these in both the end-stage and the round.

The first of the end-stage plays is *Bedroom Farce*, which was originally commissioned for the National Theatre with the agreement it would be premiered at the Library Theatre, Scarborough. Although commissioned as an end-stage play, Alan wrote it with enough flexibility so it could be produced in the round.

The earliest notes for the play indicate a concept which clearly favoured the round. Alan began work on the play in 1975, whilst still involved with his and Andrew Lloyd Webber's West End musical *Jeeves* and the earliest notes pertaining to *Bedroom Farce* can be found on the back of pages from an early hand-written *Jeeves* manuscript. These notes and sketches offer an insight into Alan's earliest thoughts on the play which featured four, rather than three, bedrooms. Two of his sketches of the proposed set show a cross comprised of four beds, the foot of each bed meeting in the middle. Four couples are also named: Ernest and Delia, Trevor and Susannah, Nick and Patsy, Austin and Marie. The first five names are familiar from the final play, the latter three were altered.

By the time Alan wrote the play, he had reduced the set to three bedrooms and four couples with the bedless couple, Trevor and Susannah, moving between the three rooms.[15]

Incidentally, the play was actually never produced in the round at the Library Theatre. Although this was the original intention, when it came to staging the winter 1975 season it transpired the Concert Room, normally used by the company, was unavailable and a smaller room in Scarborough's public library was offered instead. As a result, the play had to be re-designed and staged three-sided.

When *Bedroom Farce* opened at the National Theatre in 1977, it was produced as originally intended in the end-stage Lyttelton and it would be another 23 years before Alan was able to stage the play in-the-round, when he revived it in 2000 at the Stephen Joseph Theatre in Scarborough.

Bedroom Farce

Description: Title - Discarded

In 1974, Alan Ayckbourn announced the title of his next play which would also be the first of his plays to be produced at the National Theatre. He announced the play as *Bedroom Farce, A Comedy*, which would later be shortened to just *Bedroom Farce* when it premiered at the Library Theatre, Scarborough, in 1975. Given the number of critics over the years who have failed to appreciate that just because the word farce is in the play title, it doesn't necessarily have to be a farce, perhaps it would have been better left unaltered!

"I'm going to call it *Bedroom Farce, A Comedy*. I'm worrying about it a bit because I've never written for the posh fellers before. It'll have everything about bedrooms but copulation, something which I believe is hardly practised in the British bedroom anyway."[16]

Bedside Manners

Description: Unproduced

Bedside Manners is a short piece by Alan Ayckbourn which bears comparison to his one-act play *Countdown*; which is part of the play anthology *Mixed Doubles*. *Bedside Manners* features a couple in bed who speak their internal monologues having both just woken up an hour before the alarm is due to go off. Their thoughts - the woman's effusive, the man's concise - reflect their views on the state of their marriage as they analyze every movement and breathe the other takes. The dialogue ends with them falling back asleep and vocalizing their dreams just before the alarm clock goes off.

The piece is similar in length and style to the duologue *Countdown*, which also features a couple speaking their internal thoughts over breakfast. Intriguingly both feature the man talking about a dream involving a motor-mower. There is no means of dating the piece, however the only known surviving copy of the script is credited to Alan Ayckbourn, which suggests the play was written post 1962 (plays prior to that date are generally credited to Roland Allen), which would make *Bedside Manners* a later play than *Countdown*, which was definitely written no later than 1962.[17]

Although no details of *Bedside Manners* being produced exist and there is no record of a performance license being issued by the Lord Chamberlain's Office, there are actor's notes on the sole surviving copy. The play's cover also indicates the woman's role was taken by Heather Stoney, who Alan did not work with until October 1962 when the Victoria Theatre opened in Stoke-on-Trent. As a result, it seems probable that, if performed, *Bedside Manners* could not have been produced until late 1962 at the earliest and probably in Stoke-on-Trent.

Man / Woman: *(simultaneously)* We are not really asleep.
Man: And though both of us think we are deceiving the other...
Woman: Neither of us are.
Man / Woman: *(simultaneously)* We know each other far too well.
Man: Unfortunately.[18]

Now held in archive at the University of York, *Bedside Manners*, is a curiosity but given its similarity to *Countdown*, it is not a play likely to be published or made available to produce.

Between The Lines

Description: Grey Play

Alan Ayckbourn's Grey Plays consist of a number of plays and revues which have been produced but never published. As a result of this, they tend to be quite obscure pieces; one of the most obscure being *Between The Lines*, a revue with material by Alan Ayckbourn that cannot actually be credited to the playwright.

Between 1978 and 1986, Alan Ayckbourn and the composer Paul Todd collaborated on ten revues and two musicals. In 1992, Paul Todd premiered a new revue called *Between The Lines* at the Etcetera Theatre, Camden, which featured 18 songs by the pair linked by a back-stage, rehearsal-room set plot. The original narrative was written by Paul Todd, which he describes as:

> "The story starts at their respective auditions. They are cast and meet to rehearse only to find that there is, as yet, no script. The script and the lyrics arrive throughout the show. They rehearse open and tour. The actor and actress play Jenny and Roger as well as many attendant characters. Paralleling the pressure of their professional life a personal relationship may be developing, too, unlikely though it seems at one point."[19]

Alan Ayckbourn had no involvement in the piece other than his lyrics are featured. The revue has been rarely produced but when it is staged, it is contractually stated that Alan must only be credited as lyricist so as not to give the impression *Between The Lines* is an original Ayckbourn creation.

Between The Lines is itself a reworking of an earlier unproduced piece by Paul Todd entitled *Todd On Ayckbourn On Song* (see separate entry).

'Blizzard' play

Description: Concept

When the acclaimed French director Alain Resnais adapted Alan Ayckbourn's *Private Fears In Public Places* for film in 2006, he transferred the setting to a snowbound Paris with every scene punctuated by falling snow. Alan was struck by this effect and discussed the idea of using snow

in his next play. Whilst the idea may seem impractical, that has rarely stopped Alan before....

> "I was immediately taken by the snowstorm which I thought was typically him [the director, Alain Resnais]. There was no storm on stage obviously; although I did get a yearning to perhaps set a play in snow immediately afterwards."[20]

> "Thanks to Alain, I've got my first idea: it starts in a blizzard. I can already feel technicians running for the hills, saying, "Snow? For two hours? It'll have the audience tunneling out.""[21]

Although the idea was abandoned, Alan did go on to mention it once more in a tribute to Alain Resnais published following the auteur's death in 2014, including the hook onto which the blizzard would be built.

> "I kept thinking of the film many weeks after the screening [of *Private Fears In Public Places*]. I briefly considered writing a play set in a blizzard. A sort of ghost story. A woman would be coming back to a man, out of the blizzard, while he is sitting in a chair with his back to her. But a two-hour snowfall on stage? It could never have worked in the round."[22]

Board Game

Description: Unproduced

Given Alan Ayckbourn's interest in board games - something hinted at in several of his plays, most notably *The Norman Conquests* - it is hardly surprising that at one point he actually wrote a short play based around several famous games.

Board Game is a short one-act play in which one of the playing pieces from *Monopoly*, Top Hat, finds himself moving across several different games on each roll of the die. He moves through *Cluedo*, chess, *Escape From Colditz* and draughts before returning to the *Monopoly* board. Along the way, he is pursued by a German guard from *Escape From Colditz*, who shoots the *Monopoly* piece Old Boot, leading Top Hat to decide to 'Go To Jail' as the safest option.

Col Mustard Enters

Col: Just one moment. Hold it right there. I suggest that the Old Boot was murdered by the Hun with the gun in the middle of Coventry Street.[23]

It is not known when the piece was written and it has no providence, although judging by the only surviving typed copy it is an early play, probably written between 1958 and 1961.

It is worth noting the piece bears certain similarities to *The Boy Who Fell Into A Book*, which Alan wrote in 1998 to mark the National Year Of Reading. There the hero, Kevin, finds himself moving from book to book, rather than game to game, but at one stage does find himself in a game of chess having stumbled into *Chess For Beginners*.

Although classed as 'Unproduced', the play has actually been performed by students at the University of York as part of an evening called *Ayckbourn Shorts* in June 2012. The students were given special dispensation by the playwright to perform the piece for the event which marked the first anniversary of the university acquiring the Ayckbourn Archive in 2011. Given this was a limited audience and permission to perform the play is unlikely ever to be given again, the play is considered to still fall within the 'Unproduced' category.

Body Language

Description: Variant

For a play dedicated to body issues and the perception of people's bodies, it seems ironic the original script for *Body Language* needed to be slimmed down before reaching a form Alan Ayckbourn was happy with. When originally produced in 1990, the body-swapping comedy ran for almost three hours and was criticised for its length.

Although some judicious pruning did take place at the time of this production, it was not substantially altered. Had the play transferred to the West End, it is probable Alan would have made extensive revisions at this point, but plans to take it into London fell through and Alan did not revise the play. *Body Language* became an acknowledged part of the Ayckbourn canon, despite Alan admitting it was not in the best of shape.

> "It was very popular when it was done in Scarborough in 1990 but there were so many other plays around at the time that it didn't get a West End transfer. It just slipped through the cracks, although it worked very well."[24]

When the Stephen Joseph Theatre In The Round moved to its new home - the Stephen Joseph Theatre - in 1996, Alan began looking at some of his earlier plays which he felt had not reached their full potential. The most obvious example of this resulted in his successful rehabilitation of the flop musical *Jeeves* as *By Jeeves*, which was quickly followed by a revised revival of *It Could Be Any One Of Us*. At approximately the same time, Alan returned to the *Body Language* script and revised it, mainly

trimming extraneous material to bring the running time down. The major cuts were to the character of the photographer Derek Short.

The end result was premiered in 1999 and, although not obviously different to the original production, was a leaner piece of writing which also generated better reviews than the original production. The published version of the script is the revised version with the original held only in archive.

> "I always wanted to do *Body Language* again, as I felt the first time around it needed some more work, but by the time I'd looked at it and decided that, it was already running. It was doing all right but I kept looking and thinking I'll tinker with it one day. Two or three years ago, I picked it up and in an afternoon went at it like a madman with a machete, as you do when you've been thinking about something that long, and I thought I'd do it one year."[25]

The Boy Who Fell Into A Book
Description: Variant

In 2014, *The Boy Who Fell Into A Book* became the first official adaptation for the stage (as opposed to an adaptation for television or radio) of an existing Ayckbourn play. The play, which originally premiered in 1998 at the Stephen Joseph Theatre, Scarborough, to mark the start of the National Year Of Reading, was adapted into a musical by lyricist Paul James and composers Cathy Shostak and Eric Angus.

The idea for a musical adaptation of the play was first mooted by Cathy Shostak to Alan Ayckbourn in 2007, but real progress on the adaptation did not move forward until 2009. Permission for an authorised adaptation was given in 2010 with the playwright's support, thus beginning a lengthy and involved process of adapting the play.

Although the musical closely follows the plot of the original play, there are some minor alterations (for example, Red Riding Hood does not appear). The most significant change is the Wooblies - children's characters invented by Alan Ayckbourn - were altered to the Wublies as Paul James notes Wooblie was a word that defied rhyming!

The musical - which includes 12 songs - was presented for the first time during a work-shop week in November 2013 and featuring the Olivier award winning actress Janie Dee in the company. The success of the workshop led to the musical being officially premiered at the Stephen Joseph Theatre, Scarborough, during the summer of 2014, directed by Alan Ayckbourn.

By Jeeves

Description: Variant

In the history of musical theatre, *Jeeves* is regarded as an almost legendary West End flop. The first collaboration between Alan Ayckbourn and the composer Andrew Lloyd Webber opened at Her Majesty's Theatre in London on 22 April 1975 and closed on 24 May 1975, having been savaged by the critics.

Over the next two decades, both men considered the idea of rehabilitating the musical by reviving and revising it. In 1996, on its 21st anniversary, a new version of the musical opened the new Stephen Joseph Theatre in Scarborough. *By Jeeves* met with great success, which can largely be attributed to it being the polar opposite of its predecessor: *Jeeves* was an ungainly, sprawling piece of musical theatre, whereas *By Jeeves* kept the basics of the original piece, but scaled everything down to a simpler production and premise.

Although it faced few of the problems which blighted the original musical, *By Jeeves* did go through a number of alterations from its first public showing in 1994 through to its Broadway premiere in 2001. *By Jeeves* was work-shopped in 1994, where the revised musical was heard for the first time in front of an audience. Although the plot and book would largely be unaltered from this point forwards, there are notable variations in the show at different stages of its life due to alterations to the libretto.

This was the original song selection for the *By Jeeves* Workshop performance in 1994:

Act 1
1. Banjo Boy
2. Code Of The Woosters
3. Travel Hopefully
4. That Could Have Been Us
5. Female Of The Species
6. The Hallo Song

Act 2
1. By Jeeves
2. When Love Arrives
3. Scylla And Charybdis And The Deep Blue Sea
4. Half A Moment
5. It's A Pig
6. Banjo Boy
7. The Wizard Rainbow Finale[26]

When the play premiered at the Stephen Joseph Theatre in May 1996, the following alterations took place: *Scylla And Charybdis And The Deep*

Blue Sea was replaced by *What Have You Got To Say, Jeeves!* and the title of *That Could Have Been Us* was revised to *That Was Nearly Us*.

During the original run of *By Jeeves* at the Stephen Joseph Theatre, another change took place with *Love's Maze* replacing *Female Of The Species*.

The play then transferred to London in July 1996, at which point several of the songs underwent alterations. *A False Start* replaced the first *Banjo Boy* and *Wooster Will Entertain You* replaced *The Code Of The Woosters*.

Finally, when the play opened on Broadway at the Helen Hayes Theatre, New York, in October 2001, there was one final change with *Wooster Will Entertain You* altered to *Never Fear*. This is considered to be the definitive version of the musical.

Callisto#7

Description: Variant

Callisto#7 is unique amongst Alan Ayckbourn's plays in being a revision of an earlier play which is still available to produce. The revised version, premiered at the Stephen Joseph Theatre in 1999, develops the plot and themes of the earlier *Callisto 5*, premiered at the Stephen Joseph Theatre In The Round in 1990, but essentially has the same structure and narrative.

Both plays are set on a space station on the moon of Callisto, although in *Callisto 5*, the hero Jem is alone except for a robot; his sister being held in cryogenic suspension. In *Callisto#7*, Jem and his sister Jodi are both stranded on the space station. The plots then follow the same basic path as the station is apparently invaded by an invisible creature, actually a diversion created by the station computer IRIS.

Callisto 5 was published in 1995 and made available for production. Despite it being revised to the arguably better constructed play *Callisto#7* in 1999, the original play is still available to buy and produce whilst the latter - having replaced *Callisto 5* in the official canon - is also available to produce, but has not yet been published.

> "I [re-]wrote it as *Callisto 7* - it's got another character in it. It's written with a little boy in it now - and a little girl. The girl is older. It made it slightly more human. She is now left to look after her little kid brother and he is the one who's going moody and she's doing her best - she's only thirteen - she's trying to keep control while the mother and father are away. But the kid is really giving her a bad time saying, "I don't wanna talk to you. I just want my mother and father." And she's saying, "So do I." And so the computer creates a

monster, like it did before, in order to unite them because it sees they're on the verge of having a breakdown. So they create the old solution of having a common enemy. The little boy finds he's helping his sister to fight it and they both learn to have respect for each other. I think it's a better slant on it."[27]

A Case Of Missing Wives
Description: Miscellany

A Case Of Missing Wives was intended as Alan Ayckbourn's 81st play for the 2017 summer season at the Stephen Joseph Theatre. He then had another idea - *A Brief History Of Women* - which he subsequently wrote and was produced. The playwright has noted, despite being completed that, *A Case Of Missing Wives* will probably now never be produced.[28]

A Chorus Of Disapproval
Description: Concept

A Chorus Of Disapproval marked the 25th anniversary of Alan Ayckbourn's career as a playwright in 1984 and was his 31st full-length play. From conception it was always highly ambitious. Wanting to write a piece about amateur musicals, Alan had the idea of a play based around Rudolf Friml's operetta *The Vagabond King*. The production would incorporate approximately 85 local amateur singers in the chorus[29] (in Alan Ayckbourn's biography, Paul Allen writes it was 20 people[30] but Alan himself states his grander intentions in Ian Watson's *Conversations With Ayckbourn*) who would be scattered around the auditorium. Once the performance began, this clandestine chorus would have started singing 25 minutes in causing "the person next to them to look absolutely alarmed."[31] Subsequently on 9 March, 1984, the Scarborough Evening News ran an editorial article advertising auditions for amateur singers with soloing experiences.

However, a number of obstacles swiftly put paid to these plans. The actors' union, Equity, absolutely opposed the use of amateur actors in a professional show; Alan's audition experiences with the local amateur operatic societies proved to be less than fruitful with singers apparently expecting nothing less than the lead roles; and the Rudolf Friml Estate, fearing Alan was intending to send up *The Vagabond King*, denied him permission to use the play, claiming a major tour was imminent, but which never took place.

A Chorus Of Disapproval was planned from the outset to be produced at the National Theatre, where the Artistic Director Peter Hall had been

aware of Alan's original intentions. Now Alan contacted him to notify him of the changes to the play.

> "Needless to say, the play is vastly different from the one I described to you on the phone a few weeks ago. No chorus of amateurs. Just a few good singers. (Equity intervened there). I had to go back to John Gay as his agent was the only one who didn't raise an objection."[32]

The playwright would turn instead to John Gay's *The Beggar's Opera* for inspiration; a musical not only out of copyright, but which mirrored Alan's themes for his play. He also dropped the plans for the amateur chorus - although rumours persist that several characters in *A Chorus Of Disapproval* were inspired by some of the people in amateur societies Alan met during auditions.

Christmas V Mastermind

Description: Withdrawn

> "The most disastrous play I've ever done."[33]

Christmas V Mastermind is the black sheep of the Ayckbourn canon, a play judged by the playwright to be so awful that it discouraged the playwright from writing for its target audience of children for more than 25 years.

The play was one of two plays Alan Ayckbourn wrote for the Victoria Theatre, Stoke-on-Trent. In 1962, Stephen Joseph opened England's first permanent professional theatre-in-the-round venue (his Scarborough venture, formed in 1955, was the country's first professional theatre-in-the-round company); Alan Ayckbourn had accepted an invitation to join the company and was commissioned to write the theatre's first Christmas entertainment. He had previously written another Christmas play, *Dad's Tale*, which had been a major disappointment but this was as nothing compared to *Christmas V Mastermind*.

In the theatre's first season, a lack of funding, publicity and common sense had a fatal impact on the play's chances.

> "It was our first attempt at a Christmas play for children and it happened to coincide with a winter of record cold. We did not realise then that children's audiences need most exclusive matinee scheduling and put it on in the evening to audiences of two or three wrapped in blankets with thermos flasks, etc. I can distinctly remember seeing the actors' breath on stage as we had only rudimentary boilers."[34]

The play concerns the machinations of a criminal mastermind, the Crimson Golliwog, as he tries to oust Santa Claus by inspiring belligerent gnomes to take industrial action. Santa's efforts to sort matters out are hindered by a pair of inept policeman intent on tracking down the criminal. In this extract, Santa's fairy secretary describes the man she works for.

> **Scrunch:** Rather peculiar behaviour for a managing director
> **Fairy:** Well, he's a bit old you see. So he gets funny ideas. Some of his staff have been with him for 500 years and he reckons some of them are getting stagnant. So we have community singing in the canteen and dancing classes for unskilled labour.
> **Scrunch:** Sounds unethical to me.
> **Fairy:** We had a Happy Work Week not long ago. You know, 'see the sunny side of your work' and all that. He wanted the whole building ringing with laughter.
> **Scrunch:** Did it work?
> **Fairy:** No. Ended up in a punch up on the Wednesday.[35]

With the Crimson Golliwog's original plan foiled, he decides to instead blow up Santa Claus's factory by stuffing a bear with TNT, which ends up in the hands of the inept policemen. As Santa desperately tries to get his factory working again with no workers to hand, the policemen try to return the teddy to its rightful owner during the course of their investigations. The play ends with the Crimson Golliwog blown up as he tries to escape the apparently doomed Santa Claus and his associates.

Taken out of context, *Christmas V Mastermind* is, certainly for its time, an original idea and is surely the first children's play - and possibly the last - to be based around the concept of industrial action. This is also one of its most significant problems. Although there is much farcical humour for the children, the majority of the script seems far more suited to adults and it seems to be perched uneasily between the two audiences.

The one review held in archive points out the "'plot' is of no great significance", but did "heartily recommend the show as wonderfully wholesome entertainment for anyone aged from nine to 90."[36] Patently no-one was reading the Evening Sentinel that evening to take notice of the review.

> "It was quite a broad, jolly farce, with lots of fights in telephone boxes. And there were two policemen, who tracked everything down, disguised as hedges and letterboxes. But it was received in dreadful silence. None of it seemed to succeed and we died the death with it."[37]

In retrospect, the most notable aspect of the play is it is the first Ayckbourn play to feature his future wife Heather Stoney, playing the Santa Claus's lush fairy secretary. Her most memorable moment being when the Crimson Golliwog pushes her out of a window with her wings fastened together by a bulldog clip.

Alan meanwhile swore he would never write for children again - which he managed until 1988 before writing *Mr A's Amazing Maze Plays* and discovering that he was rather better at it than he initially thought.

Cinderella's Star Night

Description: Ephemera

One of the most obscure Ayckbourn creations is the playwright's contribution to a charity evening in 1982. *Cinderella's Star Night: An Evening Of Wit, Charm And Panic* was a fund-raising pantomime in aid of The Bobath Centre held at the Prince Edward Theatre, London, on 31 January 1982. Narrated by Ned Sherrin and directed by Tudor Davies, the pantomime featured a host of theatrical luminaries such as Ian McKellen, Joanna Lumley, Nigel Havers and Helen Mirren. The script was written by a number of writers including Michael Frayn, Jack Rosenthal and John Cleese with the epilogue provided by Alan Ayckbourn.

Narrator: Ian McKellen

As theatre folk, we often say
The world's a stage; that life's a play.
And yes it's true, it really is
There's just no business like show biz!
To smell the greasepaint, sniff the sighs!
To stand beneath those open flies!
To hear those cheery first act calls
Of usherettes there in the stalls.
To find an artist's role entails
Filling the lull between bar sales.
Yet realizing with certain pride
One stands where Henry Irving dried!
Ah, history! We're all a part
Of this, the theatre's magic art!
And if it would be quite untrue
Were we to hide the facts from you.
Despite our hopes, our actor's dreams
The finest time of all it seems
Is not that moment when it starts -

When first the velvet curtain parts -
But rather (just between us friends)
When once the bloody thing descends! [38]

Alan's contribution to the pantomime - and indeed even the event - might have been lost to posterity were it not for the fact that an audio recording of the event was made and released on vinyl in 1983. Although extremely rare, it ensured Alan's contribution to the evening survived as no notes or record of Alan's epilogue survive in his own archive.

The Circle

Description: Concept

The Circle is an early idea for what will eventually become *Improbable Fiction*. The title is featured on notes which feature character descriptions as well as a hint at the plot; both names and plot are considerably different to the play as written.

> **The Circle**
> The Group has dwindled to five:-
> Carla, the chairwoman and driving force. Romantic novelist.
> Glynis, the thriller writer. Loves to write gory scenes à la Patricia Cornwell.
> Tilly, who writes poetry and is very shy.
> Morton, writes about locomotives for the *Trainspotters Journal*.
> Only one whose [sic] been published.
> Hugo, a humorous writer of unfunny short stories.
> Suddenly there is a newcomer, Ben. The women all show an interest. He is good looking and apparently free.[39]

Although the concept of a writers' circle being fascinated by a newcomer survived to *Improbable Fiction*, it was substantially altered. The newcomer Ben became the mysterious young girl, Ilsa. Meanwhile the driving force behind the now six-member group - who has been published - is Harold. The romantic novelist is Jess; Glynnis becomes Vivvi with a love for Agatha Christie type mysteries; the poet Tilly becomes the children's author Grace, whilst science fiction writer and conspiracist theory Clem and musical writer Brevis replace Hugo.

Clue (Cluedo)

Description: Screenplay

Alan Ayckbourn's interest in board games has been well-documented over the years and whilst games have played a substantial part in several

plays, he has never dedicated an entire full-length play to games. Yet in the early 1980s, he almost had that opportunity when Polygram Pictures and Universal Pictures were actively considering making a film based on the famed board game *Cluedo* (*Clue* in the USA). In January 1981, Lynda Obst, vice president in charge of creative affairs at Polygram, approached Alan's agent Margaret 'Peggy' Ramsay, noting that Alan had been suggested as a potential script-writer. The film was being produced by Debra Hill with Jon Peters and Peter Guber as executive producers (regarded as two of the most powerful producers in Hollywood during the 1980s). Peggy, knowing Alan's passion for board games, passed the request on to the writer which apparently "greatly amused"[40] him and, unusually for Alan with regard to screenplays, he replied he was open to the possibility of discussing the project.

Cleverly, Peggy suggested to Polygram that Alan first write *Clue* as a stage play, which could then be adapted into a film. This appealed to Alan as potentially it would involve Universal putting money into the theatre. Coincidentally, the previous year he had already begun work on a thriller called *Sight Unseen*, which had been abandoned at the last minute in favour of *Season's Greetings* (but would ultimately form the basis of *It Could Be Any One Of Us*). This, combined with the challenge of writing a script which could be successfully opened out into a movie, intrigued him. He suggested the play could be written for the summer of 1982 and joked that as his next play was due to go the National Theatre, this would be a good play for them![41]

Although the studio agreed in essence to this proposal, an initial screenplay was requested which seemed rather pointless to Alan as he felt there would be no need to write a play if a screenplay existed. He had also begun to have a number of reservations about the idea having gone back to the original board game.

> "I dug out my old *Cluedo* board which was interesting. What of course the *Cluedo* inventor has done is what the inventors of all the classic games have done. He's taken every cliché from the genre and boiled them all down into a board game. It's even subtitled in the rules *Murder at Tudor Close*, and the whole thing is a mixture of every Christie, Ngaio Marsh, Allingham murder mystery you've ever read…. Nothing wrong with that I suppose, providing they want another in the endless series of nostalgia movies. Do they really want another *Murder on the Nile / Orient Express*, particularly when there's about two hundred of that good lady's books still left to adapt. Not to mention Dorothy L. Sayers.
>
> "No, as I see it we must somehow concentrate on the project's most original theme, which is perhaps somewhat oddly the

fact that it is a board game. I am not suggesting that the characters all be dressed as wooden counters whilst the audience are expected to throw a dice - though I wouldn't rule that out - but unless it's set somehow within the framework of a game then the *Cluedo* part of it will essentially be lost and all we'll have is a run of the mill thriller."[42]

Alan's involvement in the project was reported by the New Standard newspaper in an article on 11 February 1981. However, by the time Alan had fulfilled his playwriting commitments and turned his attention to *Clue* in June 1981, the project was already unravelling. Peggy was not convinced a suitable deal could be arranged and shortly afterwards Alan withdrew from the project, which was put on the back-burner by the film's producers.

Clue would eventually be made into a movie with a story by John Landis and Jonathan Lynn and screenplay by Lynn. It was filmed in November 1984 with Lynn directing, Debra Hill producing and featuring Tim Curry and Christopher Lloyd. It was a disastrous attempt to create a comedy thriller with several random final reels distributed to some cinemas to incorporate the game's element of a random killer (although most cinemas were apparently only given one climax, defeating the raison d'être of the film). However, critical opinion concluded this was just a gimmick and none of the climaxes made sense anyway; the movie had an approximate budget of $15m and took just over $14m at the US box office.[43]

Meanwhile, Alan's experiences with *Clue* and *Sight Unseen* would inform his experiences when he wrote the multiple choice murderer thriller *It Could Be Any One Of Us* in 1983.

Communicating Doors

Description: Concept

Prior to starting his intense writing period on a new play, Alan Ayckbourn will often write out the main plot points for reference. Occasionally, these notes become a far more detailed synopsis which, judging by the few surviving examples, seem to occur when he is writing one of his more densely plotted plays.

A detailed synopsis of *Communicating Doors* survives in archive, offering a glimpse of not only how close Alan's finished play is to his pre-writing plan, but also demonstrating he is not afraid to make notable plot changes during the writing process.

The synopsis for *Communicating Doors* is to all intents and purposes the final play - with the exception of several minor alterations; of which two are rather notable. The plot, as briefly as possible, as written and

performed is set in a hotel suite in 2014 with a communicating door that goes back in time 20 years. A dominatrix, Poopay, is asked by the elderly Reece to witness a confession of the murder of his two previous wives, but this is discovered by his associate Julian who attempts to kill her. She goes through the door and unexpectedly finds herself in 1994 with Reece's second wife, Ruella. Together they manage to alter time and save both wives' lives, whilst Julian also arrives from 2014 but is killed by slipping on a bar of soap whilst attempting to murder Poopay. She returns to 2014 to discover her actions have changed Reece and that she has been adopted by Ruella and Reece and her life has been utterly changed for the better.

The synopsis notably differs in that Julian follows Poopay back to 1994 but is killed by a heart attack whilst attempting to throw her out of the suite's window. The other major difference is at the climax of the play, Poopay returns to 2014 to discover her actions have altered time. Reece is now a good man who did not murder his wives and lived happily with Ruella for many years. They did not, however, adopt Poopay who is still a dominatrix. Having altered time, she then offers to give the elderly Reece a final free session as the play ends! Needless to say, the actual ending of the play in which Poopay's timeline has been altered for the better is far more satisfying and considerably less disturbing!

Communicating Doors

Description: Variant

Generally speaking, Alan Ayckbourn is against alterations to his plays or them being updated. He views his work as period pieces which only make sense if they are performed within the context of the time they were written: i.e. *Bedroom Farce* is a play which only makes sense when set int the late 1970s, it can't be updated as the near ubiquity of mobile phones in the present day makes the premise untenable.

There are occasional exceptions to this though, most notably with the playwright's future-set plays given the future has a habit of over-taking predictions or even the dates the play were themselves set. The most obvious example of this is *Communicating Doors*, which was written in 1994 and has 'future' set scenes in a dystopian London riven by civil war, set in 2014. Obviously London hasn't - yet - degenerated into civil war! In recent years, the playwright has allowed productions to bring the 1994 scenes to the present day and the future plays 20 years hence (so a production staged in 2017 would have future scenes set in 2037). To accommodate this and changes in technology since the play's debut, Alan has also allowed alterations to be made to specific references such as updating terms such as 'videos' and other now outmoded technology.

Complications

Description: Concept

Complications is the title of a proposed five act play in the same vein as Alan Ayckbourn's 1974 piece *Confusions*. It is first referred to in an interview with the playwright in 2013. Within the interview he talks about the origins of his two one-act plays, *Farcicals*, and how he intended to write a larger piece called *Complications*.

Although Alan did not write *Complications*, it seems possible that it was related to his original idea for his 2012 play *Surprises*, which was initially conceived as containing five inter-related one act plays.

> "They [*Confusions*] were five loosely linked plays, and I had it in mind that I was going to write five more short plays to match them, this time called *Complications*, but in the end *Farcicals* stuck its head over the parapet."[44]

Confusions

Description: Concept

It's probable that at some point, Alan Ayckbourn has written notes, early concepts and ideas for the vast majority of the plays he has - and has not - written. However, rarely have any of those notes been preserved for posterity; surviving notes tend to surface on the back of manuscript drafts or documentation preserved for other reasons.

In the case of *Confusions*, there exists a hand-written note in archive which shows an early concept for the play, still incorporating several short plays and five actors but in a six act format with temporary titles. The only similarity to the final play is the inclusion of *Mother Figure*, which had originally been written for a separate aborted project entitled *Mixed Doubles*, and around which *Confusions* was constructed. The concept details were:

1. Bride and groom – discovery (1m 1f)
2. Marriage breaker – re-union and interruption (2m 1f)
3. Mother Figure (1m 2f)
4. Man whose wife leaves him (3m 2f)
5. Reversals (1) (2m)
6. Reversals (2) (2f)[45]

Although we only have these surviving placeholder titles to compare with the actual play, they do not appear to bear any resemblance to the basic plots of the four one-act pieces - *Between Mouthfuls*, *Drinking Companions*, *Gosforth's Fête* and *A Talk In The Park* - which accompany *Mother Figure* in *Confusions*.

Cover Version

Description: Title - Discarded

One of several titles Alan Ayckbourn considered for his 2005 play *Improbable Fiction*.

A Cut In The Rates

Description: Ephemera

A Cut In The Rates was for many years considered one of only two produced screenplays written by Alan Ayckbourn. It is actually a one-act play which has the distinction of its first performance being screened on television as part of a BBC educational programme exploring theatre.

A Cut In The Rates was commissioned as part of the *English Files* educational series on BBC2 and broadcast on 21 January 1984. It looked behind the scenes of a play from read-through to production with the play then performed and recorded in front of a live audience. This was the only time Alan Ayckbourn has directed the play and it featured Michael Cashman, Liza Sadovy and Lavinia Bertram; it also made use of the set for the current production at the Stephen Joseph Theatre In The Round, Michael Cashman's *Before Your Very Eyes*.

A Cut In The Rates has been published but although the *English Files* episode was repeated several times during the 1980s, it has not been broadcast again since then and never been released commercially.

The play is about a rates collector attempting to collect taxes from an illusionist, confronted by the apparently dead victim of a magic act gone hideously wrong. When the magician appears, saw in hand, the collector flees conned by an elaborate tax avoidance scam.

> **Miss Pickhart:** You mean your -
> **Ratchet:** Yes.
> **Miss Pickhart:** In half?
> **Ratchet:** It was a terrible mistake. I was acquitted. The coroner said it was a tragic case of a misguided search for artistic perfection.[46]

Dad's Tale

Description: Withdrawn

"My first taste of theatrical failure."[47]

Dad's Tale was Alan Ayckbourn's first play for children and one of two Christmas plays in quick succession, the failure of which led him to abandon children's theatre for more than 25 years.

It also marked the first time Alan would collaborate with someone else on a play, in this case fellow playwright David Campton. Stephen Joseph, Artistic Director of Scarborough's Library Theatre, asked Campton and Alan to collaborate on the 1960 Christmas production using Mary Norton's novel *The Borrowers* as a starting point; largely because Campton had already begun adapting the book.[48] Alan read the play, wasn't keen on it and the writing partnership dissolved leaving Alan to write the book alone.

And the ballet.

> "Stephen just said: "Um... will you be putting any ballet into your play?" And I said "WHAT!" and he said: "Ballet." Well I pointed out that I didn't write ballet but Stephen just said I should."[49]

Alan was apparently unaware that Stephen had agreed the show would be a co-production with the British Dance Drama Theatre, which had appeared at the Library Theatre earlier that year. It is doubtful Stephen ever fully considered the practicalities of commissioning a play involving dance with a writer who knew nothing about dance, a co-production with very little budget and, astonishingly, a show where the two companies would only meet for the first time during dress rehearsals!

Alan cleverly circumvented the dance problem by writing dream sequences into which the dances could be dropped and which had little effect on what little plot there was.

> **Martin:** (to audience) That night Auntie had dreams about giant turkeys that kept sticking their heads out of the oven and biting her. And well - Dad, I don't think Dad dreamed about anything much, he just snored, I know I heard him as I lay awake thinking about Jenny. When I did get to sleep though, I dreamt about joining the circus.
>
> (The CIRCUS BALLET)
>
> (The Christmas music fades to the sound of bells. It is Christmas morning)[50]

The play opened on 19 December 1960 to "an audience of five with an average age of forty"[51], the intended school audience having already broken up for the Christmas holidays.

Although the play was a commercial failure and obviously misguided from conception, it is notable for a scene in which two characters tell the same story of Dad's theft of a Christmas hamper. The interpretations of the act are completely different and break the narrative structure to present alternative viewpoints. It has been argued by the critic and author Michael Billington that this was a very early use of this technique in contemporary British theatre.

"A simple enough tale. But what is interesting is how, even at this early stage, Ayckbourn experiments with different ways of telling it. Long before David Helliwell began to explore the possibilities of multi-viewpoint drama, Ayckbourn shows us a single incident from several points of view."[52]

Dad's Tale is also the final canon play to be credited to Alan's pseudonym Roland Allen; *Standing Room Only*, written the following year, was originally credited to his pseudonym, but was later revived and credited to Alan Ayckbourn.

December Bee

Description: Title - Alternative

December Bee is the subtitle for the play *Woman In Mind*; it is rarely used for actual productions, but is carried on the covers of the published editions. It refers to the protagonist Susan's distorted language during her breakdown, translated literally as: "Remember Me."

The Divide

Description: Ephemera

The Divide is one of the most unusual of Alan Ayckbourn's works and marked a complete departure for the playwright when it was unveiled to the public in 2015. The eight-hour long work is described as a 'narrative for voices' and features 39 speaking roles. It is not a play and emerged from the playwright's desire to write a novel, unencumbered by the practical limitations of a staged play.

The Divide is closer to prose than a play and consists of diary and journal entries, newspaper articles, transcripts, minutes and reportage; although initially presented as a dramatic reading, it is perfectly conceivable the piece could be published as a book. It marked a deliberate decision by the playwright to push himself in a new direction and write in a format he had never attempted before.

The plot centres around a post-catastrophic England where a disease has made contact between adult men and women fatal. The sexes are segregated by The Divide, with the men living in the north and the women in the south. Into this, a young man falls in love with a member of the opposite sex, leading to tragedy and rebellion.

The Divide's first public performance took place on 27 September 2015 as a special gala event celebrating the Stephen Joseph Theatre's 50th anniversary that year. This version of the piece was heavily edited from the original draft which contained more texture and world-building,

but which Alan felt needed to be edited down to substantially reduce the running time; as it was, the event ran to more than eight-and-a-half hours! The reading featured 18 guest actors reading their parts directly from the script.

Although Alan had no immediate plans for *The Divide* following its unveiling in Scarborough, there has been interest from other theatres, radio and the possibility of it being published. It seems likely *The Divide* will eventually reach a far wider audience within the foreseeable future.

The following extract reproduces the introduction to *The Divide* in its original form being being edited for public performance.

SOWEEN: (aged 68) Being so closely involved with the events leading up to the fall of the Divide, I have been asked on countless occasions to write down my experiences leading up to that momentous event. Till now, I have always declined. I had two reasons for doing so. The first was that, on a professional level, my reputation such as it is has been based till now as a successful writer of popular fiction. Not only was I hesitant to attempt a factual account of real events but I was anxious lest they be mistaken especially by the young as creations of my own imagination. This period in our history is far too important to be relegated to the realms of myth. For recent generations who never experienced them at first hand. We are often too ready to dismiss or conveniently forget such uncomfortable or inconvenient chapters in our history. My second reason for refusing was, on a personal level, though long in the past the events are still too clear for us who lived through them for the pain they caused to be entirely softened by time, most especially for my Mother. Although we both lived through them together, I somehow felt she, a loving parent and partner bore the brunt of events far worse than I, an immature fourteen-year-old. But my Mother died a few weeks ago. It was thankfully a peaceful passing, in her own bed as she would have wanted. She'd reached a good age and we, her family were all there, myself, her daughter, her devoted son-in-law and this her three beloved grandchildren, Fayla, Japeth and Jilli, to say our farewells to Mama.

First, some apologies. What follows is less a straight narrative and more a montage gathered from various sources, mostly from my own diary from the age of eight upwards. I've edited this as little as possible, attempting to avoid the obvious trap of trying to improve, through misguided hindsight, the outpourings of an immature girl battling the usual agonies of adolescence. Some entries I was tempted to remove to spare

my blushes. Particularly my embarrassing 'sub Brontë' period in which I appear to have been completely carried away! Nonetheless I hope my diary will capture at least some of the flavour of how it was to live and grow up, as a child, during the final years of The Preacher's regime, in an isolated, strictly puritanical all-female society entirely segregated from men. The inhabitants meekly underwent a form of endless penance on behalf of their sex for sins long past and wrongs long forgotten. The image in our Village Square of The Men's Memorial with its ten thousand names of those who died from The Plague will remain with me for ever. It stood dominating everything, a massive granite reminder to all us Women, of our responsibility for that appalling loss of life. We were a society ruled by guilt which we were seldom allowed to forget. Four times a year, spring, summer, autumn and winter, came those Days of Reflection, when the entire Village would fall silent for twenty-four hours, whilst each of us jointly acknowledged her responsibility for the past. I suppose my view of events is slightly skewed by the fact that my mother's partner, my Mapa as she was known, was devoutly Orthodox. As children, during our early years especially, my brother and I were brought up strictly according to the rules laid down by The Preacher.

As to The Preacher, himself (or herself, we were never quite sure), we were encouraged to believe that he/she was immortal and still lived. But I think many of us abandoned that belief along with Father Christmas (who was most definitely frowned upon!) Evidence, following the fall of the Divide, suggests that the original Preacher died many years earlier (some reports say from a sexually transmitted disease!) and was replaced by a committee of two, initially men but later on of both sexes in an attempt to maintain the status quo established by The Preacher and the legacy he left in his Book of Certitude, the Bible we were all meant to live by.

There were, needless to say, powerful factions of society, particularly on the Male side, with a considerable vested interest to maintain it. But when has it ever been otherwise?

The other major source I have drawn from is my own brother, Elihu's diary. He was a slightly less conscientious diarist than I, being a boy he became preoccupied with Other Things.

Soween Clay-Flin

April 2243 [53]

Dividing Line

Description: Title - Discarded

Dividing Line is one of a number of titles considered by Alan for the play which was eventually produced as *Absent Friends*. The potential title is listed on a hand-written note of early ideas for the play which also includes the final title.

Double Hitch

Description: Grey Play

Long thought lost, *Double Hitch* is one of three one-act plays by Alan Ayckbourn, although attributed to his pseudonym Roland Allen, written during the first three years of his professional writing career.

The precise origin of *Double Hitch* is unknown; in Alan's biography, the author Paul Allen tentatively dates it as being written in late 1960 [54] - which is likely to be correct. However, a license to produce the play was not granted until 27 February 1962 by the Lord Chamberlain's Office.[55] Strictly speaking, until 1968 a license had to be issued by the Lord Chamberlain's Office for any play to be performed unless the performance was for a private club. Any public performances of the play before 1962 would have been unlicensed, which initially suggested the play might have been written later than 1960.

But in 2009, a former member of Scarborough Theatre Guild, Evelyn Corradine, supplied The Bob Watson Archive at the Stephen Joseph Theatre with scans of programmes for productions of *Double Hitch* prior to 1962. She was able to date these programmes to 1960 at the latest and, again previously unknown, demonstrated the play was produced several times before February 1961 normally in conjunction with the play *Lonesome Like* by Harold Brighouse. As a result of this, it now seems certain the play was written circa 1960 and premiered in-the-round at the Library Theatre, Scarborough, but not, as previously thought, in conjunction with another Ayckbourn one-act play *Follow The Lover*, which is known to have had its premiere in 1962.

Double Hitch was probably first directed by Margaret Boden and comes from a period when Alan recalls writing a number of short one-act plays for amateur production. These are known to include *Double Hitch*, *Follow The Lover*, *Love Undertaken* and *The Party Game*. Of the surviving manuscripts, only two copies of *Double Hitch* are known to exist, one held by the British Library and a second held in a private collection.

Unlike the other plays intended for amateur performance from that period, *Double Hitch* had an extended shelf-life. In addition to at least two recorded performances in 1960 (in all likelihood there were several more), it was also staged at the Fourth In-The-Round Festival, at the Library

Theatre, Scarborough, by Anlaby Youth Drama Group in September 1963. A further production was presented by Scarborough Technical College Drama Group at the British Drama League Combined Theatre Festival at the Library Theatre, Scarborough, during the mid-1960s.

The plot revolves around two newly-wed couples who have been double-booked into a decrepit rural cottage by a dubious man who looks like Blackbeard. The state of the house encourages distinct differences of opinions between the partners of each couple. When the husband of one couple and the wife of the other leave to try and find alternative accommodation without either of their partners' knowledge, those left behind presume the pair have eloped and so pretend to have slept with each other themselves in case the others return. When the partners do return, the original couples are restored presuming they have each been seduced against their wills by the opposite partner. With the couples reunited, they all leave the cottage to book into a pub room. The same room, of course.

> **Phyllis:** Darling, you're not a poor man. I'd never have married you if you were.[56]

Dracula

Description: Grey Play

Given that Bram Stoker's novel *Dracula* features Whitby, a seaside resort just up the road from Scarborough, it seems only apt that Alan Ayckbourn should at some point write his own version of one of Yorkshire's most famous literary visitors. *Dracula*, as written by Alan Ayckbourn, has very little to do with the actual literary creation though, being a short sketch for the revue *What The Devil!*. This was devised in 1975 by Bob Eaton and Polly Warren for the Library Theatre company to tour to pubs in the Scarborough area with three actors; *Dracula* was not part of the original production.

What The Devil! was then presented as a late night show at Scarborough's Library Theatre and lengthened to two acts with an expanded cast of five actors; one of the additions being Alan Ayckbourn's *Dracula* sketch.

It had been assumed that the revue - and consequently *Dracula* - was never produced again. However, *Dracula* was performed at least once more professionally as part of a different revue, also compiled by Bob Eaton, produced at the New Victoria Theatre, Stoke-on-Trent in 1992. *The Night Before The Morning After Show* featured a variety of sketches including *Dracula*.

> "Alan Ayckbourn's *Dracula* skit proves to be a little known comedy gem."[57]

The plot of *Dracula* sees the infamous vampire and his hunch-backed henchman Squelch arrive at the home of an unintelligible shepherd Seth, his wife Martha and their peculiar daughter Deidre. Looking to stay the night and seduce Deidre, the vampire that she is, in fact, a werewolf.

> **Martha** (screaming): Lord help us, what is that?
> **Squelch:** Nnnn.
> **Dracula:** A thousand pardons. May I present my servant Squelch, he won't harm you. Be not alarmed. His appearance is, I confess, disconcerting. But I assure you he is quite harmless. Usually. On the whole. Mainly. More often than not. Come in, Squelch, come in.
> **Squelch:** Nnn. Nnnn.
> **Seth:** Woor.[58]

In 2012, *Dracula* was one of several rarely revived Ayckbourn plays performed by students at the University of York for the production *Ayckbourn Shorts*; this was one of several events arranged to mark the first anniversary of the acquisition of the Ayckbourn Archive by the Borthwick Institute For Archives at the university.

Although not exactly the same play, audiences had a taste of the style of *Dracula* when it was used as the basis for the *Horror Story* section of *The Karaoke Theatre Company* in 2016. This interactive piece by Alan Ayckbourn encouraged the audience to take part in a short one act play, heavily inspired by his play *Dracula*, by providing gothic sound effects and narration. The premise is essentially the same but features a newly married couple taking refuge in a creepy castle with a mysterious woman and her unintelligible manservant. She is revealed to be a lisping vampire looking to seduce the young woman, who turns out to be a werewolf.

Dreams From A Summer House

Description: Concept

Although the Ayckbourn Archive contains some concept notes for plays by Alan Ayckbourn, none are as detailed as a nine-page correspondence for an early version of Alan Ayckbourn and John Pattison's first full-length musical *Dreams From A Summer House*. This document offers ideas and a detailed synopsis for a play which bears only a nominal resemblance to the 1992 musical as written by the playwright.

Although undated, the notes seem likely to date back to 1991 and were written for the composer John Pattison as a guide to Alan Ayckbourn's initial ambitious plans for the musical. Whereas the final play featured characters from *Beauty And The Beast* stepping into suburban England, the original concept has a third strand based around the

characters in an unfinished novel who cross over into the fairy-tale realms.

Within a covering letter letter to John Pattison, Alan discusses the challenges of the play.

> "We obviously need to find differing musical and visual styles for the three levels of the story. I think the 'Musical' level should be a gothic sort of style. Like all those old movies of *Frankenstein* - set in Transylvania. But the difference between the Novel and the Real world are more difficult to mark. I thought perhaps of making the musical brightly coloured, whereas the novel could be in black and white and the real world somewhere in between. As Beauty, Beast and their world are affected by the grim novel, all the colour drains out of them. Easy on film."[59]

Alan then sets out a detailed six page synopsis of the plot of the musical. Given its complexity, the technical challenges and the grimness of the 'Novel' section, it is perhaps understandable why Alan Ayckbourn decided to eventually simplify the plot and to concentrate on the fairy tale characters crossing into suburbia plot of the final play.

Despite this, it is intriguing to see how vastly the final play differs from the concept with very little material connecting the play as written other than the setting of a summer house and the idea of *Beauty And The Beast* interacting with the real world. The plays do not even share the same character names or motivations and the musical element seems more borne out of the fact the protagonist is a lyric writer rather than the play's motivating idea that the only way to communicate with the fantasy characters is through song.

The play as actually written follows divorced artist Robert illustrating a book of *Beauty And The Beast*. Belle appears from his painting - having escaped from the beast, Baldemar - unable to communicate except through song. Robert's ex-wife returns home and is kidnapped by the Beast and taken to his castle. Amanda wreaks havoc on the Beast and while Robert is besotted by Belle, she slowly loses her voice away from her world and senses Baldemar is dying too. Desperate to restore order, Amanda is persuaded to sing and, discovering her inner voice, she restores everything to its rightful place. Richard also finds a more realistic love with Mel, Amanda's previously disparaged sister.

The original concept centred on widowed writer Larry working on his Great Unfinished Novel; the action coming to life as he writes. Chris, a composer, hopes to relaunch his and Larry's careers on the back of their one success, a musical of *Beauty And The Beast*, and persuades them to see an agent where Larry meets Inge and falls in love. Larry, inspired, begins writing lyrics again and Beauty - who resembles Inge - and the

Beast appear as he does. Following a drunken evening, Chris reveals he had an affair with Larry's wife, who then committed suicide. A drunk Larry finds himself in his Novel where the heroine, Jill, has leapt to her death and ended up in Beast's castle, captured. Belle appears to Larry, who promises to love her forever, but shuts her away and begins changing her into his former wife; as a result, she loses her singing voice and also leaps from the balcony. Jill meanwhile has emasculated the Beast and returns to her unhappy life in the Novel as Belle returns to Beast and saves him. Larry awakes believing it all a dream, but Chris comes in with a new song which Larry heard in the 'dream'. Inge offers Larry a chance to be with her and he prevaricates until Chris's music inspires him to show his true feelings and the couple sing together.

Early Writing

Description: Ephemera

Alan Ayckbourn recalls writing from a very early age, influenced by his mother, Mary James, who was a professional writer.

> "I watched her write them, because she used to thump them out in the kitchen. And it sounds a corny anecdote, but she really did. I suppose if Mummy had been washing up all day, I'd probably have become a very good washer-up - she gave me a little typewriter and I started to thunder out my own awful tales. I wrote stories and I wanted to be a journalist: later things changed!"[60]

He would continue to write whilst at primary school, particularly during a period when he was ill and at home, creating a play based around Anthony Buckeridge's *Jennings* novels.[61] When he went to Haileybury, he also recalls writing end-of-term plays; although none of his school-day writing survives.

As a teenager, Alan went straight from school into professional acting and was writing extensively throughout his teenage years, leading up to his first professional commission of *The Square Cat* in 1959 when he was 20. Most of these plays, unfortunately now lost, were early attempts to emulate other writers as Alan learnt his craft and were often read by his mentor Stephen Joseph.

> "I began around the age of nine, I suppose! Certainly I was tapping out plays in my early teens and had written a good half dozen before I had my first one professionally produced."[62]

As it stands, the only documented plays which can be tentatively - but not definitively - dated to this period prior to his first professional

commission are: *The Season*; *The Party Game*; *Relative Values*; *Mind Over Murder*; a lost play inspired by Pirandello; a lost play inspired by Ionescu.

Ecraf

Description: Concept

Ecraf is a concept for a farce that Alan has mentioned repeatedly in interviews since the late 1960s. Whether it is anything more than a clever concept or something that will eventually be realised is anyone's guess.

Essentially, the concept is a farce which runs backwards - hence the title - presumably structured in the manner of such a play as Harold Pinter's *Betrayal*.

> "I've always wanted to play around. I wanted to write one play backwards, which started with a cupboard full of vicars with no trousers on, and then wound down to two people having breakfast, And call it whatever farce is backwards - *Ecraf*."[63]

That the playwright is fond of the concept is highlighted by the fact that 30 years after this quote (which may not even be the earliest reference to *Ecraf*), Alan was still mentioning the proposed play during interviews.

> **John Moore (Denver Post):** What's your best idea for a play you've never written?"
> **Alan Ayckbourn:** *Ecraf*, which is farce backwards. But then farces are notoriously difficult to write. And one that runs backward would be very hard indeed. But it's there, so, I suppose, all things being equal, I might have a go at it one day.[64]

Elevator / Escalator play

Description: Concept

This is another concept occasionally mentioned by Alan Ayckbourn based on a desire to create a play with vertical movement on stage. The initial concept appears to have been for two working escalators on stage - and there have been hints the announced but unwritten 1994 play *Private Fears In Public Places* might have utilised this idea; it has also been suggested the play might have incorporated travelators given it was set in an airport..

In interviews since 1996, Alan has sometimes refined this idea to an elevator play (his home theatre, the Stephen Joseph Theatre in

Scarborough, has under stage access and it would be possible to have elevators rising and falling through the stage), but it has remained nothing more than an intriguing concept.

Ernest & Delia

Description: Ephemera

Not strictly an Ayckbourn creation, *Ernest & Delia* was a proposed television spin-off from Alan Ayckbourn's 1975 play *Bedroom Farce*.

Following the success of the television adaptation based on the National Theatre's production of *Bedroom Farce* in 1980, Thames Television approached Alan about creating a spin-off series featuring the two elderly characters from the play. The proposal was always contingent on having the actors Michael Gough and Joan Hickson reprise the roles of Ernest and Delia they played on stage (although Gough's role had been played by Michael Denison in the television adaptation of the play).

Alan, who has never shown any interest in writing for television, declined the offer to write the pilot[65], but cautiously backed the idea of them approaching another writer offering firm suggestions as to how to approach the characters.

> "I think, were I writing them, I'd keep them very much within the confines of the house. Ernest and Delia make only occasional forays elsewhere. They mistrust it."[66]

A proposed format was suggested to Alan's agent, Margaret Ramsay, consisting of four series of six half-hour episodes.[67] Lacking Alan's involvement as a writer, Thames approached and commissioned the playwright Peter Tinniswood to write the pilot; Alan had worked with him previously in Scarborough. Peter had similarly strong feelings about the characters and it seems likely these may have jarred with Thames' vision for the show.

> "Michael Mills [producer of the planned show] was talking about moving Ernest and Delia out of the house and giving them 'adventures'. I threw my hands up in horror and said that under no circumstances must they be moved from the house, In fact, if we could do everything in the bedroom itself, I should be happy."[68]

Peter wrote a script for the pilot and Mills set plans in motion to begin filming. However, when Joan Hickson made Alan aware she was unhappy with the piece; Alan decided to withdraw from the project and made clear his intentions on 25 July 1982. Lacking the playwright's support, Thames made a decision to halt the project and officially confirmed the project's

termination on 4 August.[69] The only substantive attempt to make a television spin-off of an Ayckbourn play was never discussed again.[70]

Peter Tinniswood died in 2003 and it is doubtful any copies of the pilot script for *Ernest And Delia* still exist.

An Evening With PALOS

Description: Grey Play

When the award-winning National Theatre production of *A Chorus Of Disapproval* transferred to the West End in 1986, it was without its leading man Michael Gambon. Into his shoes stepped the acclaimed actor Colin Blakely playing the role of Dafydd ap Llewellyn; tragically his final stage role when he died on 7 May 1987, just two months after the play closed.

The shock death of an actor perceived to be at the height of his career led to a memorial event at the Lyric Theatre on 4 October 1987 to commemorate the actor's life. Hosted by Albert Finney and directed by Bill Bryden, it featured contributions from luminaries such as Harold Pinter, Michael Frayn and Alan Ayckbourn. Alan's contribution was a one-act play written specially for the evening to honour the actor's final role in *A Chorus Of Disapproval*.

An *Evening With PALOS* centres on a rehearsed reading, by several members of Pendon Amateur Light Operatic Society, of Murdoch Parkes' epic poem on rural life *A View From The Pump* (Parkes being one of Pendon's most pre-eminent authors and a major influence on Dylan Thomas - or possibly vice versa). Being PALOS, things run far from smoothly.

The role of Dafydd for the evening was taken by David Jason and the production featured several members of the National Theatre company reprising their roles from *A Chorus of Disapproval*. *An Evening With PALOS* has never been published and has been performed only once subsequently at the University of York in 2012 as part of the *Ayckbourn Shorts* event.

> **Dafydd:** So on with the show, to coin an already well-minted phrase. Tonight we present for you a short, rehearsed - *(glancing at his colleagues)* - a semi-rehearsed - play-reading of an unfinished fragment by a writer - sadly no longer with us - but in his day a living legend - certainly within the borough boundaries of Pendon itself - I refer of course to the late Murdoch Parkes. Those of you who were fortunate to see his fine adaptation - some years ago admittedly - of *The Tale Of The Genji*, *Almond Blossom Time* or those of you who perhaps admired his final, though sadly unrealised, musical biography

of Lord Nelson, *Kiss Me, Hardy Hardy, Kiss Me* - will know what a treat we have in store for us tonight. As I say, this is but an unfinished fragment. But what a fragment, ladies and gentlemen, what a fragrant fragment. Discovered in the basement of his bungalow by his lovely widow and leading contralto Evadne Parkes, discovered as the result of an unfortunate incident with a faulty gas-fired central heating boiler - we have reason on this occasion to raise our voices and say, God Bless the Gas Board. For this is a bird's eye picture, a worm's level view of life within a living village. Intended originally as a panoramic experience to be spoken and sung by a cast of ninety-five plus brass band, I have tonight not without some regret been forced to render it down to be spoken by a mere six voices.

Enid: *(sotto)* Five.[71]

Fancy Meeting You

Description: Title - Alternative

Fancy Meeting You was the original title for *Table Manners*; one part of *The Norman Conquests* trilogy. After its world premiere at the Library Theatre, Scarborough, in 1973, the title was altered for its original London production at the Greenwich Theatre, which later transferred to the Globe Theatre.

Father Christmas Versus The Master Mind

Description: Title - Discarded

The earliest recorded reference to Alan Ayckbourn's fourth play, *Christmas V Mastermind*, is within an article published in The Times on 3 December 1962, highlighting the work of the recently opened Victoria Theatre in Stoke-on-Trent.

The article refers to Alan Ayckbourn's new play by an alternative title; whether this was an error on the part of the journalist or the title was later altered is unknown.

> "A new season will soon open with *Father Christmas versus The Master Mind*, specially written for the season and for children by Mr Ayckbourn, who says that it is 'slightly off-beat', which may well suit modern children."[72]

Father's Day

Description: Title - Discarded

When first performed at the Library Theatre, Scarborough, in 1965, *Relatively Speaking* had the title *Meet My Father*. However, the producer Peter Bridge - who had optioned the play for London -was unhappy with this, feeling it was a little too provincial and he asked Alan to think of a new title. As a result, the play went through several title revisions on its journey to the West End including *Father's Day*, before finally settling on *Relatively Speaking*.

"By the following February [1967] the play having been re-christened *Taken For Granted*, *Father's Day* and finally *Relatively Speaking* was in rehearsal in London."[73]

Five To Five

Description: Title - Discarded

Five To Five was an early potential title for what would become the play *Confusions*. The title playing on the fact it consists of five plays performed by five people.[74]

FlatSpin

Description: Abandoned

For the 2001 summer season at the Stephen Joseph Theatre, Alan Ayckbourn set out to revive the repertory company tradition at the Scarborough venue. He intended to write two plays featuring the same cast and the same set which would run in repertory with each other. In the autumn of 2000 he began writing a duology, but by Christmas realized neither play fitted the bill so he discarded these ideas - of which no details are known about the original *FlatSpin* - and started writing afresh.

"I started work on two linked plays in October of last year (2000), but a few days before Christmas, I realised that one of them was horribly wrong. Then I realised the other wasn't worth doing at all, and ditched them both.... I thought 'Wow. You're not secure in the process even now.' But my maturity meant I could bin both original plays. I remember pressing the delete key on my computer and thinking: 'Now what have I done?'"[75]

Floor 71

Description: Screenplay

Following the completion of Alan Ayckbourn's first play *The Square Cat* in 1959 and his marriage to his first wife Christine Roland in the same year, a newspaper article local to Christine's parents ran a story about the couple noting they were writing a number of treatments for television dramas, which they hoped might lead to screenplay commissions. A number of television plot outlines survive in the Ayckbourn Archive, which are presumably the result of these efforts. It is worth noting that Alan's mentor Stephen Joseph had close associations with the TV company Associated Rediffusion and the couple may have been looking to take advantage of his contacts.

Floor 71 is a proposal (incomplete as it stands) for an hour-long futuristic drama, set in vast buildings from which people never leave as everything they need is present in each building - somewhat reminiscent of the Mega City One city-blocks created for the British comic strip *Judge Dredd* during the 1970s. Each floor is the equivalent of a city with each corridor a street, thereby giving the impression of a real city. The action is set on Floor 71 in a world where social standing is judged by floors; the higher one's position in the world, the higher the floor occupied.[76]

> "At the very top, here, we have floor 96 and at the very bottom, here, is floor five. What, asks a child, is underneath floor five, Miss? Nothing at all, she replies guardedly, you just fall and fall and fall."[77]

Folk From T'Smoke

Description: Screenplay

Folk From T'Smoke was discovered in the Ayckbourn Archive in 2009 and is little more than a collection of unorganised and undated hand-written notes. It comprises of several unfinished sketches which appear to have been written as the basis for a revue or sketch show; although it is impossible to say with complete certainty what the author's intentions were.

Each sketch features a presenter, Trish, filming the latest edition of *Folk From T'Smoke: Singers And Their Songs From The North*. Each sketch has the same format with filming beginning before stopping as it develops into a rant by Trish with commentary by the film and stage-crew, much of which is conducted while Trish's microphone is still live. Although unfinished, some of the ideas from the sketches recur in later plays *A Chorus Of Disapproval* and *Man Of The Moment*.

Although undated, the notes include a cast list which features the 1977 Stephen Joseph Theatre In The Round company, suggesting it was written that year.[78]

Follow The Lover

Description: Grey Play

Follow The Lover is one of several one-act plays written by Alan Ayckbourn during the formative years of his professional playwriting career. It was originally presented during 1962 in a double bill alongside an earlier one-act play, *Double Hitch*.

It was written by Alan under the pseudonym of Roland Allen, probably in early 1962. Although, intriguingly, no copy of *Follow The Lover* is held at the British Library and there is no record of a license being issued for performance by the Lord Chamberlain's Office as was required of all public performances at that time.

The play was directed by Margaret Boden and Alan vaguely recalls acting in this production in the role of Phil. It was performed in the round at the Library Theatre, Scarborough, and does not appear to have been performed again; *Follow The Lover* has also never been published and is considered one of Alan Ayckbourn's Grey Plays.

The plot revolves around an older couple, Mr and Mrs Poulton Smith, who each believe the other is having an affair and have each hired detectives, Philip and Jennifer, to discover the truth. Naturally both of the couple believes the presence of the attractive young detectives is proof of each other's infidelities.

> **Mr Poulton-Smith:** But I never make mistakes. Can't afford to - not in my business.
> **Young Lady:** But your wife is hardly business.
> **Mr Poulton-Smith:** Of course she's business - what else do you call her? I've invested a lot of money in that woman and if it looks as though the market is going to crash, I mean to sell out - quick.[79]

Foreseeable Futures

Description: Title - Discarded

An early discarded title for Alan Ayckbourn's 2012 play *Surprises*. The title is present on an early draft of the play. This draft also clearly states it consist of 'three linked one act plays' called *Future Wife*, *Future Love* and *Future Dreams*. As published and performed, *Surprises* is described as

'three romances' and the individual acts are named *The Surprise Husband*, *The Surprise Party* and *Surprises*.[80]

Despite the different play and act titles, *Foreseeable Futures* is essentially the same as *Surprises* and just an early draft of that play.

GamePlan

Description: Abandoned

In the autumn of 2000, Alan Ayckbourn began writing a duology with the intent of reviving the repertory company tradition at the Stephen Joseph Theatre. Both plays would share the same company and be performed in repertory. However, Alan soon realised the first play - it is not known whether this piece was then called *GamePlan* - was not working and he ditched the idea and began again from scratch. Just to compound matters, the second play was also abandoned by Alan for similar reasons.

> "I started work on two linked plays in October of last year (2000), but a few days before Christmas, I realised that one of them was horribly wrong. Then I realised the other wasn't worth doing at all, and ditched them both."[81]

GamePlan

Description: Revised

It is very rare for Alan Ayckbourn to alter - or allowed to be altered - his plays. The playwright has long since made it clear he considers his plays to be period pieces specific to the year they were written; the obvious exceptions being the future-set science-fiction plays. In 2015, the playwright was asked by Pitlochry Festival Theatre if a substantial number of alterations could be made to the play *GamePlan* to make it contemporary.

Unusually, the playwright agreed perhaps realising that a play which puts social media and the internet so firmly at its centre is, in the present climate, likely to date far quicker than other plays and that what was trending and common in 2001, now might seem either archaic or meaningless now.

Examples of the alterations include references to the London Dome being changed to the 02 Arena and acknowledging that two teenage girls would be using social media - such as Facebook and Twitter - far more actively. They also reflected actual societal changes such as changing WPC (a female police officer) to just PC; strangely the term WPC was abolished in 1999, two years before the play was originally written.

That it was this specific play which proved problematic is indicated by the fact the venue performed all three *Damsels in Distress* plays, but felt the need only to ask for alterations to *GamePlan*.

The Game's The Thing
Description: Title - Discarded

One of several proposed titles for *Time And Time Again*, which Alan Ayckbourn had written in his early notes for the play.

The Garden Pact
Description: Title - Discarded

Another one of several proposed titles for *Time And Time Again* which Alan Ayckbourn had written in his early notes for the play.

The Ghost Of 'Enry Albert
Description: Ephemera

The Ghost Of 'Enry Albert is not a play but actually a song written by Alan Ayckbourn with Bob Eaton and presented as part of the 1975 revue *What The Devil!*. This was a touring show with a supernatural theme, which was later expanded and performed at the Library Theatre, Scarborough. Alan contributed two pieces to the revue, this song and the one-act sketch *Dracula*.

The 'Malcolm' referred to performing a soft shoe shuffle is the actor Malcolm Hebden; well known for his role of Norris Cole in the long-running television soap opera *Coronation Street*. At the time he was in performing in his first season at Scarborough.

The Ghost Of 'Enry Albert

I've had only one ambition
And it's always been the same
To get married and have children round me feet.
When I met this electrician
'Enry Albert was his name
Then I really thought me happiness complete.

Henry was a little terror
He was only five foot three
Quite the nicest geezer you could hope to meet

Till he made his final error
When he tried to carry me
Through the doorway of our brand new bridal suite.

Now, I told him not to do so
I've got heavy bones, you see
Thus, he breathed his last upon our Welcome mat
Leaving me to count my trousseau
In my see-through negligee.
From a bride into a widow just like that.

As a token of my sorrow
I decided I'd observe
Deepest mourning all of Tuesday afternoon
But before teatime tomorrow
And before I lost me nerve
I'd remarry to forget my honeymoon.

I looked round in desperation
Till a sailor boy called Fred
'E decided we would make a lovely pair.
But imagine our frustration
As we cuddled up in bed
When we saw the ghost of 'Enry standing there.

CHORUS

What's a blushing bride to do upon. her wedding night?
How's she ever going to get herself enjoyed
When the bridegroom dims the light and just shrivels up with fright
At the sight of 'Enry Albert Murgatroyd.

So my second true love story
Ended briefly as the first
Just as I was all prepared to heed the call
Lying there for Queen and Glory
As I called out "do your worst"
Fred ran screaming and stark naked down the hall.

Still it's always my contention
They can't blame you if you've tried
I forget the times I've wed and changed me name.
But I hardly need to mention
As he bends to kiss his bride
'Enry Albert always spoils his little game.

CHORUS

Now I've had no education
As you're probably aware
But I know I'd make some man an honest wife.
For I've always known my station
And I've always paid my fare
On this grand old railway line that we call life.
Listen, ladies, heed a warning
When your husband is deceased
Don't be hasty in your race to start anew
Give the bloke a decent mourning
For a week or two at least
Or you'll find the bleeders started haunting you,

CHORUS
(MALCOLM IN GHOST OUTFIT, DOES A SOFT SHOE SHUFFLE)
REPEAT CHORUS[82]

Grass Widow

Description: Title - Discarded

Grass Widow was an early proposed title for Alan Ayckbourn's 2002 thriller, *Snake In The Grass*.

The title, which is a relatively obscure term referring to a woman who is either divorced or separated from her husband, is mentioned in personal correspondence in 2001 before he wrote the play.[83]

Haileybury Revues

Description: Ephemera

Alan Ayckbourn's first real interest in theatre developed whilst he was a pupil boarding at Haileybury. One of the masters, Edgar Matthews, encouraged Alan to take an interest in theatre and would become an early guide and mentor to the budding young actor.

Although Alan was primarily interested in acting at the time, he did apparently contribute sketches to the end of term plays. These - alongside the *Jennings* play written at prep school - were the sum of Alan Ayckbourn's playwriting interests as a student, although nothing survives of the writing.

"I used to write the house play at the end of every term. That was in the way of revue sketches, really. And I also edited the

house magazine. Which, because I was such an inefficient editor and could never get any contributions, I used to finish up writing myself as well, under various assumed names."[84]

Hark At Barker

Description: Screenplay

Alan Ayckbourn has rarely ventured into the realms of television, being most happy working in theatre. Early in his career though, he did contribute material for the comedian Ronnie Barker's first major television sketch show *Hark At Barker*.

At the time Alan was working as a radio drama producer at the BBC and was contractually forbidden to write for any other company, but Barker - who had appeared in the disastrously received 1964 West End production of Alan's play *Mr Whatnot* - persuaded him to contribute some sketches for the first season of the show in 1969, which was produced by the ITV network. Alan thus wrote under the pseudonym Peter Caulfield and provided substantive linking sketches for both this and the second series featuring the character Lord Rustless, who was inspired by the character Lord Slingsby-Craddock which Barker had played in *Mr Whatnot*.

> "That character stayed at the back of my mind and he became Lord Rustless, because I [Ronnie Barker] enjoyed playing him so much. He's also in *The Picnic* and *By the Sea*, but he just mutters in those. He's not called Lord Rustless, no-one's called anything. But to me he was Rustless. He was one of my favourite characters. When I did *Hark at Barker* - that was him, albeit with sketches. Alan Ayckbourn wrote all the links for that show but I don't think he admits it. He called himself Peter Caulfield, but I don't know whether he would like people to know that was him or not. He liked the character in *Mr Whatnot*, so he knew what the character was about. Rustless was really giving a lecture to the audience on a subject, such as "communication" or "servants" or something and he would illustrate it with sketches, which enabled me to play lots of different parts."[85]

Haunting Julia

Description: Variant

A minor variation, but *Haunting Julia* was originally conceived and presented in 1994 as a one-act play without an interval. Complaints from the Stephen Joseph Theatre In The Round's accounts department that bar

takings substantially dropped as a result of this decision, led Alan to produce it as a two-act version when he revived the play in 1999 at the Stephen Joseph Theatre.

The two-act script was unaltered with the exception of an interval at a cliff-hanging moment. When the play resumed, the final few lines of the previous act were repeated to emphasise time had not moved forward and the play was - in essence - still in real time.

The play was restored to its one-act form when published by Faber in the volume *Alan Ayckbourn: Plays 3* in 2002. When it was revived in 2008 at the Stephen Joseph Theatre as part of the *Things That Go Bump* season, it was also presented as the one-act version with Alan Ayckbourn stating the interval ruined the tension.

> "We are taking part in a séance. We're trying to triangulate an image of the girl with these actors on stage, which is why there's no interval: there's no way you can take 15 minutes from a séance to have a drink and come back and say: 'Where were we? Was anybody there?'"[86]

It is also worth noting that *Haunting Julia* is one of only several plays Alan has conceived as an end-stage play and which was intended to open The McCarthy auditorium at the Stephen Joseph Theatre for its original intended completion in 1994. Until 2012, it was presumed the sole reason the play was instead originally staged in-the-round at the company's then home, the Stephen Joseph Theatre In The Round, was a delay in the renovation of Scarborough's former Odeon cinema until April 1996 and Alan did not want to wait to write a play so firmly set in his mind.

> "I remember originally thinking that I would write something for The McCarthy. I think there were two things changed: The McCarthy was delayed and I also had a time-span in my mind and *Haunting Julia* was very clear in my head and I didn't want to delay writing it. I hate the idea of sitting on a play, deliberately not giving birth to it as it was already three dimensional in my head. And therefore I did do it in Westwood [the Stephen Joseph Theatre In The Round] in the round."[87]

However, correspondence in the Ayckbourn Archive discovered in 2015, shed new light on the true reason behind the play being produced in 1994: the fiscal position of the Stephen Joseph Theatre In The Round following Government cuts to the arts that year. Needing a cost-effective start to the 1994 season and knowing he had planned *Haunting Julia* to feature just three actors and one set, Alan decided to write the play earlier than intended as a budget-saving measure and despite knowing the play would lead directly into the world premiere of another Ayckbourn play *Communicating Doors*.

"I have had to write that [*Haunting Julia*] earlier than I planned (about 9 months) because of our rather perilous grant situation. e.g. funding standstill = cuts."[88]

Alan Ayckbourn would finally get the opportunity to produce the play as originally intended in 1999, when the play was finally presented in the end-stage in The McCarthy at the Stephen Joseph Theatre.

Henceforward...

Description: Abandoned

That *Henceforward...* was abandoned, destroyed and then rewritten - probably in much the same form - is one of the less well known pieces of Ayckbourn ephemera. Alan Ayckbourn has only publicly referred to his problems with the play in the second edition of Ian Watson's book *Conversations With Ayckbourn*, published in 1988, and in an interview for LA Theater Works in 2010.

In 1987, Alan began writing his new play *Henceforward...*, which he completed but then apparently destroyed as it was felt to be too dark. His uncertainty about the play was later revealed to be as a result of the reaction of his then partner and later wife, Heather Stoney, to the piece.

"I wrote it on my word processor and then showed it to Heather, who hated it. She said it was so serious, so awful that she couldn't bear it. So I erased it, without keeping a copy. But when we only had four days until rehearsals, I just sat down and wrote it again."[89]

Having apparently destroyed the play and with less than a week before the play was due to go into rehearsal, Alan announced he would instead be writing a piece called *Meeting Like This*. As noted though, with such a limited time-frame to complete the play, Alan returned to *Henceforward...*, having actually kept a back-up of the original play, He rehabilitated *Henceforward...*, keeping the basic plot of the play but subtly altering a major dynamic.

"I've found in one or two cases that I have to write out the subtext, actually put it on to paper, a very black format of a play - and then find ways of telling it which are bearable to watch. Some of my plays are very, very dark, and if you wrote *Woman in Mind* without the humour (although there will always be people who will say, 'This is what should be happening'), I claim that people would not watch it. Or rather, the people who should be watching it wouldn't watch it. Those who are already converted to this sort of thing don't need to watch it anyway. You have to be careful how you get your

laughter from a subject but, at the same time, a subject needs its laughter just to make it flow. In this case [*Henceforward...*], in the end I was writing about one or two themes I have obviously touched on before: what people do to other people, particularly men to women, and also, something I haven't covered before, the nature of the creative artist, and his relationship with reality, and people, and those he purports to love."[90]

It had never been explicitly stated what element Alan changed in the play until an interview with LA Theater Works broadcast in 2011, when Alan candidly revealed for the first time what changed in the play (and that there was, contrary to the interview given in 1989 and quoted earlier, a back-up copy of the play).

"I'd written it [*Henceforward...*] and the speech at the beginning, he [Jerome] says, "I want to write about the misery and the despair in the world and what I want is to make everyone aware of how dreadful life is." It was really the most depressing play and it spiraled down. And then Heather [Stoney] turned to me at the end and said: "You can't possibly do this! It's just terrible, it's so depressing." And I went: "Well, right." Picked up the hard-copy and ripped it in half, rather dramatically and I said: "Right, that's it, I'll write another one." And she said: "Well, I'm sorry, but that's the way I feel." And after she'd gone, of course I had a copy and just had another floppy disc hidden under the desk and I just wrote 'for hate, read love' and I just inverted it and it made all the difference."[91]

Henceforward...

Description: Revised

Alan Ayckbourn's future-set plays have always been slightly problematic given the rate at which technology moves forward, frequently outpacing the imaginations of writers and making what was supposed to be a vision of the future look like yesterday's detritus.

Henceforward..., written in 1987, was always meant to show an unspecified near-dystopian future complete with robots, self-cooking food, personal alarm systems and portable Global Positioning Systems. When the playwright came to revive the play at the Stephen Joseph Theatre, Scarborough, in 2017. he realised many of his future predictions had been superceded leading to a need to alter some of the specifics to bring the play up to date.

Whilst androids may not quite be common domestic items in 2016, the rise of the mobile phone and its associated technologies had rendered several pieces of technology obsolete leading to several small but notable changes, most pointedly the technology obsessed Mervyn's gadgets being reduced from an answering machine, location machine and personal alarm system to just the alarm system..

Interestingly, the playwright noted the one thing that hadn't been invented yet was the self-cooking TV dinner; not yet available in your local supermarket!

The Honeymoon

Description: Unproduced

Next to nothing is known about *The Honeymoon*, a play written by Alan shortly after his marriage to Christine Roland in 1959. He has never spoken publicly about the play and the only written reference to it is a quote from Christine in Paul Allen's Ayckbourn biography, *Grinning At The Edge*.

When Allen enquired about the play, the playwright believed it got no further than a reading but its precise history and contents are likely to be shrouded in mystery forever as no copy of the play is known to exist and there is no record of it ever being performed.

> "We enjoyed a happy and snowy Christmas [1958] including an out-of-work actor who arrived on the doorstep with no money and nowhere to stay and who later appeared as 'HB' in *The Honeymoon*, a play Alan wrote shortly after our marriage the following year."[92]

'Hotel' Play

Description: Concept

The 'Hotel' play was a concept discussed by Alan Ayckbourn in an interview with The Stage newspaper in 2007. The sheer scale of the piece suggests it is both nothing more than a flight of fancy and a means of highlighting an issue mentioned earlier in the interview: that British theatres were increasingly being run by administrators and accountants with financial considerations often given priority over artistic considerations.

> "I want to do a play where we turn this whole building into a hotel. The main auditorium is a conference on some incredibly boring subject. The whole audience has delegate badges. This man, from some distant country, talks to them in a difficult

accent. Actors planted in the audience take the audience off to different areas and they get involved in various different shows all over the building. The actors can go off and have lunch. They'll say, 'Oh, I've got to go back now and do a fight scene in the bar'.... You'd need 50 actors and about 30 directors. It just carries on all day and all night. You don't know what is real or what isn't. People would come from miles. The accountants would say, 'These figures don't stand up'. But it would be great fun."[93]

Alan would go on to extrapolate in greater details about the idea in a talk at the Stephen Joseph Theatre in 2016, during which the sheer scale, demands and unfeasibility of the piece became apparent.

"When I was running the Stephen Joseph, I did think about turning the theatre into a site specific work. I had an associate director at the time, Laurie Sansom, and I said to him, 'I want to turn the theatre into a hotel. Only for one performance.' I wanted to do a whole day where the audience turned up and were given badges - like delegates - and they all came into The Round, where we'd have rows and rows of seats and a rostra; this would have been the first playing space they came to. Someone then comes on and gives the most catastrophically boring address. Within the audiences are plants - actors - saying, 'do you want to get out of here?' Slowly the audience gets entirely peeled off, some of them going to the restaurant and some of them going down to the workshop and some of them going to the rehearsal room. And they all go off with the actors and there's these little shows which are all linked. Meanwhile this poor actor drones on to an increasingly diminished audience, so by the time he finished, hardly anyone is left - except for the ones that have fallen asleep - and they've all been taken away. It was a good idea, but unfortunately it would have required about six directors and a lot of goodwill from the audience and an even greater amount of goodwill from the actors. I've put it on the back burner - until I can persuade the management to let me take over the entire theatre and use the entire budget for next year, You'd have to schedule it for about 12 hours to run!"[94]

House & Garden
Description: Concept

House & Garden is famously Alan Ayckbourn's 1999 creation in which two plays are performed simultaneously in two separate auditoria sharing

the same cast with the characters moving between the two plays. Although either play can be seen independently of the other, seeing both gives a much broader and satisfying narrative.

The impetus for writing the play came about as a result of being based in a venue with two auditoria; the Stephen Joseph Theatre is home to both The Round and The McCarthy auditoria. Alan decided in 1999 to write something epic for his 60th birthday and created *House & Garden* to utilize both spaces.

What is not well known is this wasn't a new idea, but one which Alan had thought of 24 years earlier when the newly opened Sheffield Crucible has independently asked him to write two plays for its own two auditoriums. Although this project never came to fruition, Alan's solution of two interlinked plays, mentioned in an interview in 1975, is likely the genesis of what would eventually become *House & Garden*.

> "It started at Sheffield Playhouse, where they have a main auditorium and a studio theater. I breezed in there one day to see the director, and he asked me for a play. I said fine (I always say fine to everybody). Twenty minutes later the studio theatre director asked me for a play, and I said fine again. I then thought it would be a lovely joke to have a play going on in the big house and the off-stage action going on in the studio, with the actors cross-fertilizing."[95]

The previous year the director Eric Thompson essentially told the same story in an interview with The Times. However, he believed this was the genesis of *The Norman Conquests*, which obviously took a slightly different course to what Thompson describes. Given Alan Ayckbourn rarely lets go of a good idea, it's not hard to believe that what began as the inspiration for *The Norman Conquests* was stored away for future use to be fully realised in later years.

> "They've got a new theatre there [the article mentions Stoke, but it was probably Sheffield], with a studio theatre and a main theatre. He [Alan] was walking across the studio stage to get to the main stage, and he suddenly thought: 'if you had two plays going and you worked it out carefully, you could have two audiences in the same night watching the same actors. They could go from the main stage to the studio stage and do two different plays. As long as you wrote both and made sure they got off in time for their entrance on the other side."[96]

That this idea was never abandoned, but just waiting for the right opportunity, is confirmed in a letter to the BBC from 1994 in which Alan

discusses a suggestion of writing two screenplays which would be broadcast simultaneously on BBC1 and BBC2.

> "I've always wanted to write a play for two theatres simultaneously - and might still do so for our new theatre in Scarborough when it opens."[97]

A House Divided
Description: Title - Discarded

One of several proposed titles for *Absent Friends* which Alan Ayckbourn had written in his early notes for the play.

How The Other Half Loves
Description: Variant

How The Other Half Loves was originally performed at the Library Theatre, Scarborough, in 1969 and became Alan Ayckbourn's second major commercial success when it transferred to London in 1970.

Prior to its West End premiere, the play had a try-out at the Phoenix Theatre, Leicester, as well as a short tour during which the play underwent minor revisions and refinements. Although there was apparently an element of sharpening of the script, the plot and the majority of the text stayed the same.

When the play opened in London however, it arrived with the actor Robert Morley in tow. This larger-than-life actor, playing the role of Frank Foster, was a huge box office draw and had a strong belief - probably not mistaken - the majority of the audience came to see him rather than the play. As a result, what was an ensemble play came to be dominated by Morley, who proceeded to take enormous liberties with the script, improvising on a nightly basis. Frequently the play only bore a passing resemblance to the script as Alan had written it or how it would eventually be published; although some of the alterations in the definitive script owe something to Morley's own contributions.

> "Robert Morley was a great ad-libber and history has a way of revenging itself. So within the script are the very best of Robert's jokes - now claimed as my own!"[98]

It should be noted that at the time Alan was not quite so sanguine about the situation, which from rehearsal through to performance was affected by Morley's improvisations and contributions.

> "I didn't actually go to see it after a bit, because there was no point in getting unnecessarily upset. I was a younger, more

vulnerable author then. The night I did see it, I was terribly upset because nothing seemed to be as we had originally arranged it."[99]

Other alterations to the final script were also prompted by an unexpected intervention in the original production by the playwright during the play's original production in 1969.

> "It's had three different endings and several beginnings and I won't say that the middle hasn't been altered from time to time. For several performances early on I was actually forced, through illness in the cast, to take over the part of Frank. I distinguished myself, not only by having to carry a script (I can never learn my own lines), but by actually losing several pages during the action and having to ad-lib a scene. My fellow actors, confronted by the sight of this actor-director-author in full flow, spouting fresh dialogue, stood uncertainly about convinced that these must be new re-writes about which they hadn't been told. I later rushed off, jotted it down, and it's in there somewhere to this day."[100]

If I Were You

Description: Concept

If I Were You is Alan Ayckbourn's 70th play, which premiered in 2006. An early draft of the play also exists - a rarity for Alan - although there is no indication of when it was written in relation to the finished play.

The differences between the original and the final draft largely comprise the omission of three characters; the removal of a hotel foyer from the composite set; altered names and a variation in how the play's plot twist is presented. While the plot is practically identical, the finished play is leaner, tighter and puts almost all its emphasis on the central family to the benefit of the script.

> **Pat:** What's he need to learn boxing for?
> **Mike:** Because he's getting beaten up at school, love. No son of mine's going to get beaten up at school. Not without putting up a fight.[101]

Incommunicado

Description: Title - Discarded

A proposed title for a play conceived by Alan Ayckbourn circa 1994, found with a brief note on the rear of a sketch by the playwright for the

set of the world premiere of *Communicating Doors*. The title has never been used and the notes do not correspond to any completed work.[102]

In Future
Description: Title - Discarded

An early discarded title for Alan Ayckbourn's 2012 play *Surprises*. The title is present on an early draft of the play.

Intimate Exchanges
Description: Variation

In 1987, the BBC adapted Alan Ayckbourn's *Intimate Exchanges* for the radio. The play is famous for its branching structure which from a common first scene leads to 16 possible permutations of the plot. The initial scene is short and largely silent; its crux being whether the character Celia decides to have a cigarette or not. If she does, she hears a doorbell which she answers, if she resists the temptation, she misses the bell and the play head off in another direction.

None of this is problematic on stage, but the silent decision is an issue for radio. To tackle this, the director of the radio adaptation, Gordon House, asked Alan to write new dialogue for the first scene, which he agreed to and which is unique to this production of the play.

> She [Celia] stands for a moment to catch her breath. She's obviously been overdoing it more than she realises.
> **Celia:** It's no good. I need a cigarette. I must have one. I cannot possibly get through the rest of today without one. Well, can I? Can I possibly? (pause)
> Then either: -
> **Celia:** Yes, of course I can. Don't be so weak willed.
> Or:-
> **Celia:** No, of course I can't. Not possibly. (She lights a cigarette).[103]

'Ionescu' Play
Description: Unproduced

Prior to writing his first professional commission, *The Square Cat*, Alan Ayckbourn has frequently noted he had written approximately nine plays. Most of these plays have not survived, but apparently one of the

plays was in the style of Ionescu (the French dramatist who pioneered Theatre Of The Absurd).

> "I'd written a little before then [*The Square Cat*]. Pseudo Pirandello and Ionescu. All awful plays, so awful no actor would even read them."[104]

> "I was very influenced by Ionesco."[105]

IOU

Description: Title - Discarded

An early discarded title for Alan Ayckbourn's 2014 play *Roundelay*. The title is present on an early synopsis which also includes several alternative titles for the five one act plays contained within *Roundelay*. Whilst the final play's parts are: *The Agent, The Judge, The Novelist, The Politician* and *The Star*. The *IOU* synopsis includes descriptions for plays entitled *The Night Club, The Novelist, The Politician, The Star* and *The Teacher*.

The various synopses for the plays within *IOU* are also markedly different to the plays as written for *Roundelay*, even where the names are the same.

Isn't It Romantic?

Description: Concept

Isn't It Romantic? was an idea for a science fiction play conceived by the playwright in 2008. Although the notes bear no resemblance to any subsequent play, they do include several names which would be recycled in *Surprises* (2012). *Isn't It Romantic?* exists only as an unfinished synopsis with detailed notes of the various characters.

The synopsis describes *Isn't It Romantic* as 'a sci-fi farce' [106] and the premise of the play is described as follows:

> The programme *Million Dollar Honeymoon* was initially intended as a vehicle whereby lucky couples (preferably with young families) on the verge of separating are brought together for the holiday of a life time. We follow them with in real time during their fortnight together, all expenses paid in an exotic tropical hotel, hopefully mending the relationship with hopefully a happy ending and a re-united couple.
> The programme is the flagship of a once promising independent production company, Stardust. But of late the company's fortunes have slumped and staff have been laid off.

We sense a last ditch attempt is about to be made to save it - rumours of a sell-off by the controlling company, TLC are rife. Latterly, as the public inevitably tired of the predictable feel-good formula (the couples almost invariably did get together, at least temporarily) the production team have been searching further afield and widening the formula and bending the spirit of the programme to breaking point finding more and more incompatible couples, much to the dismay of the originating producer, Peregrine, whose brainchild it originally was. But the new team of Caspar and Maxine represent a new breed of reality show producers, manipulative and ruthless.[107]

It Could Be Any One Of Us
Description: Variant

It Could Be Any One Of Us was premiered at the Stephen Joseph Theatre In The Round, Scarborough, in October 1983. For several years Alan had toyed with the idea of writing a thriller - he had made notes for the thriller *Sight Unseen* in 1980 - but had never actually begun one. When he did write *It Could Be Any One Of Us* in 1982, the finished play was unusual in that the protagonist altered every evening; the assailant of the piece being randomly chosen by the drawing of a playing card in the opening scene of each performance.

The play was relatively successful, although it did not transfer to the West End and was perceived as having a flaw: no murder victim.

> "As a writer, a major problem I had was in justifying why there was a complete household of homicidal maniacs! I'm prepared to admit there may be one, but that an entire family is capable of killing struck me as strange...."[108]

Although the play proved to be quite popular in Germany, Alan was unhappy with it and it was never published. In 1996, he revived the play at the Stephen Joseph Theatre in Scarborough, having re-written it to include a murder half-way through. This version, which satisfies the tropes of the genre, was published and is now regarded as the definitive version of *It Could Be Any One Of Us*. The original version of the play has now been withdrawn and is held only in archive.

I To I

Description: Title - Discarded

I To I was the original title of Alan Ayckbourn's 70th play which was completed just weeks before he suffered a stroke in February 2006. In

correspondence, the play is titled *I To I*[109], although when it was then announced to the Stephen Joseph Theatre company in June 2006, the title had been amended to *If I Were You*.

However, it very briefly reverted to *I To I* when the company was informed of the change shortly afterwards, before being restored to its final title of *If I Were You* several weeks later. At least one early draft of the script and a rough sketch of the set exist in the Ayckbourn Archive with the title *I To I*.[110]

Jeeves

Description: Withdrawn

Jeeves was the infamous collaboration between Alan Ayckbourn and the composer Andrew Lloyd Webber, which resulted in one of the great flops of British musical theatre.

Based predominantly on P.G. Wodehouse's book *The Code Of The Woosters*, *Jeeves* opened at Her Majesty's Theatre, London, on 22 April 1975 and closed on 24 May 1975 having being vilified by the critics. It was directed by Eric Thompson, composed by Andrew Lloyd Webber with book and lyrics by Alan Ayckbourn, designed by Voytek, choreographed by Christopher Bruce and featured David Hemmings as Bertie Wooster. None of whom had ever been involved in a major West End musical.

Jeeves went through several permutations on its way to notoriety, none of which helped to save it from the well-known disaster it is now regarded as. The earliest existing draft is titled *An Evening With Bertram Wooster* and is 202 pages long and features 16 songs. This became the basis for the rehearsal draft which is 158 pages and also has 16 songs. It is this draft which opened the show on 22 March at Bristol Hippodrome for the musical's pre-West End try-out. The first night ran to a mere 4½ hours and was accompanied by a notorious incident with the orchestra.

> "[We] had this disastrous experience in Bristol: on the first night, the band stopped playing 15 minutes before the end because the producers wouldn't pay overtime. So these poor, non-singer actors were left completely adrift, without musical accompaniment. I remember walking back to the hotel with my son, who was then very young, and he broke a long silence by saying 'I'm sure it'll get better'. But it didn't."[111]

Despite some immediate editing, it was obvious the play was running far too long and needed some serious pruning. Lloyd Webber noted: "There is still a lot of work to be done on *Jeeves*. It will have to be reduced in length, and there are one or two bits I'm not happy with."[112] The most obvious problem was an over-abundance of sub-plots which led to the role of Aunt Dahlia being completely cut. Of course, it wasn't just a

case of cutting a minor role, the production had been sold on the involvement of Hemmings, Michael Aldridge and Betty Marsden - the latter playing Dahlia. Alan's description of her reaction to the news is memorably recorded by Paul Allen in Alan's biography, *Grinning At The Edge*.

> **Betty:** Hello darlings!
> **Eric:** Erm, Betty...
> **Betty:** Don't tell me, you've cut the whole fucking role!
> **Eric:** Yes.
> **Betty:** I don't believe it. I do not believe it. I do not f---
> **Eric:** Well, you see -
> **Betty:** Well, that's it. 'Bye! [113]

The play now transferred to Her Majesty's Theatre in London for previews on 11 April, without Marsden and with a reduced running time of 3½ hours. It was this version that the long-absent producer, Robert Stigwood, finally saw and on which he based his decision to immediately remove the director, Eric Thompson, from the show leaving Alan to take over his duties.

Jeeves opened on 22 April as planned and - by this point - had, thanks to the work of Alan and Thompson prior to being fired, been reduced to a running time of 2¾ hours, now featuring just 14 songs. A substantially edited piece compared to the day it opened, but still not short by anyone's standards. The running time was the least of the problems though as the critics arrived and left little unbloodied. Barely anyone came out well with Hemmings foremost amongst the many victims accused of being out of his depth, closely followed by Lloyd Webber and Alan - who succinctly summed up the experience: "It was one of the least successful West End musicals and probably distinguished Andrew's career as the biggest failure he's had. It really did get a critical drubbing the first time."[114]

With box office receipts falling on a daily basis, the decision was made on 12 May to close *Jeeves* on 24 May following just 38 performances.

Aside from a single heavily abridged student production at Dulwich College in 1981 to mark P.G. Wodehouse's centennial, *Jeeves* was never seen again in the form it took in the West End; it was withdrawn and never published, although an original cast recording was issued on vinyl in 1975. It was never forgotten though and over the next two decades both Alan and Lloyd Webber talked about revising and reviving it. Convinced there was a good musical in there, they would eventually get the chance to prove it on the 21st anniversary of *Jeeves* when *By Jeeves* was chosen to open the Stephen Joseph Theatre, Scarborough, in 1996. Virtually unrecognisable from the original piece, *By Jeeves* proved to be a hit that went on to the West End and Broadway.

'Jennings' Play

Description: Ephemera

Almost certainly Alan Ayckbourn's first 'play', this was an adaptation of one of Anthony Buckeridge's *Jennings* novels written by Alan while still at prep school and performed at the end of one term. The novels - the first of which *Jennings Goes To School* was published in 1950, following the character's radio premiere *Jennings Learns The Ropes* in 1948 - are set in a boarding school and feature an impulsive young pupil who frequently gets into trouble. Having heard the radio broadcasts as a child, Alan was very influenced by *Jennings*.

> "When I was nine or ten I used to roll around on the floor laughing at the *Jennings* stories. First I head them broadcast, but that was in those happy days when radio used to do that sort of thing. Then I read them. By the time I was eleven I wanted to be Derbyshire more than anything in the world. As a result, I wrote - or rather plagiarised - my first play from a *Jennings* book. I forget which one. I do recall there was a very good part for Derbyshire, though."[115]

Unfortunately - or perhaps fortunately from the playwright's perspective - the play has not survived.

> "I had started reading Anthony Buckridge's *Jennings* stories which reflected my own lot as an unhappy, homesick boarding school boy, left to fend for himself away from home in an alien, virtually all male institution. The *Jennings* books provided a refreshingly humorous perspective, mirroring my own life. I particularly identified with the bookish, unworldly character of Derbyshire, Jennings' best friend. Quite illegally and in total breach of the author's copyright, I adapted one *Jennings* story, turning it into a dramatic vehicle in which I intended to star as Derbyshire. Alas the best theatrical plans, as I later was to discover professionally, are never to be relied upon. On the day of the performance, I was in the school sanatorium quarantined with measles. I not only failed to star but missed the entire show which went ahead with a last minute understudy."[116]

It was also the first play to be subjected to scrutiny by his peers. Fortunately, the reviews would get better....

> "When I asked a friend how it had gone, he said: "S'all right." That was my first review."[117]

Joking Apart

Description: Concept

Within the Ayckbourn Archives at the University of York, there is a sheet of sparse hand-written notes that for many years was believed to be related to the play *Just Between Ourselves*. The notes actually relate to his 1978 play *Joking Apart* and offer a very early concept for the work.

The notes relate to a "three act study of seven characters over x years"[118] which lay the basic foundations for *Joking Apart* which is the first Ayckbourn play to take place over years rather than hours or days; as written, it is a two act (four scene) study of seven characters - and several girlfriends of one character - over twelve years. That is where the similarities with the notes end though as, essentially, *Joking Apart* is about a golden unmarried couple and what their 'perfect' relationship does to the relationships around them.

The notes include two initial ideas for the play and although elements of them survive into *Joking Apart*, neither reflect the actual play.

> Man In Love (divorcee)
> Woman he loves married to a strong man who mistreats her (collapses?)
> Man's business partner - neurotic
> His wife - Stronger[119]

Of this first note, the main familiarity is the neurotic business partner with a strong wife which bears similarities to the character Sven and his wife, Olive. A second note on the page reflects this relationship, but very little else corresponds with the final play and the introduction of a third related couple is unique to this set of notes.

> A is on the make - in collusion initially with B his weaker but wealthier partner. A's wife X is under his thumb but is loyal and devoted. B's wife Y is stronger. X's sister Z, married to C.[120]

The Jollies

Description: Concept

In 2002, Alan Ayckbourn set out to write a family show for the Christmas slot at the Stephen Joseph Theatre, inspired by the country's growing obsession with reality television shows such as *Big Brother*.

The premise of the play, *The Jollies*, involved a family living under the constant eye of the camera who begin to realise things aren't quite what they seem. This plot information was passed on to the Stephen Joseph Theatre marketing department and letters sent out to schools in June; the

first two weeks of the Christmas schedule being geared entirely towards school bookings with schools being informed about the Christmas show as early as possible and well in advance of the summer holidays.

What actually transpired was very different to what was advertised. Having announced the play in June, Alan began writing it at the start of August but suffered from writer's block and wasn't able to write the play he'd originally announced. A week later he contacted the theatre and announced there would be another play with a different title - neither of which he was sure of yet!

Fortunately, three weeks later, Alan was inspired and wrote a new play using the same title *The Jollies*, but totally different in content to his initial idea. The schools which had already booked were actually not informed of the change - although press releases and subsequent letters made no secret of the totally different plot - and there is no record of any school actually noticing the change and querying it with the theatre.

> "I cleared a writing space three weeks ago and hit a brick wall. Total disaster. Nothing happened. I said to my wife, Heather, that's it - that's the end, I'm finished. Then I got back from Bath on Sunday and began a completely new play. It's got the same title as the one I'd abandoned, *The Jollies* - because we'd already sold 1500 seats - but it's a brand-new piece."[121]

The Jubilee Show

Description: Grey Play

Occasionally there are plays which are genuinely forgotten or lost. In the case of Alan Ayckbourn, this refers generally to very early unproduced plays. However, *The Jubilee Show* is a case of a play which was professionally produced at the Stephen Joseph Theatre In The Round, but details of which were never recorded and it was forgotten and all mention of it lost for thirty years.

In 2007, the sole known surviving copy of *The Jubilee Show* was found at the back of a filing cabinet in the Stephen Joseph Theatre; there were no written details as to what it actually was nor was there any record of it having been performed.

The Jubilee Show is in fact a full-length revue which dates back to the 25th anniversary of the coronation of Queen Elizabeth II in 1977. The Stephen Joseph Theatre In The Round was already celebrating the Silver Jubilee with a successful lunchtime show called *Westwood Coronation Day Street Party* by Bob Eaton, which had proved to be a tremendous hit and, as a result, it was decided to mount a one-off revue for the actual night of the Jubilee celebrations. Mervyn Watson, then a director at the theatre, did the research and Alan shaped it into a revue. It is ostensibly a trip

through the major events of the previous 25 years delivered as a slightly surreal news broadcast, interspaced with music and songs. The entire acting company was involved alongside accompaniment by the pianist Michael Garrick. The play was staged on 7 June, 1977, to a practically empty house. What had seemed a good idea in the wake of *Westwood Coronation Day Street Party*'s success (which had already been performed that day to a full house) was tempered in hindsight with the realisation most people were either watching the celebrations on TV that evening or taking part in the myriad other events organised to celebrate the day.

The revue was never performed again and was forgotten. Because it was a late addition to the season, it was not included in any brochures and no flyers or programmes for the play survive - although it is not known whether these were even produced. The only public mention of *The Jubilee Show* known to exist is an advert from the Scarborough Evening News found in The Bob Watson Archive in 2009, although it does not even carry the final name of the revue.

The discovery of the script in 2007 led to the play being identified and its place in the Stephen Joseph Theatre's history restored. As it had been performed, but never published or made available to produce again, *The Jubilee Show* was classified as one of Alan Ayckbourn's Grey Plays.

> "1967. The death of Stephen Joseph and the return of the professional company to the Library Theatre, Scarborough. You know, it beats me what people see in them. I mean, for a start there's no curtain, is there? I mean, if you're going to have theatre, you've got to have a curtain. Like the National Theatre. Well, not the Olivier Theatre because that doesn't have a curtain. Nor the Cottesloe. But the Lyttelton Theatre's got a curtain. I know it keeps sticking and you can only see Ralph Richardson's feet but it has got a curtain. And what about those backs? I mean, I'm not spending good money to see people's backs. I mean, I haven't been mind you. The wife goes. She enjoys it but I don't like the sound of it. I like a curtain."[122]

Just Between Ourselves

Category: Concept

As has been mentioned previously, it is rare for actual documentation to survive in archive which offers an insight into the development of Alan Ayckbourn's plays between concept and the final manuscript. For *Just Between Ourselves*, several pages of early hand-written character notes survive though, which give an insight into the author's early thoughts on the characters and their paths through the play.

The earliest surviving concept paints a portrait not only of Vera undergoing a breakdown as a result of Dennis's actions - which is a major part of the final play - but that Dennis's actions are themselves driven by depression and mood-swings. Even if *Just Between Ourselves* is considered one of Alan's bleakest plays, it might have been even bleaker.

> Dennis - The dominant, the ambitious - always a helping hand to his friend - dissolution into manic depression. The repercussions he causes.
> His wife (Vera?) - who bears the brunt of his variations. What starts as a game (her clumsiness and general dimness) finishes as a total lack of self-confidence and neurosis - inability to cope with him. Wanting to get out and nowhere to go.[123]

In these early notes, Neil is also described as Dennis's business partner and brother-in-law, rather than the stranger who comes to buy his car in the actual play. The final note on the page is ambiguous in the possible direction the play was taking, but offers an insight into a possible structure for the play with Neil's wife then called Jenny rather than Pam.

> D [Dennis] tells N [Neil] his wife is going round the twist.
> V [Vera] tells J [Jenny] that D [Dennis] is going mad.
> M [Marjorie] tells them she is going round the twist.[124]

A separate set of notes - it is unclear whether they are earlier or later than the notes above - offers a slight variation on these characters and their direction with a more familiar Dennis alongside a suicidal Neil. The notes again indicate a darker direction than even that of the final play.

> Dennis - keeps on despairing cheerful tone throughout - end uncertain.
> Neil - hypochondria and insecurity leads to ultimate depression and suicide attempt - numb nerve ends etc for final scene.
> Vera - imminent collapse accelerated to a showdown with Dennis and empty void.
> Pam - Imminent break up with Neil. But her own inadequacies and the fact that she has yet to find her vocation stops her.
> Marjorie - physically wrecked. Unrelenting sheen of depression and sad smiles.[125]

Karaoke Play

Description: Concept

Karaoke Play was a concept suggested by Alan Ayckbourn for the summer 2005 season at the Stephen Joseph Theatre. From what little is

known about the proposed play - and a later similar piece - it is probably as close to an improvised drama as Alan Ayckbourn has ever considered.

The play would apparently have involved audience members being drawn into the action on stage, partaking in the drama and influencing the direction of the plot.

> "I woke up in the night in a cold sweat and thought: 'Do I really want the audience on the stage with the actors? No....'"[126]

Something obviously changed for the playwright though as, in 2015, he wrote *The Karaoke Theatre Company* - variously also known as *Alan Ayckbourn's Karaoke Theatre Company* or just *Karaoke Theatre Company*. This marked a departure for Alan as it consists of five short plays within which the audience is invited to become involved to various degrees; from providing sound effects to one person actually taking a lead role in one of the plays. The script is unusual in that it allows for a large degree of improvisation particularly within the sections between the plays, but also in regard to how the audience react on any given night.

The improvisational nature of the piece means Alan Ayckbourn does not consider it as one of his canonical full-length plays, but rather regards it as a celebration of theatre or 'a party' as he frequently describes it.

> **Karen:** Let me tell you a little about the Karaoke Company. We're called that because unlike a lot of other companies which, when you're watching them, you often get the impression that they'd far sooner you lot weren't there at all, the Karaoke Company genuinely need you to be here. Because without you, our audience, without your contribution, nothing at all's going to happen. Not a thing.
> **Alyssia:** For us, Theatre unlike film or television or video is first and foremost a live event.
> **Rufus:** Tonight is special. It's special in the way that every Theatre performance is unique. It's unique because you're here -
> **Anna:** - tomorrow, us lot, we'll be back, same time, same place - - unless the management cancels our contract, we will be - - we'll be back, the five of us, but you probably won't be -
> **Olly:** - unless you're gluttons for punishment.[127]

Life After Beth

Description: Title - Discarded

Alan Ayckbourn's 71st play, *Life & Beth*, was premiered in 2008 at the Stephen Joseph Theatre. All existing drafts of the script have the same

title, but in an interview in December 2007 published in *The Morning After: Performance Arts In Australia*, Alan calls the play *Life After Beth*.

> "I have also written a new play which will also open here in Scarborough next year, a ghost story called *Life After Beth*. [N.B. Now called *Life & Beth*.]"[128]

In the summer of 2008, Alan confirmed the play had indeed originally been called *Life After Beth* and that in his original concept, Beth was dead - whether she was thus the prerequisite ghost of the piece is unknown.

> "It was originally called *Life After Beth*: We didn't have a Beth in it then."[129]

The title *Life After Beth* does crop up again, but illustrates only careless journalism rather than Alan's thought processes. During the week of 12 April 2008, the Scarborough Evening News printed the play's title as *Life After Beth* several times. Unfortunately, the articles were primarily promoting the launch of the Stephen Joseph Theatre's summer season and the title had long since been established (and had even been reported correctly in previous articles!). Despite working from and having access to a correct press release, the new theatre brochure and two official websites with the correct title, the newspaper carried the wrong title in at least two separate articles.

Life Of Riley

Description: Concept

This is another example of Alan Ayckbourn thinking of a title for an earlier unused project and then keeping it for a later piece of writing. In the Ayckbourn Archive there is an undated hand-written note entitled *Life Of Riley* with a short synopsis involving a doctor, Jack, discovering his friend may have a terminal disease. The ailments, discovered by Jack's mentor, may or may not actually exist and, as a result, Jack is constrained from giving the news to his friend who he believes is about to die. This is not the plot for the play which eventually bore the title *Life Of Riley*, although this does involve a terminally ill unseen character.

That this note was written a considerable time prior to Alan writing *Life Of Riley* can be construed from the fact it contains a list of characters which includes an 11 year old girl, Winnie Barnstairs, who is studying French. Winnie - and her French studies - became the subject of Alan's 73rd play, *My Wonderful Day*, which he wrote in March 2009, a year before he actually wrote *Life Of Riley*.

Although the notes shares similarities with the other *Life Of Riley* precursor, *Barnstairs Syndrome*, this is an entirely different concept for the play.

Like A Sister

Description: Title - Discarded

One of several proposed titles for *Sisterly Feelings* which Alan Ayckbourn had written on early notes for the play.

Love After All

Description: Withdrawn

For many years, *Love After All* was the great Ayckbourn enigma. This was his second commissioned play and the only full-length work in the Ayckbourn canon for which a manuscript apparently did not exist. It was produced just twice, in 1959 and 1960, and both versions were apparently very different from each other, serving only to confuse matters even more.

In 2007, Alan Ayckbourn's Archivist, working in conjunction with the British Library, discovered a copy of the original play was held in the Lord Chamberlain's Collection at the British Library, untouched and unread since 1959. This significant discovery helped to clear up some of the mystery surrounding the play, but the full story remains tantalizingly out of reach due to the likelihood that no copies of the script for the second production have survived.

> "Stephen Joseph warned me that the second one was going to be a lot harder but, because I stole the plot of this, it was actually a lot easier. It was about a very handsome young man - played of course by the author - wooing and winning the beautiful but brainless heroine, despite her father's objections. Actually the best character was a pig breeder called Rupert Hodge played by William Elmhirst who stole the show. The finale had several Chinamen rushing about. Heaven knows why."[130]

Love After All, like Alan's first play *The Square Cat*, was written under the pseudonym Roland Allen with input from his first wife Christine Roland. It was commissioned by Stephen Joseph for the 1959 winter season at Scarborough's Library Theatre and written with the intention of Alan appearing in the lead role; this being stymied by Alan being called up for a very short-lived National Service.[131]

The play is loosely based on *The Barber Of Seville* and is an Edwardian farce centred around Jim Jone's attempts to win the hand of the beautiful Angelica, despite the machinations of her father Scrimes who intends to marry her off to a member of the local aristocracy. Alan has frequently said that his early plays were written largely to show him off as an actor and *Love After All* certainly supports this as the hero

appears on stage in a number of implausible disguises including Scrimes's long-lost American female cousin! The play ends farcically with most of the characters dressed as Punjabi Indians - the Chinamen of Alan's recollections replacing the Indian characters in the 1960 revival.

> **Angelica:** I've never abducted before. What do you do?
> **Minta:** Just sit and wait till someone comes. They do all the work. You just scream or don't scream according to how you're feeling.
> **Angelica:** Shouldn't I take sandwiches or something?
> **Minta:** Don't think so, Miss. He'll arrange all that side.
> **Angelica:** Minta - what shall I wear? I haven't got any abduction clothes.[132]

Unfortunately no script survives of the second version of the play, although it is known several of the characters' names were altered and the play was moved to a contemporary setting. About the only other thing that can be ascertained is the play must have had a decent production budget as the director Julian Herington was fired soon after the play opened, having allegedly spent the Library Theatre's entire season budget on just his productions, *Wuthering Heights* and *Love After All*.

> "It [the original production] was very tight and quite fun, and we did it Edwardian. It was later revived, the following summer I think, with me playing the lead; and it was directed by Julian Herington, who decided there were certain bits of it he didn't like very much, like its Edwardianness, and its rather jokey names. He brought it up to date, and I don't think the play actually gained from what we did to it."[133]

Love Undertaken

Description: Grey Play

Love Undertaken is an early Ayckbourn one-act play which only came to light in 2008; its existence having been forgotten by the playwright.

It is one of several one-act plays Alan Ayckbourn wrote for amateur companies in the early 1960s and it was only when an actor in one of just two identified productions of the piece came forward, that its existence and a manuscript came to light.

It seems likely the play was written in 1961 as a record at the British Library notes the play was licensed for performance by the Lord Chamberlain's office on 4 October 1961.[134] The first production was staged at St Mary's Parish House, Scarborough, and seems likely to have been performed by Scarborough Theatre Guild with Alan Ayckbourn appearing in the play.[135]

The other production, from which one of the two surviving manuscripts is drawn, seems likely to have also taken place in 1961, performed by Scarborough's Cresta Players amateur dramatic society. The company was looking for a suitable play for a drama festival in Hull; not having any success, they approached Alan Ayckbourn who gave them *Love Undertaken* which was produced at the festival, possibly at the Little Theatre, Hull.

The play is a light romantic comedy centred around a couple forced to conduct an affair clandestinely in a village undertaker's parlour, in order to keep it from prying eyes and their respective guardians.

There are only two extant copies of the manuscript in existence; an incomplete copy is held by a private collector and a second copy - discovered as a result of the first coming to light - is held at the British Library in the Lord Chamberlain's Collection. Alan Ayckbourn did not keep a copy of the script and like several other plays written for amateur production in this period, it was forgotten and no record made of it.

> **Henry:** For six months I've stood outside that door watching people go past - not wishing them actual harm of course but just wishing they didn't all look quite so healthy. I spoke to Dr Greenstreet about it. He says that business usually goes in bursts.
> **Miranda:** I can't understand it. I thought people were always dying. Anyway surely Uncle Horatio will understand? He'll know about these bursts of business.
> **Henry:** Understand? Doctor Horatio? He'll just ask me why I didn't go out and poison a few people off just to step up production.[136]

Make Yourself At Home

Description: Title - Alternative

Make Yourself At Home was the original title for *Living Together*; one part *of The Norman Conquests* trilogy. The play was originally produced under this title at Scarborough's Library Theatre in 1973 and then altered for its London production and all subsequent productions.

Making Tracks

Description: Withdrawn

Making Tracks is one of only a small number of Ayckbourn plays since 1980 which has never been published. The reasons for this in the specific case of *Making Tracks* are not altogether clear. It was Alan's second full-

length musical collaboration with the composer Paul Todd, following their work together on *Suburban Strains* and was directly inspired by Alan Ayckbourn's experiences working as a radio drama producer for the BBC between 1965 and 1970.

These experiences inspired the central conceit of the play, which is set in a recording studio where who and what characters can hear is controlled by whether the microphones are switched on or not. It can broadly be seen as a development and refinement of an idea used by Alan in the *Between Mouthfuls* section of *Confusions*.

The play's central plot centres on a producer bringing a singer, Sandy Beige, into his studio upon whom he stakes everything. Unfortunately, her vocal talents are limited to say the least. The only solution is for her to pretend to sing, whilst someone else provides the actual vocals.

> **Stan:** If Wolfie does arrive, for God's sake don't let him see or hear that song. At least let him think we've got a hit.
> **Rog:** He's going to hear it sooner or later.
> **Stan:** Well, later then, later. If we can get enough tracks down before the main vocal, backing tracks, counter melodies, wah-wah choruses, echo, phrase distortion, you name it, maybe we won't hear her at all. Be like whatsisname. That Tamla man. Phil.
> **Rog:** Phil Spector.
> **Stan:** He used to do that. Never could hear a word on any of his records. He sold millions.[137]

Although this plot is reminiscent of the classic film *Singin' In The Rain*, its actual inspiration was from a real-life encounter the playwright had whilst working at the BBC.

> "Paul [Todd] and I were looking for a second theme, and I suddenly had the idea that I wanted to incorporate the music on the stage. Then I decided to use my experience in the recording studios of Leeds, and it came to me that it might be quite fun to set it all in this place, with the glass between studio and control room as another device, so that you could use the silence of the sound-proofing between the two sections. I had actually had an experience with a singer, whom I booked while rather drunk one night in a club, and when we'd got her into the studio, she couldn't sing at all!"[138]

As to why the play has had such a limited life, it could well be attributed to the perception of Alan's direction as a writer. *Making Tracks* opened at the Stephen Joseph Theatre In The Round, Scarborough, just 11 weeks after the world premiere of *Way Upstream* and suffered as a result of this. *Way Upstream*, although not universally acclaimed, was

seen as a definite progression for the playwright tackling wider moral and social issues. *Making Tracks*, on the other hand, was a light entertainment intended for a Christmas audience with little real depth or comment.

The play was phenomenally successful at the Stephen Joseph Theatre In The Round, Scarborough, despite a lukewarm critical response. It was revived at the theatre in 1982 with some minor changes to the songs and did equally good business before it transferred to the Greenwich Theatre, London. There the critics, by and large, mauled the piece. The audience, however, adored it and it reportedly played to an extraordinary 97% capacity audience during its run.

Whether the critical reaction to the piece affected its future prospects is unknown but this was, to all intents and purposes, the end of the play. It has not been produced since, nor published and marked the final full-length musical collaboration between Paul Todd and Alan Ayckbourn.

Meeting Like This

Description: Concept

Meeting Like This was the name of a proposed play that was intended to take the place of *Henceforward...* when Alan Ayckbourn apparently destroyed the original manuscript for the latter. Late in the writing process, Alan felt *Henceforward...* was too dark and apparently the Stephen Joseph Theatre In The Round was notified he would instead be producing a play called *Meeting Like This*; unfortunately no other details of the proposed play exist. It is not known whether Alan even began writing the alternative play as he subsequently rewrote *Henceforward...*, which was swiftly reinserted into the schedule.[139]

Meet My Father

Description: Variant

Relatively Speaking is the play which launched Alan Ayckbourn into the wider public eye and made him one of the country's most successful playwrights. However, the play's life did not begin with the triumphant 1967 West End production, but two years earlier at Scarborough's Library Theatre with a different title and a substantially different text.

In 1965, less than a year after joining the BBC as a Radio Drama Producer and following the critical roasting given to his first West End production *Mr Whatnot*, Alan wrote the play *Meet My Father* for the Library Theatre. The Artistic Director, Stephen Joseph, had suggested Alan write a well-made play in the aftermath of *Mr Whatnot* for the summer season at Scarborough. Stephen was to direct the play and Alan submitted the script to him, not entirely satisfied with the result. The first

Alan saw of the play, being based in Leeds, was the first night performance and it greatly differed from what he had submitted. Stephen habitually made drastic cuts to plays he felt over-ran or needed trimming; in the case of *Meet My Father*, there were some deep cuts.

> "When he [Stephen Joseph] found it was over-running, characteristically he just tore the middle pages out at random. Despite this, it seemed to work."[140]

As no actual script had survived in archive of this production, the true extent of the cuts was unknown. When a copy of Stephen's edit was found in 2007, Alan's seemingly far-fetched statement actually appeared to be quite conservative as page after page of the manuscript had been scored out with thick marker pen, reducing the play's length by at least a third. As Alan noted though, the play - although lacking some finesse - obviously worked as when the London producer Peter Bridge came to see the production, he immediately optioned it for the West End.

What Peter Bridge received though was not what he saw in Scarborough; Alan gave him the original unedited manuscript and ignored most of Stephen's alterations to the play. Although the script would undergo a number of substantive revisions between 1965 and its West End premiere in 1967, these were the result of Alan's editing, rather than Stephen's. One of the final and most far-reaching edits was the play's famous twist ending involving the disputed ownership of 'Philip's' slippers, which did not appear until the play pre-West End run and was a suggestion from Tom Erhardt, who was then working for Peter Bridge and would later become Alan's agent.

Meet My Father

Description: Title - Alternative

As seen in the previous entry, *Relatively Speaking* was originally produced under the title of *Meet My Father* in Scarborough in 1965. The decision to alter the title appears to be entirely at the behest of the London producer Peter Bridge, who wanted something a little more eye-catching for the West End. As a result, the play went through several title alterations before arriving at *Relatively Speaking*.

> "Peter Bridge said: 'that title's very vulgar and seaside, darling, really not suitable for the West End.' So we went round and round and round until we came across a Noël Coward title that he hadn't written!"[141]

Meet My Mother

Description: Title - Discarded

Relatively Speaking was first produced under the title *Meet My Father*. However, the play was originally called *Meet My Mother* and traditionally Alan has said he thought of this title, which was then altered to *Meet My Father* by the director Stephen Joseph as he felt it more catchy. However, in a programme note from 1969, Alan attributes *Meet My Mother* to Stephen and *Meet My Father* to himself. The truth of the matter will probably never be resolved!

"In May the pre-publicity posters were due and Stephen by now sensing that a helping push was required suggested that he bill the play *Meet My Mother* a new comedy by.... That night I sat up till 4 a.m. trying to think of a play which might possibly suit that title and finally decided it wasn't very inspiring. I 'phoned back the next morning and, on impulse rather than anything else, asked if the proof copy of the poster could be amended to read *Meet My Father*."[142]

Me Times Me

See *Me Times Me Time Me*

Me Times Me Times Me

Description: Title - Alternative

In 1970, Alan Ayckbourn premiered *The Story So Far...* at the Library Theatre, Scarborough. The play was picked up by the producer Eddie Kulukundis the following year for a tour which was planned to go into the West End. Unhappy with the play, Alan revised it and gave it a new title *Me Times Me Times Me*. The tour began at the Phoenix Theatre, Leicester, in 1971 but by the time it opened at its next venue, the Lyceum Theatre in Edinburgh, the title had again been altered to the shorter *Me Times Me*. Presumably, this had a knock-on effect on both the budget and the marketing as all the publicity material was reprinted. Whatever the case, the play did not transfer to the West End at the culmination of its tour.

A year later and the producer Michael Codron picked up the play and again it was toured as a prelude to a possible West End transfer. It was produced as *Me Times Me* and starred Celia Johnson. Unfortunately, this production only played two venues, ending its life in Brighton. The play would be revised again in the early 1970s and renamed *Family Circles*, which has since been successfully revived and produced, although Alan has admitted he will never be totally happy with the piece.

Although the play has seen many revisions over the decades, it central conceit of how three sisters' lives might have altered with different partners was essentially untouched.

"I should have left it alone."[143]

Millennium character sketches

Description: Ephemera

In May 1993, a major tourist attraction opened in Alan Ayckbourn's adopted home town called the *Scarborough Millennium*. Created to mark the town's 1,000 year anniversary, it featured recreations of places and scenes from throughout Scarborough's history, each of which was manned by a character from the period. Alan Ayckbourn was asked to contribute to the attraction and wrote a short script for each of these actors, which formed the basis for their semi-improvised interaction with the public.

Each character had a single page of dialogue for a short scene, offering an informative guide to Scarborough in that period, which could then be used as a basis for improvisation. The characters were a young Viking woman, a servant at Scarborough Castle at the time of King Richard the Lionheart's reign, a man at St Mary's Church during the Civil War and a Victorian lady clad in wet undergarments at Scarborough Spa.

The Millennium attraction closed in 2002, although the use of Alan's scripts had ended some time previously as financial difficulties had seen the use of actors in the scenes steadily decrease over the years.

> **Servant:** Every single morning the Queen has to be sewn into her clothes and every evening she has to be unsewn. What about that, then? Did you ever hear anything like it? When I was a lad we never had any of that. Twice a year, that's all. My mum used to sew us in come October and unstitch us in April. Never did us any harm.[144]

Millie's Wonderful Day

See *Winnie's Wonderful Day*

Mind Over Murder

Description: Screenplay

Mind Over Murder is a very rare example of Alan Ayckbourn writing a play and a screenplay of the same material, as well as marking his first attempt at a thriller.

The piece exists as two manuscripts, both with the same title and both attributed to Roland Allen (Alan's writing pseudonym between 1959 and 1961). The first manuscript is an incomplete playtext - the final pages are missing but given the existence of the second manuscript, the implication is the pages were lost rather than not completed. The second manuscript is a complete and detailed screenplay; probably the play-text adapted for television though as the actual dialogue is identical.

Although not dated, the use of the name Roland Allen and the existence of the screenplay allows it to be placed between late 1959 and mid 1960; after the success of writing his first play *The Square Cat*, Alan noted in an interview he and his wife Christine Roland had written several treatments for proposed screenplays in the hope of receiving a commission for television. It is probable, given Alan has rarely shown any other interest in writing screenplays, that *Mind Over Murder* was one of these ideas.

Mind Over Murder has a cast of six and takes place over four days with a policeman investigating the apparent suspicious death of a professor's sister. The professor - who has an improbable knack for Sherlock Holmes style deduction - solves the mystery of who murdered his sister and for what purpose, whilst the police inspector plays the role of Watson to the professor's Sherlock. Notably, the plot jumps about over the four days revealing previous events as the murder is unraveled.[145]

> **Professor:** (*calling softly*) Michael!... Michael!
> *Inspector Michael Roberts steps suddenly from out of the shadows bedside him.*
> **Michael:** Right beside you Edward.
> **Professor:** (*Startled*) Oh my dear fellow, must you skulk in the shadows like that or is it part of your police training?
> **Michael:** I was observing the moonlight on the roof, it managed to bring out the beauty of those Victorian Twiddley [sic] bits. This house must be amazingly ugly by daylight.
> **Professor:** My sister was fascinated by the hideous. Just wait until you see the inside.[146]

While *Mind Over Murder* was neither produced as a play or screenplay, it is of interest if purely for marking Alan's first attempt to write a thriller so early in his career - certainly given his later attempts to successfully crack the genre. Until *Mind Over Murder* came to light, Alan's first acknowledged attempt at a thriller was the announced but unwritten *Sight Unseen* in 1980 which formed the basis of his random murderer thriller *It Could Be Any One Of Us* in 1982. The latter was deemed an unsatisfactory piece by the playwright - and lacked an actual murder - and he eventually revised the play to his satisfaction in 1996.

Although other plays such as *The Revengers' Comedies* in 1989 have elements of the thriller genre in them, his most successful attempt at writing in the genre is considered to be his 2002 play *Snake In The Grass*.

Modern Love
Description: Ephemera

Modern Love is a two-page sketch held in the Ayckbourn Archive of which no details are known other than it is an early piece of writing by Alan Ayckbourn, probably written during the early 1960s.[147]

The Musical Jigsaw Play
Description: Withdrawn

The Musical Jigsaw Play is probably the least well-known of Alan Ayckbourn's plays for families, largely due to it only ever having had one production and having never been published.

It began its life not - as usual - at the Stephen Joseph Theatre In The Round, Scarborough, but at the Royal Exchange in Manchester. Alan was contacted in 1992 regarding the possibility of writing a children's play for spring 1994 for the venue. Alan suggested the concept of *The Musical Jigsaw Play*, which he would write with the Stephen Joseph Theatre In The Round's musical director John Pattison. Unfortunately the Exchange was unable to find sponsorship for the play and for this and various other reasons, the deal fell through and the play was never produced in Manchester.[148]

Alan and John had completed the play though and it was decided it would be suitable for Christmas 1994 in Scarborough.

It was written specifically for the round and saw the stage transformed into a jigsaw puzzle, which the cast with the aid of the audience first assembled and then utilised to create a song. There was a high degree of interactivity in the show, a challenging sound and lighting plot and participatory singing.

The Musical Jigsaw Play opened in December 1994 and proved to be a hit with its young audience. The first performance was excessively long though and fairly major cuts were made to parts of the puzzle-solving. This apparently did not harm the show as the children latched onto the concept of what was going on very quickly, which allowed Alan to make cuts to move the plot forward whilst not damaging the integrity of the piece.

Reviews were extremely mixed with several critics likening it more to a game show than a play and most having difficulty with the amount of

time spent in the first act creating the puzzle; although most critics agreed the children enjoyed the interactivity and the singing.

The play has never been produced again, largely one suspects because of the need to perform it in the round and its technical demands. It has also never been published.

The final song, which propels the pop-group *Why Not?* back into the music charts, has survived though....

> It's true to say both day and night
> Our tune can change plain black or white.
> Good sweet chords can paint rainbow hues
> With green, brown, yellow, reds and blues.
> To help guide us from dark to light
> We must make sure our song sounds right.
> Sing all through life. Make that our choice.
> And join together with one voice.
>
> It's good to sing
> True to say sweet chords can help
> Guide us all through life both day and night,
> Paint rainbow hues from dark to light.
> Make that our choice.
> Our tune can change plain black or white
> With green, brown, yellow, reds and blues.
> We must make sure our song sounds right
> And join together with one voice.
>
> It's true to say both day and night
> Our tune can change plain black or white.
> Good sweet chords can paint rainbow hues
> With green, brown, yellow, reds and blues.
> To help guide us from dark to light
> We must make sure our song sounds right.
> Sing all through life. Make that our choice.
> And join together with one voice.[149]

Neighbourhood Watch

Description: Concept

Neighbourhood Watch was premiered at the Stephen Joseph Theatre in 2011 to great success. The theme of perceived apprehension in society about the breakdown of law and order struck a major chord, seeming particularly prescient given the play opened in the wake of the 2011 UK summer riots; although it had been written months prior to these events.

The play is based in Bluebell Hill estate, which during the course of the action becomes a gated community with a rather draconian approach to a neighborhood watch scheme. The plot focuses on eight of the estate's residents - although several others are mentioned.

Early concept notes for the play held in the Ayckbourn Archive indicate Alan initially intended to show far more of the community on stage as every actor was to double up on roles. Judging from the character descriptions, each actor would have played a major character alongside a minor character, presumably to give a flavour of the estate's community with occasional cameos. In the end, Alan decided not to populate the play with the extra characters; instead creating several memorable unheard, off-stage characters.

What is also fascinating is Alan drew up notes for all 32 residents of the 16 properties on the Bluebell Hill estate - although originally it is called The Glade (see In The Archive) - even though most of the residents are not featured or only name-checked in the concept notes.

Although the notes generally seem to follow the plot of the final play, there are significant differences in the names of the characters and the lead couple, called Martin & Hilda Krark rather than Massie, appear to have had a darker upbringing than is mentioned in the play. The other characters's names also differ (actual name in brackets): Larry and Magda Hunter (Luther & Magda Bradley), Roddie Trusser (Rod Trusser), Dorothy Beadie (Dorothy Doggett), Gareth & Amy Mundle (Gareth & Amy Tanner). If nothing else it demonstrates the care Alan Ayckbourn takes with naming his characters.[150]

The Night Club

Description: Concept

The Night Club is a one act play conceived for a play originally named *IOU* but which was later retitled to *Roundelay*. The piece consists of five inter-related plays whose order of performance are determined randomly by the audience; although the concept for *IOU* is the same as *Roundelay*, the content and titles of the five short plays are markedly different in places.

The Night Club is a title unique to *IOU* and was, essentially, altered to *The Judge* for Roundelay as there are distinct similarities between the two. In *Roundelay*, *The Judge* centres on a retired and widowed judge having a meal with an escort called Lindy, who has been told to play Tom's wife for the evening. Unable to play the role convincingly, she begins to add in her own life story, which the judge begins to accept as they realise memory is what you make of it and the pair form a kind of bond in their bid to evade loneliness.

In the synopsis for *The Night Club*, the thrust of the plot is essentially the same but it is set in a hotel rather than a club and Lindy and Tom's stories of their past become ever more outlandish and surreal, aided by drinks and drugs. As their tales becomes increasingly improbable and intertwined, they become "twin souls temporarily reunited" [151] before finally falling asleep on each other.

The Norman Conquests

Description: Ephemera

The Norman Conquests are among Alan Ayckbourn's best known and most successful plays. The trilogy consists of *Living Together*, *Table Manners* and *Round And Round The Garden* and was originally produced at the Library Theatre, Scarborough, in 1973. What is not generally known is they were not called *The Norman Conquests* at this stage; they were not even marketed as a trilogy. The fear being that Scarborough's tourists would be put off visiting the theatre if they felt they had to visit three separate times during their stay.

> "People come here [Scarborough] for a holiday week. They're not going to go to the theatre three times in one week, so I wanted them to enjoy the play on the one night they went."[152]

The title of *The Norman Conquests* was created for the plays' premiere in London at the Greenwich Theatre, which would later transfer to the Globe Theatre. The earliest recorded use of the title is the 4 April 1974 edition of The Stage.

> "Tom Courtenay is to star in three new full-length Alan Ayckbourn plays, which open at the Greenwich Theatre on May 9 under the general title *The Norman Conquests*."[153]

Although the original production of the trilogy did not use the now famous title, there was a hint of what was to come as each play had a subtitle in the world premiere programmes:

> "A weekend view of the Norman Conquest"[154]

The Novelist

Description: Concept

The Novelist is one of the five one acts plays present within Alan Ayckbourn's 2014 piece *Roundelay*. Originally, *Roundelay* had the title *IOU* and although the concept was the same - five inter-related plays whose order of performance are determined randomly by the audience - the

plots of *Roundelay*'s five plays are markedly different from the original synopsis for *IOU*.

The Novelist as written follows the Reverend Russ Timms visiting the recently widowed and retired judge, Tom Holgate, and his daughter, Blanche. She is convinced her mother is still alive and ringing bells around the house. Her sanity is further questioned when the plot of her latest crime novel bears an alarming similarity to how her mother was killed. But when an apparently broken bell starts ringing, the question becomes, is she mad or really haunted?

The original synopsis for *The Novelist* still focuses on Blanche, but her mother is alive although immobile after a terrible fall years earlier. Blanche's career as a novelist is entirely fabricated for her mother's benefit who dreamt of having artistic children. The piece climaxes with a confrontation between Blanche and her father who threatens to reveal everything to his wife. Blanche is left alone reading from her latest unpublished work in which a child watches her father knock down her mother, leading to a fall which severely curtails her life.[155]

Now Being Served

Description: Title - Discarded

The original proposed title for Alan Ayckbourn's only produced screenplay.

The playwright was commissioned by the BBC in 1973 to write a half-hour screenplay for the educational television series *Masquerade*. The play was originally titled *Now Being Served* before being altered to *Service Not Included* during production.

One Day In Spring

Description: Title - Discarded

An early discarded title for the play which will become *Life Of Riley* (2012). It is included in a synopsis for the proposed play, which is thematically similar to the finished work. [156]

Order Of Appearance

Description: Title - Discarded

An early proposed title for Alan Ayckbourn's 2014 play *Roundelay*. The title, probably a placeholder, refers to the fact the order of the play's five one acts is determined randomly each night prior to performance.

Pageant play

Description: Concept

An ambitious concept for two plays which would have marked the playwright's 65th birthday in 2004. The concept for the 'Pageant' play consisted of two connected plays; one of which would have taken place at the Stephen Joseph Theatre, whilst a second would have been performed in the grounds of Scarborough Castle. Negotiations with English Heritage were initiated and the theatre's box office and front of house had begun to consider the logistics of running the piece, before the ambitious idea was eventually abandoned.

In the aftermath of this, it was also apparently considered running Alan Ayckbourn's *A Chorus Of Disapproval* in repertory with John Gay's *The Beggar's Opera* (the latter being the musical produced during the course of the Ayckbourn play) in repertory at the Stephen Joseph Theatre. As it was, only *A Chorus Of Disapproval* was revived during the venue's 2004 summer season.

The Party Game

Description: Unproduced

Found in a loft in Scarborough in 2007, *The Party Game* is a unique piece of Ayckbourn writing which offers a fascinating insight into how the young playwright was experimenting with form and structure prior to his first professional commission. The one-act play survives in a single manuscript which has the author, Roland Allen, handwritten on the title page suggesting it was written prior to him adopting the pseudonym following his marriage to Christine Roland in 1959; (all existing manuscripts attributed to Roland Allen and definitely written under that pseudonym feature the name typed on the cover of the manuscripts).

From a historical point of view, the manuscript is intriguing as it is unlike any of Alan's other early writing being replete with stage directions and poor grammar; neither of which can be applied to any of Alan's professionally produced manuscripts - even the earliest. In consultation with the playwright, it is now considered the play was probably written around 1958, when the playwright was 19 years old.

Very little is known about *The Party Game* as Alan Ayckbourn has next to no recollection of it. He recalls it was offered to Scarborough Theatre Guild to perform - of which Scarborough's Library Theatre manager Ken Boden and his wife Margaret were leading members. Apparently Margaret turned down the play and Alan has no recollection of it ever being performed; backed up by the fact there is no record of a performance license being issued by the Lord Chamberlain's Office. A large cast of 10 and the one-act nature of the piece suggest it may have been written with

an amateur production in mind; at the time the Library Theatre rarely had such large professional casts.

The play is predominantly set in the living room of 45 year old Phyllis during a cocktail party and is essentially dialogue rather than event driven. The dialogue centres on the banalities of small conversation and the frequently acerbic relationships between the characters. Over all this is the spectre of an appearance by Matthew Llewellyn, a noted film critic, who is a clearly painted off-stage character never appearing at the party despite the anticipation of his arrival dominating the evening.

The Party Game is a fairly bleak character piece and unlike anything Alan was writing at the time. Perhaps of most interest is the fact an off-stage character is so strongly drawn (a device which the playwright would later develop) alongside a strong theme of unsatisfactory and fractious relationships. A good example of this is a striking conversation between Carol and the bohemian artist Julian, which also expresses a viewpoint against marrying young which Alan himself has frequently expressed in similar terms in interviews since.

> **Carol:** Yes I remember you telling me you thought that marriage was wrong on principle but I thought you'd grown up a bit since then.
> **Julian:** Oh, Carol, don't start getting motherly, please.
> **Carol:** I'm sorry darling but you make me feel it sometimes. Or maybe I'm just old fashioned.
> **Julian:** Look at it this way... when two people get married, they make a hell of a lot of promises, to each other, to God... and they've no right to make them. I mean, how do they know how what they'll feel like in twenty years or even five years. Nobody can be that certain. The chances are they'll both either get bored to tears with each other, stick it grimly to the end and both die miserably or else get a divorce and break a promise they shouldn't have made in the first place.
> **Carol:** People can be happy for a lifetime together. I agree with you up to a point, nobody's ever perfect for each other and they probably wouldn't recognise the perfect mate if they saw him... but if you get two people who are prepared to give and take a bit, to compromise...
> **Julian:** What do you mean by compromise? Toning down your own individuality till you're as dead and lifeless as most of the so-called happily married couples you see about?
> **Carol:** No, I don't mean that at all....[157]

Although the majority of the characters are little more than ciphers, the relationships can be seen to foreshadow themes and ideas which Alan will become very much associated with later in his career. This is

particularly clear in the tense relationship between 20 year old Michael and his mother, Jean, as well as the presence at the party of a married man, Harold, alongside his neurotic wife, Evelyn, and his former mistress, Caroline, who despite initial confident appearances practically breaks down during the course of the evening.

> **Carol:** Phyllis. She says you've got to talk to Evelyn before you have a row.
> **Harry:** Everyone's suddenly very concerned about us…
> **Carol:** No we're not. We're not interested in the least. We just don't want to get involved in one of your squabbles.
> **Harry:** This is an entirely personal matter…
> **Carol:** Oh no it isn't Harry. You're trying to drag other people into it, me for one and it just isn't fair…
> **Harry:** The Swiss air seems to have brought out all your hidden morality.
> **Carol:** It's cleared my head, that's all. You're not my boss any longer and I'm not your secretary. When I met it was all part of the job: boss flirts with secretary, secretary flutters her eyelashes and listens to him telling her what a monster his wife is… a six days a week, 9.30 to 5 romance and thank God I had the sense to get out while it was still that. Now it's all gone – finished. New secretary, new boss.
> HARRY *just looks at her and shakes his head.*
> **Carol:** I'm sorry, Harry, one of us had to say it. I know it sounds callous and cold blooded but it's true isn't it. Listen, Harry you don't love me, you don't really give me a damn about me. I'm just someone that isn't Evelyn… some girl, any girl… I want more than that…
> **Harry:** It appears you want a hell of a lot. (*he suddenly takes her arm*). Caroline…
> **Carol:** No, please… don't make a fool of yourself…[158]

Technically, the play is also unusual in the use of spot-lights in the opening and final scenes to reveal characters in their home locations, quickly cross-cutting between them. It is a technique rarely used by Alan and only in *Private Fears In Public Places* (2004) is it fully realised. The final scene in *The Party Game* sees spots focus on each of the characters briefly in their homes, in silence, showing the mundanity of their lives; strikingly similar to the final of scene of *Private Fears In Public Places*, where each character is also highlighted, in silence, alone in their lives.

The only existing original manuscript for *The Party Game* is held in a private collection and has never been published nor is it available to produce. However, it was finally given a first public hearing when on 10 October 2010, it had a read-through at the Concert Room at

Scarborough's Public Library - the room where the Library Theatre was based - at a special Ayckbourn event. It is unlikely permission will be given for it to be performed again.

Past Tense
Description: Concept

Past Tense is an unused concept for a play, written in October 2012. It exists as an incomplete synopsis concerning a prostitute whose life is threatened if she does not find a large amount of money within 48 hours. She approaches two former clients who happen to be friends, but both resolve not to meet her blackmail demands. The synopsis ends with the deadline passing and an ominous knock on the prostitute's door.[159] Aspects of it bear certain similarities to one act play *The Agent*, which is part of *Roundelay* (2014).

Pen To Paper
Description: Miscellany

Pen To Paper was an anthology radio series with each episode featuring different themes. For the broadcast on 22 February 1981 on BBC Radio 4, Alan Ayckbourn and his regular musical collaborator Paul Todd contributed two songs for an episode with a theme of travel. Unfortunately, the programme is not believed to have survived in archive and Sir Alan's only recollection of the songs - also now believed lost - is one was concerned with train travel. The songs were written specifically for *Pen To Paper* and were not featured subsequently in Alan Ayckbourn and Paul Todd's later collaborations.

'Pirandello' Play
Description: Unproduced

Prior to his first professional playwriting commission, *The Square Cat*, Alan Ayckbourn has frequently noted he had written approximately nine plays. His mentor, Stephen Joseph, apparently saw many of these plays, which presumably gave him the confidence to commission Alan to write *The Square Cat*.

Most of these early plays have not survived, but Alan has noted that one of the plays was his version of a Pirandello play (the likelihood being it was inspired by the playwright's most famous text *Six Characters In Search Of An Actor*).

"He'd [Stephen Joseph] seen my Pirandello play, which was the one that everyone writes, about the group of actors with a director, and they all take on the characters - and he said: 'Yes, that's a Pirandello play!' I said: 'Yes it is.'"[160]

Plays And Players

Description: Title - Discarded

One of several proposed titles for *Time And Time Again* which Alan Ayckbourn had written on his early notes for the play.

Play For Today

Description: Screenplay

In 1974, Alan Ayckbourn agreed to write a 75 minute play for the BBC television series *Play For Today*. Although no details are held in archive regarding the initial discussions about this, it seems likely - given the time frame and the people involved - it developed out of Alan writing the screenplay *Service Not Included* for the BBC series *Masquerade*.

The director of the proposed play was Herbert Wise, who had also directed *Service Not Included* and who appears to have been Alan's main liaison with the BBC. When the initial deadline passed in April 1975 with Alan having not written a script, a new open-ended contract was offered with the hope Alan might still be able to write a play for the series. Unfortunately, his many commitments meant a screenplay was never written and the opportunity for Alan to write his first full-length play for television passed.[161]

Private Fears In Public Places

Description: Concept

Private Fears In Public Places is a rare instance of an Ayckbourn play being announced and officially advertised before being replaced by a piece with an entirely different title and plot.

"Basically, I had two ideas bouncing around my head. So the final piece could have emerged from either one of them. And the play I absolutely thought I would write is a rather grueling piece set in an airport departure lounge - so that is the one which went in to the brochure. When I actually started to write the advertised play, *Private Fears In Public Places*, it all rather alarmingly began coming to pieces in my hands. It wasn't

ready to be written. Certain parts were intact, but it was like crafting a piece of furniture without legs."[162]

The proposed play, which Alan has described as being "pretty bleak"[163], was advertised in the spring 1994 Stephen Joseph Theatre In The Round brochure and bookings were taken for the production.

Ironically, in a memo to the theatre's press officer containing the advertising copy for the play, Alan had written beneath: "By the time I get round to writing it, it'll probably be about eight obstetricians trapped in a lift."[164]

Having tempted fate, Alan went on holiday to write the play and had to call the theatre to announce *Private Fears In Public Places* had fallen through; unfortunately the press and marketing department had sent the theatre's brochure to print the day before and it was not possible to stop the print run, which would feature *Private Fears In Public Places*.

Although very little is known about the original concept for *Private Fears In Public Places*, it was to be set in an airport and there seems to be the possibility the play might have featured an escalator or travelator.

"At the airport, Jessica waves a fond farewell to her husband. Then a chance encounter changes her life. How well does she know, how far she can trust herself?"[165]

Never one to throw a good title away, Alan Ayckbourn held onto *Private Fears In Public Places* until 2004 when he wrote a new play with this title, but which bore no similarities to his original 1994 idea for the title.

Relatively Speaking

Description: Screenplay

Relatively Speaking was Alan Ayckbourn's break-out play proving to be a critical and commercial hit in London in 1967. Inevitably there was a lot of interest in the play as a result of this, including producers keen to adapt it for the big screen.

All attempts to move a film forward though were stymied by the prolonged and ultimately unsuccessful attempts to transfer the play to Broadway; Alan's agent was unwilling to sell the screen rights until it had transferred to Broadway, when their value would have obviously soared if it had been a success.

Although all initial attempts to make a film fell by the wayside, there was still interest in adapting it (as witnessed by two subsequent television adaptations of the play in 1969 and 1989) and in the early 1970s, Alan drafted his own screenplay for the producer Clive Donner.

The script greatly expands the action, adding scenes before the play between Ginny and her older lover Philip as well as showing Ginny's first meeting with Greg, who she is already in a relationship with at the beginning of the play. These additions mean it is actually forty pages in before the familiar play begins.[166]

> **Ginny:** (*Aggressively tipsy, hardly pausing for breath*) Old maid be damned! All I say is - if a man does that to a woman's life - if for the sake of a few highly dubious, so called pleasures, I have to give up my whole life for him - I'd sooner do without him or without him or his bloody fringe benefits... marriage, co-habitation, the lot-
> **Man:** Just because one man -
> **Ginny:** It's not just because one man. It's any man. Living with any of you – it's exactly the same result -perdition and possibly pregnancy. Well, I say to hell with your manhood. To hell with your fast cars, your fancy restaurants, you smooth chat and your dirty washing. I've had you and I've had it.
> *She turns away rather dramatically and cannons into Greg behind her.*
> **Ginny:** Whoops-!
> *Greg rises politely. In his cramped position this requires literally slithering his body the length of Ginny's until they are nose to nose.*
> **Greg:** (*nervous*) Hallo...[167]

The unresolved plot-line from the play of what happened to Ginny's love letters to Philip - her initial motivation in the play for going to The Willows is to retrieve the letters - is also addressed with a scene in Phillip's loft showing the pair arguing whilst searching for the incriminating notes. Having retrieved the letters, they are then lost as they fall out of Ginny's bag as she and Greg hastily leave The Willows; later seen being eaten by a cow.

At present, it is known three versions of this screenplay are held in various private collections.

> "He's [Alan] just completed a film script of *Relatively Speaking*, but he's not mad about the cinema and he's convinced he's no good for TV."[168]

That the script never went any further was probably for the best as a decade after writing the script, Alan offered an honest appraisal of his lack of experience writing for film and his thoughts on the screenplay for *Relatively Speaking*.

> "[I] felt on reflection that that particular version of the play merely inflated it without adding anything much except a few

extraneous visual gags. For any future film thoughts I feel I should return to the stage text and start again."[169]

Relative Values
Description: Unproduced

Relative Values is an early unproduced and unpublished one-act comedy by Alan Ayckbourn and credited to his pseudonym Roland Allen; the play probably being written in 1960.

The action takes place in a house in a village and centres on the Spragg family as they prepare for a visit from their recently bereaved and abrasive aunt from America. Her blunt interference in the family's life leads everyone to re-evaluate their own relationships and lives for the better.

> **Harold:** What's happened to your face?
> **Molly:** I've got make-up on.
> **Harold:** Looks like you've forgotten to wash it.[170]

The Revengers' Comedies
Description: Ephemera

Less a concept than an interesting footnote of what might have been. When plans were first mooted to produce Alan Ayckbourn's epic two-part play *The Revengers' Comedies* in London, the first person to express interest was Richard Eyre, Artistic Director of the National Theatre. Unwilling to produce them as they stood, Eyre suggested alterations to the existing five hour production.

> "He [Richard Eyre] felt they should be one play and not two."[171]

Eyre's suggestion was not quite that simple: he believed the plays would not work over two separate evenings at the National Theatre and suggested the solution to this was to abridge the plays to fit into one evening. In theory, this would have meant starting the plays in the early evening with a supper break at the end of part one, before continuing onto part two. It was estimated that Alan would have needed to cut approximately 20 to 30 minutes from each play to reduce the overall five hour running time to approximately four hours. Alan, however, was unconvinced by the idea.

> "I defy anyone to make them one play. The thing is, they are what they are: four rather jolly, long acts for two evenings. I'm rather defensive about my plays these days and don't

make many changes in rehearsals. In the early 1970s, I was similarly pressured to not make *The Norman Conquests* three separate plays. But I stuck out."[172]

Alan's decision to retain the plays as he originally intended led to Eyre declining to produce them at the National Theatre, but Alan's regular West End producer Michael Codron decided to take a risk with the plays. The two plays were presented as intended over two evenings at the Strand theatre, but unfortunately weren't financially successful and ran for less than one hundred performances.

The Roland Allen plays
Description: Ephemera

Between 1959 and 1962, Alan Ayckbourn wrote under the pseudonym of Roland Allen and generally the use of this name on manuscripts allows the plays to be placed into a specific period of his writing career. Alan stopped using the pseudonym when the literary agent Margaret 'Peggy' Ramsay took him on in March 1962,[173] coinciding with him joining the Victoria Theatre, Stoke-on-Trent. The pseudonym is a combination of his first wife's name, Christine Roland, and his own name.

Initially, this pseudonym was used because Christine assisted Alan with suggestions and advice on his first two plays, *The Square Cat* and *Love After All*. Its continued use after that was probably due to the fact that the Scarborough audiences were familiar with the name and Alan was also acting under his own name.

The plays attributed to Roland Allen are *The Square Cat* (canon), *Love After All* (canon), *Dad's Tale* (canon), *Standing Room Only* (canon), *Love Undertaken* (Grey play), *Follow The Lover* (Grey play), *Double Hitch* (Grey play), *Mind Over Murder* (screenplay), *The Party Game* (unproduced and likely written prior to 1959) and *Relative Values* (unproduced).

Standing Room Only is usually the final play attributed to Roland Allen; although strictly speaking this is also considered the first play attributed to Alan Ayckbourn, as when he revived the play at the Victoria Theatre in 1963, it was credited to Alan Ayckbourn.

It is also worth noting that although *The Square Cat* was attributed to Roland Allen in press releases and contracts, a spelling mistake in the original programme gave the name as Roland Allan.

What is also often frequently forgotten is the true identity of Roland Allen was no great secret as the programme for the original production of *Love After All* in 1959 demonstrates.

> "So we are delighted to have this opportunity of presenting a new farce by Roland Allen - a pen name that conceals the

identity of Alan Ayckbourn, who has acted with us for several seasons."[174]

Ron And Julie

Description: Ephemera

In 1991, Alan Ayckbourn wrote a short one-act play for the National Theatre highlighting the work of its technical departments. *Ron & Julie: A Love Story* is essentially a showcase for lighting, sound and special effects within a love triangle between lighting technician Julie, who is the object of desire for sound technician Ron and the special effects technician Raymond.

The surreal plot sees Ron and Raymond fighting for Julie's attentions through the increasingly extravagant use of their individual technical skills. It culminates in Julie slipping from a tallescope ladder and having to be rescued by Ron, leading to a spectacular and bloody denouement between the three characters.

The play was probably written for a student open day to showcase the work of different departments within the venue.

It has also been performed by students at the University of York in 2012 as a finale to the *Ayckbourn Shorts* production. In 2013, it was also staged at the Tron Theatre, Glasgow, as part of the production *Scenes Unseen*.

Roundelay

Description: Variant

Roundelay is Alan Ayckbourn's 78th play and premiered at the Stephen Joseph Theatre in 2014. It is inspired by Chris Ware's graphic novel *Building Stories* and consists of five inter-related short one-act plays. The order in which these are performed is determined by a live random draw of coloured balls by the audience prior to the evening's performance.

Issues immediately became apparent with the early drafts of the play indicative of a too-long running time. Alan began editing the plays back but once in rehearsal, it became obvious the play was still running too long at more than three hours.

Thus on 20 August 2014, Alan made a difficult - if short-lived - decision that only four of the five plays would be staged each night; although the random choice would still be from the five plays. Briefly *Roundelay* became a play which did not entirely represent its author's original intentions.

The next day, the playwright changed his mind and *Roundelay* was restored to five plays and with some more judicious editing, the running time fell to three hours, including interval. The show opened with audiences watching - as intended - five plays performed in one of 120 random permutations each night; the order of the plays informing and altering each night's experiences.

In 2015, the play went on tour and in an unusual decision, an alternative version of the play was offered to venues. The play as written and conceived with five plays each evening or, to achieve a shorter running time, a return to Alan's abandoned idea that only four of the five plays would be randomly chosen each evening. Although there were still 120 possible permutations, certain audiences only saw four of the five plays and thus did not have a complete experience of the work; the playwright himself was reported to be unhappy that this abbreviated experience was offered by the company.

Satisfaction Guaranteed

Description: Concept

This is a concept for an unwritten play which exists in the form of a synopsis with character notes. The play, described as a sexual farce, is set in the future and features three plot strands which, in that respect, is similar to Alan's 2012 science fiction play *Surprises*. The synopsis is dated October 2008, not long after another abandoned synopsis - *Isn't It Romantic?* - which shares some of the same character names as *Satisfaction Guaranteed*.

The background to the play is unique to this synopsis though and offers an interesting view of sex in the near future with the play building on the sexual frustrations and dysfunctional relationships of the characters.

> A dating agency, occupying the 57th and 58th floors of a 90 storey building. Or rather a futuristic version of one. Where men and women come in order to be 'processed' to clear s safe and lawsuit-free path to sexual congress. The current compensation culture atmosphere (combining with recent Gender Equality laws) has grown so hostile and unsympathetic for couples seeking consensual sex that people (beyond a reckless few who often live to regret it) are terrified to touch each other without first signing a series of waivers and pre-sex agreements. Alleged date rape is the simplest of these. Women have successfully sued men for mental and physical trauma brought about by anything from unsatisfactory sex to excessive physical demands. Men have recently started to do

the same. A man recently sued his partner for deliberately lying about her true bodyweight, following his attempt to raise her up to a standing sexual straddled position, thereby claiming he damaged his back .

As a result couples, prior to indulging in consensual sex, have taken to consulting agencies such as Satisfaction Guaranteed. In response such agencies staffed by a mixture of civil lawyers and marriage guidance consultants have sprung up everywhere, eager to cash in on the boom.[175]

Schooldaze

Description: Concept

In 1994 the Stephen Joseph Theatre In The Round advertised Alan Ayckbourn's new play *Private Fears In Public Places*. Although publicised, Alan did not write the play and instead produced *Communicating Doors*. When initially considering ideas for his 46th play though, one of the ideas prior to *Private Fears In Public Places* was apparently called *Schooldaze*, although it never went any further than being a concept.

According to the recollections of a former Stephen Joseph Theatre In The Round employee, the play was intended for an all-female cast and concerned a school reunion for a class from an all-girls' school. During the course of the weekend, the women regressed back into their childhoods creating what appears to be a female *Lord Of The Flies* scenario. Unfortunately, the promising concept was dropped for *Private Fears In Public Places* which was then dropped for *Communicating Doors*.

The Season

Description: Unproduced

The Season is the earliest example of Alan Ayckbourn's writing known to still exist and was written no later than 1958. It is described as "a drama in four scenes"[176] and features two characters, The Girl and The Traveller. The only surviving script does not carry the name of the author, which strongly indicates this was one of Alan's early plays written before he received his first professional commission with *The Square Cat* and started using the pseudonym Roland Allen.

> "I'd been writing before that [*The Square Cat*], but they'd never had the test of production, and most of them, with a couple of exceptions which had been rather morose pieces, had been comic in tone."[177]

The Season falls into the morose rather than comic category; each scene is set in a different season beginning with spring and ending with winter with each season moving forward in time from medieval times to Edwardian England to a post-apocalyptic future. The play follows the relationship that develops between The Girl and The Traveller with the story continuing through each different time period.

During the first act, the couple meet and during the second, they are together but leave each other in anger. The third scene, apparently 18 years on, sees The Traveller now meeting The Woman for the first time since he left her. She is close to death and the scene apparently ends with a nuclear explosion. The final scene is set in a winter some years after the attack when The Traveller meets The Girl but apparently for the first time, acquainting themselves in an outside world which no-one has seen since the attack. The play ends with the pair agreeing to explore the new world together.

> **Girl:** Please don't talk like that. I am afraid. It would be like the winter - death would. I know it. Cold and white with no colours at all. Everything sharp and pointed - the trees spikey like the icicles that hang from the branches and the wind brushing over the snow and biting through your bones - eating you away.[178]

Season's Greetings

Category: Variant

Although not substantially different to the definitive version, the original production of *Season's Greetings* at the Stephen Joseph Theatre In The Round was a three act play, which ran considerably longer than the play as it stands today. This version also toured to the Round House in London, where *Season's Greetings* received its London premiere. The following year, Alan revived the play in Scarborough, altering the structure to two acts and shortening the play.

The major difference between the two plays is Harvey, the elderly uncle, is married and his wife, Shirley, is also at the house but remains unseen and unheard in an off-stage part of the sitting room. The characters address Shirley and respond to her as if she has replied, but her own dialogue is unheard. When Alan revised the play, the main alteration was to remove all of the dialogue regarding Shirley and references to her.

> "When I first wrote *Season's Greetings*, I had an offstage woman (Uncle Harvey's wife) whom we never saw but whom he spoke to quite a lot. The device didn't work (it seemed he was completely mad as opposed to half mad)."[179]

Harvey: Shirley'll know. *(calling across the room)* Shirley, is this chap, the dark one, is he the one we were reading about who has a drink problem.
He listens as Shirley replies.
Harvey: Oh, was it? Somebody else. *(to Bernard)* Somebody else.
They watch again, Harvey laughs.
Harvey: Damn fine film though. Even if they are all dead.[180]

This revised production, which ran at least half-an-hour shorter than the originally production, was staged at the Greenwich Theatre before transferring to the West End and is the published version of the script.

Service Not Included

Description: Screenplay

Service Not Included is Alan Ayckbourn's only screenplay which has been filmed and was commissioned by the BBC in 1973 for the educational series *Masquerade*.

Alan was approached in July 1973 on behalf of Herbert Wise, a well-respected director who had directed Alan's play *Relatively Speaking* for television in 1969 and who in 1977 would go on to helm the acclaimed television adaptations of *The Norman Conquests*. The initial suggestion was Alan write a play set at "a masked fancy dress party, taking place now in a large nineteenth century country house…. The plays should have no more than four main speaking parts and not more than the same number of sets."[181]

Alan completed the first draft of his first screenplay at the end of November 1973 with the provisional title *Now Being Served*. Set at a fancy dress party at the climax of a business convention, the play follows in the footsteps of a waiter, experiencing only what he sees and hears. In a letter to his agent Margaret Ramsay, Alan noted the challenges of writing for a new medium.

> "It seemed to me the only way to handle this minute medium - minute in the terms of scale it can tackle - was to understate furiously and concentrate on minutiae. Thus the dialogue is functional and the whole success of the thing will only work if we get the impression, when they translate it into pictures, that we're walking alongside this waiter and just gleaning such scraps as he would glean."[182]

Although Alan felt the screenplay was "really very downbeat", it was enthusiastically received by Wise and Alan was encouraged to take it

further, particularly to edit down some of the many parts; a band was immediately removed alongside several minor walk-on roles.

By February 1974, a final draft had been completed and the play's title altered to *Service Not Included* - one of several alternative titles offered by Alan to the director. Filming took place between 25 and 29 March on location at Berystede Hotel, Ascot, with a substantial cast of 16. It was then broadcast on BBC 2 on 20 May 1974.

Of note is the fact it featured the playwright's now wife Heather Stoney in the cast and that the central conceit of the play - the waiter moving in and out of conversation and the 'audience' hearing only what he hears - was the inspiration for his one-act play *Between Mouthfuls* which he wrote later in the same year as part of *Confusions*.

For many years, it was considered Alan had written two television screenplays: *Service Not Included* and *A Cut In The Rates*. Although *A Cut In The Rates* debuted on television, it was written specifically as a theatrical one-act play, leaving *Service Not Included* as the only televised Ayckbourn screenplay.

Service Not Included

Description: Title - Discarded

When Alan Ayckbourn was first commissioned by the BBC to write a 30 minute screenplay for the educational series *Masquerade* in 1973 he initially gave it the title *Now Being Served*.

However, the option of the final title he gave to the director Herbert Wise having made the following suggestions which include the final title *Service Not Included*.

> The Waiter
> Waiting Time
> Wait And See
> Not So You'd Notice
> Waiter Service
> Service Not Included
> They Also Wait...
> Waits And Measurements

Sight Unseen

Description: Concept

Sight Unseen was Alan Ayckbourn's first attempt to write a thriller for the stage. It is a rarity in being a play that was announced to the general public, but was never produced.

"I'm about to write play 25 and am pacing nervously. It's called, somewhat fittingly, *Sight Unseen*. Assuming I finish that, I shall have it rehearsed and into repertoire by the end of September."[183]

The play was announced as part of the Stephen Joseph Theatre In The Round's 1980 winter season and was intended to be a thriller; the likelihood being that the play would feature a random murderer. Alan began writing it, but quickly found difficulties with both the concept and the characters. It was replaced in the schedule at the last minute by the hastily written *Season's Greetings*.

"Well, it's wrong to say I was actually into the dialogue stage. I was into the construction stage: I was putting up the fences. I then did a volte face and left myself with just two things from the thriller. One was that I set it in a hallway which I quite liked."[184]

Although the play was abandoned, Alan would return to the idea very quickly with *It Could Be Any One Of Us* which opened in 1983 at the Stephen Joseph Theatre In The Round. Intriguingly, Alan had similar reservations about this play (and would later revise it in 1996) to those he had with *Sight Unseen*.

"I like thrillers, I really enjoy reading them, and I quite like whodunnit plays. But if you're going to write a good whodunnit, everyone's got to have done it, you see; and you then pull away about six motives and leave one there. And then you say: 'Ah yes, he's the one who did it, because he was the only one who had the front door key.' But the point is that I first of all had to write a cast of homicidal maniacs, because they all had to have killed Mr. X. And that was extremely boring. When you've got a couple of homicidal maniacs it's quite fun, but here they were all saying: 'I really hated him, I'd have killed him if I'd had the chance.' And I felt there were awful limits in having to prescribe your characters' behaviours. I'm very used to letting my characters roam around much more freely than that. To have to saddle them with a load of hatred and malice, or even sheer clumsiness, was very hard. And I didn't want to write a straight whodunnit where we just eliminated it down to one: I wanted to write a whodunnit where any one of them could have done it - to keep it absolutely open. And I came to the conclusion it was rather a boring thing to write."[185]

Prior to 2010, very little about *Sight Unseen* could be said with any certainty - not even whether it was actually an early attempt to write a

thriller with random murderers. However, amongst some archived handwritten manuscripts from the period, two pages of notes were found relating to *Sight Unseen* by Alan Ayckbourn's Archivist in 2010. The notes include the names of the characters (Neville, Belinda, Giles, Jocelyn, Bernard, Veronica, Eddie, Derek and Phyllis), many of which would be used in *Season's Greetings*, but most significantly there are structural ideas which offer definitive proof it was intended to be a random killer thriller with a list of the potential killers and their motives.

> Belinda kills Nev to free her
> Derek kills Nev to free her
> Bernard kills Nev to avoid family break-up
> Veronica kills Nev to avoid family break-up[186]

The Silver Collection
Description: Title - Alternative

The Silver Collection was the original title for Alan Ayckbourn's eighth play, *The Sparrow*. It received limited advertising as *The Silver Collection* but the title was altered before the launch of the summer season at the Library Theatre, Scarborough.

Apparently there was no change in the concept of the play, but Alan felt *The Sparrow* better suited the subject, although he was not completely happy even with this title....

> "My latest play started life on the posters as *The Silver Collection* as I hadn't begun work on it when the publicity was due. It was later presented as *The Sparrow* but I'm not really happy with that title either. Please send your suggestions on postcards only please to...."[187]

Sisterly Feelings
Description: Title - Discarded

According to a report in 1980 in the Scarborough Evening News, Alan Ayckbourn's 1979 play *Sisterly Feelings* had several changes of titles.

> "Mr Ayckbourn is known to change titles as he works on a play. The title of *Sisterly Feelings* was changed four times."[188]

What these titles were has not been recorded, nor has the playwright any recollection what they might have been. However, in 2011, research into Alan's original notes for the play revealed several hand-written notes suggesting working titles for the play alongside the actual title.

These titles are *As A Sister*, *Like A Sister* and *Sisterly Touches*, which are presumably some of the titles mentioned in the original newspaper article.

Sisterly Touches

Description: Title – Discarded

One of several proposed titles for *Sisterly Feelings* which Alan Ayckbourn had written on early notes for the play.

Someone Watching

Description: Screenplay

Following the completion of *The Square Cat* and Alan's marriage to his first wife, Christine Roland, a newspaper article local to Christine's parents ran a piece about the couple. It noted they were writing treatments for television shows, several of which survive although none of these treatments were developed into scripts.

Someone Watching is described as 'a comedy with soft undertones'[189], and concerns 'an average man' undergoing a mid-life crisis, unable to have any sort of meaningful relationship with anyone in his family.

We see the routine of his average day which he later breaks by going to a pub where he gets into a conversation with a typist from the office. Although nothing happens, his guilt overwhelms him during his daily routine as he believes everyone thinks he is having an affair with the typist, leading him to accidentally step into the path of car. In the hospital, he awakes to his worst nightmare: his family and the typist at his bedside, the latter only having come to wish him well having seen the accident from the office window.

The Sparrow

Description: Withdrawn

The Sparrow is the last of Alan Ayckbourn's early plays to be neither published nor performed again since its first production. Although Alan is not as dismissive of it as the very early plays, there is a sense it was a disappointing follow-up to its immediate predecessor *Relatively Speaking* and successor *How The Other Half Loves*.

The play was originally entitled *The Silver Collection* and this title featured in early discussions concerning the 1967 summer season at the Library Theatre, Scarborough, and in early advertising. However, Alan

disliked the title and it was altered to *The Sparrow*; although Alan expressed dissatisfaction even with this title (see *The Silver Collection*).

The Sparrow was performed for just three weeks in repertory and has never been performed since; the playwright did give permission for a reading of the play in 2014 by the Huddersfield-based amateur dramatic company *Dick & Lottie* as part of its anniversary celebrations marking 10 years of producing Alan Ayckbourn's plays.

The Scarborough Evening News noted the producer Peter Bridge visited the show[190] and he did take an option on the play with the apparent intent of producing it in the West End. It did not transfer to London though and correspondence between Alan Ayckbourn and his agent Margaret Ramsay indicates that Alan felt Bridge was not enthusiastic about producing *The Sparrow* in London as he wanted something similar to *Relatively Speaking*.[191]

> **Evie:** (Suddenly) Hey. I know what's wrong with me. It's my eye-lashes….
> **Ed:** What?
> **Evie:** They've gone?
> **Ed:** Where?
> **Evie:** The rain must have washed them off.
> **Ed:** Oh. Were they false ones then?
> **Evie:** I hope they were. It was only rain out there, mate, not sulphuric acid.[192]

Although Alan has sometime expressed wonder at how the play would have performed in the West End, the play was arguably lost amongst the clamor surrounding *Relatively Speaking* which opened at approximately the same time in London. Alan's feelings about the play have also appeared ambivalent over the years.

> "Since I was following up a winner [*Relatively Speaking*], there was more work in that play [*The Sparrow*], and I still think it was better than *Relatively Speaking*."[193]

> "Obviously I don't believe, in retrospect, that it's as good a play [as *Relatively Speaking*], but it's only had three weeks in its life, those three weeks at Scarborough. It's probably worth a little more than that. At the time, the only reason it was suppressed was it was a bit like *The Knack*, somebody said. Since I hadn't seen *The Knack* [by Ann Jellicoe], I didn't realize. I've seen *The Knack* since. It is a bit like *The Knack* - it's got a girl in the lead, that's what it was. But then, so has *Antony and Cleopatra*, you know"[194]

That the play may have had potential though is intriguingly indicated by one of the rare reviews of the original production which made a clear comparison to one of Alan's contemporaries and influences.

"In his dialogue, especially for the spivvish tenant of the flat, his writing is worthy of Pinter at his funniest."[195]

In 2010, Alan Ayckbourn spoke about *The Sparrow* for an interview reproduced in previous editions of *Unseen Ayckbourn*; this section of the interview is reproduced below.

Alan Ayckbourn Discusses *The Sparrow*

The Sparrow was a four hander with a leading girl, which was quite unusual in those days; a young woman who was supported by two other blokes and there was fourth woman who popped in. So it was a one girl show really and unfortunately - or fortunately for her - Ann Jellicoe's *The Knack* had opened around the same time, which I hadn't seen, with the same idea of this leading girl. And the London producers said, oh it's a bit like *The Knack*. I thought it's not like *The Knack*, I don't even know *The Knack*. But its format was the same and they got nervous - despite the fact *The Sparrow* was quite successful and went very well in Scarborough.

Peter Bridge, who had produced *Relatively Speaking* in London, couldn't find any star parts in it as it was quite a young cast, so it got lost. I think it was because there was no part for Robert Morley or Celia Johnson or Michael Hordern in *The Sparrow*, there was no part for anyone.

Rita Tushingham had made her name in *The Knack*, but that had started at the Royal Court, and I was now set on a commercial track following the success of *Relatively Speaking*. So Peter Bridge cast round in vain to think of anyone who could play it and they couldn't think of anyone - as from the original cast, Robert Powell had yet to do *Doomwatch* , let alone *Jesus Of Nazareth* and John Nettles was in his very first play, his very first role straight from drama school, and had yet to do his extraordinarily successful television career playing detectives here, there and everywhere with his forays into the Royal Shakespeare Company inbetween. So we were four unknown actors and a vaguely unknown playwright.

It was also never going to be a follow-up to *Relatively Speaking*, no mistaken identities in this - it had a man trying to build a boat in his bedroom! My instinct after the success of *Relatively Speaking* was to move on. So it was me deviating but the trouble is when you're a young writer you have to start writing only slightly differently, so people say: "Oh, it's this chap." And eventually you move further away. But if you're not careful you only move on a fraction and you just go round and round like Feydeau and I wasn't interested in that.

The Sporting Gnome

Description: Title - Discarded

One of several proposed titles for *Time And Time Again* which Alan Ayckbourn wrote on early notes for the play. The title is a reference to Bernard the garden gnome whom Leonard talks to during the play.

The Square Cat

Description: Withdrawn

The Square Cat was Alan Ayckbourn's first professional play, commissioned by his mentor Stephen Joseph and premiered at the Library Theatre, Scarborough, on 30 July 1959.

The conception of the play has often been repeated in interviews over the years, but what should not be forgotten is Alan never had any grand intentions to be a playwright; at the time of his first commission he was just an actor at the Library Theatre, Scarborough.

> "I have never made any decisions; they have always been made for me. I could look back on my life and say I planned it that way, but I didn't plan to be an actor, nor a director, nor a writer. They ran out of writers!"[196]

Alan had actually been interested in writing for many years and had written a number of scripts - mostly inspired by his favourite writers - which he was confident enough to submit to Stephen Joseph, the founder of the Library Theatre, for advice. This knowledge of Alan's nascent talent and enthusiasm for writing gave Stephen the perfect opportunity to further encourage the young writer when Alan infamously complained about the roles he had been playing recently.

> "Stephen had the complete, some would say lunatic, disregard in allowing me to write for him. The story goes that I came off stage one night and said that I could write much better than what I had just acted in and he told me to get on with it then."[197]

The offending play was David Campton's *Ring Of Roses*, although for many years Alan mentioned it was John van Druten's *Bell, Book And Candle*, as he did not want to upset Campton, a friend and contemporary at the Library Theatre.

Stephen was always keen to encourage new writers, although this also had other benefits for the company as Alan recalls there was funding to encourage new writing.

"The Arts Council gave us £300, more than I'd ever seen in one place before. I thought, this is money for old rope."[198]

Stephen's challenge was made during the winter season at the Library Theatre in 1958, when Alan was also in rehearsals for the company's brief winter tour. The play he was rehearsing was by and being directed by a relatively unknown writer who had just suffered his first West End flop. Harold Pinter had been invited to Scarborough to direct *The Birthday Party* following its critical mauling in London. This would only be the second time it had been professionally staged and it featured Alan in the role of Stanley. The play may not have directly influenced *The Square Cat*, but its author certainly inspired Alan.

"I got fascinated by his [Pinter's] use of dialogue, his use of words, the structure of sentences. You can see even now what's actually rubbed off on me from him."[199]

The Square Cat was written during the tour, but it was not a sole effort. Alan's partner and soon to be wife, Christine Roland, worked together with him offering advice on the play.

"I stomped off home and, with the help of my then wife, who was a very judicious editor, wrote a play under a joint pseudonym, Roland Allen. This was the time of skiffle and coffee bars and the play was an unashamed launch for my own acting career."[200]

The pseudonym Roland Allen (Christine Roland / Alan Ayckbourn) was used by Alan for his first four plays, although Christine was only involved in helping *The Square Cat* and *Love After All*.

The Square Cat was an unashamed showcase for him both as a playwright and actor with Alan playing two roles; it has never really been emphasised Alan spent the play quick-changing between the rock 'n' roll star Jerry Wattis and the mild-mannered Arthur Brummage.

"I came on in act one and stayed on, with all the best lines, until the end, and I danced and sang and played the guitar - none of which I was very good at. It was an immensely practical way to start. I learned a great deal from seeing the same bits die every night."[201]

It opened at the Library Theatre, Scarborough, on 30 July 1959 and was a big hit with the summer audiences. The surprise success and demand for tickets - apparently it was booked to capacity for most performances - led Stephen Joseph to cancel a week's performance of David Campton's adaptation of *Frankenstein* (which had not been well received) and scheduled a second week for *The Square Cat*'s second

repertory run the following month; the first time a play in repertory had run for two consecutive weeks at the venue.

For Alan, the over-riding memory was the pay-cheque.

> "It made me forty-seven quid, I remember, more than I earned in several weeks. It proved very popular because it was what it was - a farce, with no pretensions to anything else - and it did give people quite a laugh." [202]

Conventional wisdom has it *The Square Cat* was never performed again, but it was produced once more during the company's 1959 winter tour. Alan was unavailable to reprise his role, having received his National Service call-up (deftly avoided by being signed out after just three days) and Barry Boys took on the role for the play's swansong.

It has never been performed since then and the script has never been published. Although Alan suggested for many years all copies had been destroyed, it is surprisingly profligate. Originals of the play are held by The University Of York, The University Of Manchester, the British Library and by the playwright himself.

The only other public glimpses of *The Square Cat* have been in 2005 when on the anniversary of the Stephen Joseph Theatre's 50th anniversary, Alan agreed to let the first scene of the play be read as part of the theatre's celebration event *50 Years New*. He also agreed to a reading of this scene as part of the Royal And Derngate Theatre's *Ayckbourn At 70* celebration in 2009 and for an Ayckbourn themed weekend at the Stephen Joseph Theatre in 2010.

> "We read *The Square Cat* [at *50 Years New*] and I would say to anyone that heard it: "Take heart, if you are writing plays it can only get better than this." They [the early plays] are not producible pieces, they are nothing more than my early jottings. My early plays are an object lesson in someone having confidence in someone - I was just delighted that someone would put my plays on."[203]

The play concerns a wife's infatuation with a rock star, Jerry Wattis, and a secret liaison to meet him at a friend's house. Her husband and son find out about the plan and also travel to the house to thwart her ambitions, confronting Jerry Wattis's alter-ego, mild-mannered Arthur Brummage.

> **Dad:** Lots of people have unhappy childhoods, agreed. Mine was hell. But that doesn't make me allergic to husbands.[204]

Alternating between Jerry and Arthur, Jerry manages to extricate himself from the wife's crush - leading to him being chased by the husband with an axe - whilst, as Arthur, he falls for the couple's daughter

and becomes engaged to her with her mother still clueless that Arthur's alter-ego is her former crush Jerry Wattis.

Although the play is a farce and bears little resemblance to what Alan Ayckbourn would go on to write, there is one interesting scene - apparently largely excised from the final manuscript - which gives a hint of the marital relationships which would become a staple of his later writing.

> **Dad:** Adultery, thank God, even in this demoralised evolution has not yet been classified as an amusement.
> **Mum:** 20 years. I've wasted 20 years of my life on a man like you.
> **Dad:** What do you mean, wasted? I've always been completely fair by you, Alice.
> **Mum:** Every morning I've sat and watched you grunt your way through your breakfast. I've out up with your moods and shocking behaviour.
> **Dad:** I never lost my temper. I have always been completely calm even under the most catastrophic circumstances. And let me tell you, Alice, if I'd been half the man I am I'd have walked out on you a long, long time ago.
> **Mum:** Go on then, I don't want you.[205]

In 2010, Alan Ayckbourn spoke about *The Square Cat* for an interview reproduced in previous editions of *Unseen Ayckbourn*; this section of the interview is reproduced below.

Alan Ayckbourn Discusses *The Square Cat*

I think one of the reasons Stephen Joseph first asked me to write was I let slip early on that I'd written at school. In fact, I'd written my first play before the age of 12 and it was an adaptation of an Anthony Buckeridge book *Jennings at School*; which I wrote and never got to see because I was ill in the sanatorium. I wrote sketches and little bits and pieces once I was at Haileybury, my public school, where the arts scene was covert and undercover and which was all very exciting; like being in the French resistance!

So I was writing and writing and eventually I got to Stephen's company and I was overheard to complain about the play I was in one night, the way actors do. I didn't have a very good part in it and Stephen threw down the gauntlet: "If you think you can write a better play, do so." I said, "I can write better than this - I can write a play tomorrow that's better than this." And he said, "OK, do so smarty. There's just one thing, if you write it, be prepared to play the lead in it." Which he thought would queer my pitch actually as obviously I'm not going to be lunatic enough or suicidal enough to write myself an unplayable role in a play I

didn't have any confidence in. But I was so swollen with confidence and possibly a slight stupidity of youth, that I wrote a play in which I gave myself this starring role. The freedom was amazing and the actor in me was urging the author in me onward and onward, so the role was a rock 'n' roll singer playing a guitar, singing and dancing; it was an amazing role - Michael Crawford would have died for it! But I couldn't sing, I couldn't dance and I certainly couldn't play the guitar!

It occurred to me in the first two or three weeks of rehearsals that I ought to remedy this quite quickly, so I went for some guitar lessons. I didn't even have a guitar and this boy looked at me in amazement and said: "How long have you got?" I said: "Well, about two weeks." He said: "You can't play the guitar in two weeks! I can teach you a couple of chords." I said: "Yeah, OK, that'll do. So can we find a song to go with a couple of chords?" and he said: "Well, there's a very boring song with two chords in it!" which I finished up playing.

The Square Cat was a farce because that was how it turned out. Everyone tells you - don't write farces, they're for old men. Farces are technically very, very difficult to write unless you're a natural farceur, you have to know exactly all the wheels and nuts of play-building. Long before that, you're supposed to write a very serious play about how your mother didn't understand you and how your father was unkind to you. Write something rather introverted and gloomy and all about you - which is what 80% of all first plays written are; they come soaring out of a person's unhappy childhood and if they've had a happy childhood, they invent an unhappy one. But I started with a silly play about a woman who fell in love with a pop singer and he arranges to go on holiday with her, to her family's horror, who then turn up and try to stop her. The rest of the play is about pop singers running in and out of doors.

Farce is the most difficult sort of theatre to write, as I realised. Years later I still have only written a handful of farces - if you can call them that. *Taking Steps* was significantly my next farce which was 20 years later. That took me ages and ages to write; it was most difficult.

Because *The Square Cat* was light and had a few laughs in it, it made money because we were still doing, in those days, largely plays written by young people who were writing about their "unhappy childhoods" and this was a silly play about no childhood at all. The audience, who were on holiday in Scarborough trying to avoid the rain, ran in gratefully and saw my play, which made the theatre money. It made me more money in one lump than I'd ever earned in my life! £33, it was a fantastic amount! I went completely berserk and bought myself some records!

Stephen Joseph realised he'd actually, like some freak accident of lightning striking, found himself an embryonic commercial writer and he encouraged me to write more. I, wanting to see more £33s coming in because by then I had a family and one child with another on the way,

started to write comedies for Stephen and the first three or four all included exciting parts for me! And then as they went on I began to realise that possibly the one weak link in them was this bloke playing all the leads. So I recast them for another actor - to the eternal gratitude of the rest of the company, who were fed up with supporting me.

Standing Room Only
Description: Withdrawn

Standing Room Only is one of the most intriguing of Alan Ayckbourn's early plays and is notable for a number of reasons. Written as his fourth play in 1961, it is the last one to be credited to his writing pseudonym Roland Allen, but it is now also regarded as the first play to be credited to Alan Ayckbourn. It is the only one of the early works not available to produce that was later revived professionally. It was also the first Ayckbourn play to be directed by the playwright himself and had the potential to be the first West End production of an Ayckbourn play.

And to complicate matters, it also exists in numerous different drafts.

Standing Room Only originated with a suggestion from Alan's mentor Stephen Joseph that he write a play about overpopulation.

> "*Standing Room Only* was interesting…. I really don't like having ideas pushed at me. But Stephen did manage to push two at me; one was *Standing Room Only*. The original brief was to write a play about overpopulation. At the time, there was this great panic that by the year 1996 the world would be at a standstill, as the birth-rate would have quadrupled. Stephen suggested, in a rather bizarre way, that I set a play on Venus, where the population had exploded away from Earth and had now filled up Venus. That seemed to me sort of unlikely, even given that it was a fantasy; that we ought to concentrate on the Earth. I suddenly had this idea of a traffic jam in Shaftesbury Avenue, set on a bus. It was projected science-fiction. It said, by this age, children will be no longer smiled upon and there'd be very complicated exams in order to have them. The girl has an illegitimate baby on the bus, delivering the child on the top deck, and all that. It's pretty way out."[206]

The play was set in 2010 originally, but in subsequent revisions this was moved back to 1997, and is set on a double-decker bus in a grid-locked London under the control of an apparently totalitarian government which has implemented draconian measures to control the size of the population. At its core, it is actually a comedy about a family surviving despite the odds.

The production was premiered at the Library Theatre, Scarborough and attributed to Alan's pen name Roland Allen. It received an exceptionally good review from The Stage which ended with the infamous line: "Mr. Allen has imagined his bus in Shaftesbury Avenue: is there no management to drive it there?"[207] Considering this brought Alan to the attention of the London producer Peter Bridge, Alan could be said to owe a great deal to this critic - even if it was his stage manager, Joan Macalpine, who had submitted a review to The Stage without mentioning her connection to the production.

> **Nita:** In the Government Multiple Stores. I kept going down there till I met someone I liked.
> **Pa:** Is that how you met John?
> **Nita:** Yep.
> **Pa:** I was never told about this.
> **Nita:** You never asked -
> **Pa:** Well swipe me - let's get this straight. Am I to understand that you went round and round the Government Multiple Store with your polythene basket till you saw somebody you liked the look of and then asked him to marry you? Am I right?
> **Nita:** More or Less.
> **Pa:** Got a romantic nature, haven't you?
> **Nita:** Oh, Pa, you're so antiquated. This is 1997. You ought to keep up.[208]

Peter Bridge optioned the play for London and so began numerous re-writes suited to whichever star name was interested in it. The scale of the play also increased, but the tortured writing process led nowhere and possibly launched Alan's increasing wariness of the West End.

> "I kept rewriting till I was heartily sick of the thing. Needless to say it finished up a total mess. I've hated re-writing ever since."[209]

While the West End production never took place, Alan did successfully revive the play, having revised it, in 1963 after he had left Scarborough to join the Victoria Theatre, Stoke-on-Trent. This was the first of his own plays he directed himself and it was credited to Alan Ayckbourn rather than Roland Allen. As a result, *Standing Room Only* is now regarded as the first of the playwright's works to be written as Alan Ayckbourn.

Standing Room Only

Description: Variants

Standing Room Only is unique in the Ayckbourn canon in that a number of significant variations of the script exist in the Ayckbourn

Archive. These include the original 1961 manuscript, the edited text for performance, the 1963 revised revival at the Victoria Theatre and several versions of the script for the proposed London transfer. Although the play remains essentially the same, the later drafts incorporate extra characters and become increasingly ambitious with the later London revisions seeing the play's double-decker bus setting being winched into the air by unseen helicopters at the climax!

> "And I suppose over two years, I must have rewritten it again and again and again, till I had helicopters flying in.... That was the West End version, which was never done and never could have been done. They said, 'We want something a bit more spectacular!' And at that time, Peter [Bridge] was putting on *Come Spy With Me* with Danny La Rue, who was flown in in a helicopter, and he said this would make a good ending. And obviously a boy of that experience and that age was open to suggestions from the office cleaner onwards!"[210]

Standing Room Only

Description: Screenplay

Not only did *Standing Room Only* never make it into the West End, stalling somewhere between Scarborough and London, it also failed to make a planned transition to television.

Little is known about the proposed television adaptation other than the rights to adapt and screen it had been bought by the producers of the popular drama series *Armchair Theatre* for probable broadcast in 1964.

The play was never filmed and the only evidence of the adaptation is a mention in Alan's biography for the world premiere of *Mr Whatnot* at the Victoria Theatre, Stoke-on-Trent, in 1963.

> "The play is to be presented by ABC Television in their *Armchair Theatre* series next spring."[211]

The Star

Description: Concept

The Star is a one act play which forms part of Alan Ayckbourn's 2014 piece *Roundelay*. This was originally conceived with the title *IOU* and although the play's concept was the same - five inter-related one acts whose order of performance are determined randomly by the audience - the synopsis for the *IOU* plays are markedly different than those written for *Roundelay*.

The Star is a title used in both *IOU* and *Roundelay*, but there the similarities end. *The Star* in *IOU* has elements which surface within *Roundelay*, but its central thrust of a young girl, Rose, being sent as an escort to a gentleman's club is, perhaps understandably, not kept.

The play is set in the flat of an escort services manager, Gale, who is in serious debt to a former employer Lance, who has just turned up demanding his money back. Desperate for money - and unwilling to listen to Lance's suggestion she pimps her clients out - she turns to her best friend Lindy. She knows a dancer at Lance's club has been injured and she could fill it with someone who looks 16 and is prepared to 'dance' for a client with a schoolgirl fetish. Gale is reluctant but when Rose - a 16 year old she recently gave a business card to (see *The Teacher*) - turns up at the flat, Lindy enthusiastically persuades Rose this could be her big break into stardom. Desperate and willing to do anything for fame, she falls for Lindy's improbable inventions before heading off to the club.

The play's climax features Rose performing "her 'act' no holds barred, uninhibited and in-your-face" [212] for Gale; a scene later used in *The Politician* in *Roundelay*.

The Story So Far...

Description: Title - Alternative

This was the original title for what would eventually become *Family Circles*. *The Story So Far...* was the play's title when first produced at the Library Theatre, Scarborough, in 1970.

The title was then altered to *Me Times Me Times Me* for a tour intended to lead to a London production in 1971, which was itself altered to *Me Times Me* during the tour and for a subsequent second attempt to take it into the West End in 1972.

The title *Family Circles* was given to the play when it was again revised and later revived at the Orange Tree Theatre, Richmond, in 1978.

Suburban Strains

Description: Abandoned

Very little is known about the original concept for *Suburban Strains*, but it is known that Alan began writing the play in 1980 with one idea in his mind before abandoning it for another.

It was Alan's first collaboration with the composer Paul Todd and perfectly illustrates how the vagueness of Alan's titles gives him the leeway to start over if a project is not working. All that is known is the pair began work on the first song of a vague plot, before Alan abandoned the idea and began working on what would become the actual plot of

Suburban Strains; the title obviously being loose enough to cover a multitude of sins.

> "I had an idea for a musical, then Paul shot a tune at me and we wrote half a lyric. Then I told him the original idea wasn't on any more, which threw him into total confusion. I remained cussedly vague. I got the story sorted out, and we thought about what we needed for a song. Paul would go away with an idea: we need a song that says good-bye. He'd rattle away at an electric piano and return with a song."[213]

Suburban Strains

Description: Variant

Suburban Strains was Alan Ayckbourn's first full-length collaboration with the composer Paul Todd. The musical premiered at the Stephen Joseph Theatre In The Round in 1980 and was an early attempt by Alan to bypass the traditional route of his productions to London (these predominantly being transfers with largely new casts, several star names and performed in an end-space theatre) with an arrangement to take the Scarborough company to the Round House.

Given this opportunity, Alan revived *Suburban Strains* in Scarborough and made some extensive alterations to the book, tightening the play and introducing several new songs and cutting several others.

This amended version of the script was then produced at the Round House and became the authorised version of the play, which was published and made available for production. The songs from each version are listed here:

Original Production

Act 1	Act 2
On Our Own	Table Talk part 2
Caroline's Questions	Table Talk part 2 (reprise)
Joanna's Jingles	Never For A Man
Let's Spread It About	What Do The Expect?
Dear Mrs Hughes	Goodbye
Dorothy And Me	Risking
Two Can Play	Little Lover
Table Talk Part 1	I'm An Individual
Table Talk Part 1 (reprise)	

London Production

Act 1	Act 2
All For Love	Table Talk

Caroline's Questions
Joanna's Jingles
Easy Come, Easy Go
Dear Mrs Hughes
Dorothy And Me
Two Can Play
Table Talk

Never For A Man
What Do They Expect?
Goodbye
I'm An Individual
Caroline's Answers
Caroline's Answers (reprise)

Sugar Daddies

Description: Variant

In 2013, Alan Ayckbourn made his West Coast directorial debut at the ACT, Seattle. He had been invited to direct the North American premiere of one of his plays and he chose his 2003 work, *Sugar Daddies*.

Whilst *Sugar Daddies* had originally been a success and well-received, one of the few criticisms was the climax of the play had not given the lead character, Sasha, a satisfying dramatic journey. Something which the playwright himself acknowledged.

> "Rereading the play, I thought Sasha goes through this experience pretty well unscathed. She escapes with just a singe. I wanted those last few moments to show that there's part of Uncle Val that's been left with her. If you've supped with the devil, you've probably burnt your tongue. There is a sense that Sasha is refreshingly clear-eyed at the beginning, the 'country mouse' who has come into the city, but she has a sort of mistrust of human nature by the end - something you see in children growing up.... Sasha's not quite the girl she was at the beginning; there is a sort of ruthlessness about her."[214]

As a result, the playwright altered the final pages of the script to reflect the influence of Sasha's experiences with her 'sugar daddy' Uncle Val. The most significant alteration being a phone-call between Sasha and her half-sister's boyfriend - who has already had a mobile phone 'inserted' into him - during which it is made very clear, he is no longer welcome.

Sasha: *(into phone)* Hallo … no, Zack, it's me, Sasha … No, she's - busy at the moment … She's too upset to talk to you … yes … Listen, Zack, I'm glad you called, I wanted a word with you. Listen, I think you should stop seeing Chloë, I really do, I don't think you're good for her … no, I don't frankly … well, she's my sister for one thing … no, listen … Zack … listen to me … I'm only going to say this once … Are you listening? Now, I'm sorry to hear about your unfortunate episode with those two gentlemen … I'm glad you got your

phone back safe ... but I promise if you don't leave my sister alone, Zack, I'll arrange for them to meet you again and this time it won't just be your mobile, next time it'll be your whole fucking lap top, you hear me? *(Savagely)* Now piss off, you pillock!²¹⁵

Surprises

Description: Concept

In 2011, Alan Ayckbourn was commissioned by the Stephen Joseph Theatre, Scarborough, to write his 76th play. The venue, where Alan Ayckbourn had been Artistic Director between 1972 and 2009, had for a number of years been staging the playwright's latest play in repertory with an Ayckbourn revival and it was intended his 76th play would again run in repertory with a revival of an earlier work.

The productions were co-produced by the Stephen Joseph Theatre and the Chichester Festival Theatre and were announced as part of the London 2012 Festival (a cultural celebration coinciding with the London 2012 Olympic Games). Initially it was hoped this association with London 2012 might attract extra funding for the productions and, with that in mind, early plans were made for an ambitious revival of one of Alan Ayckbourn's largest and most challenging plays *A Small Family Business*; a play which had been written for The Olivier at the National Theatre in an attempt to deal with the size of the stage. With this in mind, Alan Ayckbourn conceived of his new play *Surprises* on a far larger scale than it eventually took, encompassing a company of 13 actors.

> "There was talk at one stage - because of the Stephen Joseph Theatre being part of the London 2012 festival - of me reviving *A Small Family Business*; which is a 13 hander, a big play, but of course that couldn't work. Maybe *Surprises* has a little bit of residue of that as it was intended to be a much bigger concept because I was waiting to hear - quite early along the line - if it would be running in repertory with *A Small Family Business*."²¹⁶

Unfortunately it transpired there would be no funding from London 2012 and plans to revive *A Small Family Business* were dropped. It was decided to revive *Absurd Person Singular* instead to mark the play's 40th anniversary and Alan's cast of 13 for *Surprises* was reduced to six.

Alan subsequently wrote the play but reduced in scale and scope. The future-set play had featured a sub-plot with several androids and mixed identities, both of which were an early casualty of these changes, and the final play involved a considerable doubling of roles (which presumably was also a consequence of the scaling down of the play).

Surprises

Description: Concept

Alan Ayckbourn's 76th play, *Surprises*, was initially conceived as a five act play which would have reflected the structure of his 1974 play *Confusions*. The play would have featured five loosely inter-linked stories set in the same near-future setting of the final play.

However, Alan realised he only had three stories he was really interested in telling and that he had found a structurally interesting way of weaving those stories together. The play is notable in that it is also Alan's first three act play since *Absurd Person Singular* in 1972; the play with which *Surprises* ran in repertory with for its original production.

> "I did have a draft idea, which I quickly got rid of, that I'd write it in five acts and *Surprises* could have been a second *Confusions* with five different linked one-act plays, but I only had three stories really: the girl and the husband, the secretary and the online affair and the lawyer and an android janitor. So those were the three stories I worked with. I did briefly think I could maybe revisit that *Confusions* structure, but I realised that it didn't interest me as there's not enough space for the characters."[217]

Take It Or Leave It

Description: Title - Discarded

Take It Or Leave It was an alternative title for *A Small Family Business* that Alan used whilst writing the play in 1986 and in early contract negotiations. It seems likely this was only a temporary title as correspondence indicates the National Theatre expected Alan to alter it.[218]

When Alan signed the final contract for the play, an accompanying note added the play was "now definitely *A Small Family Business*. Alan feels he ought to start circulating that one before the other gets locked into everyone's consciousness."[219]

Taken For Granted

Description: Title - Discarded

Taken For Granted was an alternative title for *Relatively Speaking* and was in use when Alan was negotiating the sale of the rights for its production in London.

When the play was first produced at the Library Theatre, Scarborough, in 1965, it had the title *Meet My Father*. Alan was not happy with this (even though it had already been altered from *Meet My Mother*). The play was optioned almost immediately by the producer Peter Bridge, who disliked the original title, and contracts note the play was now called *Taken For Granted*. It is not known how long this title was kept, but between August and February the following year, the title was changed again; first to *Father's Day* and finally to *Relatively Speaking*.

> "By the following February [1967] the play having been re-christened *Taken For Granted*, *Father's Day* and finally *Relatively Speaking* was in rehearsal in London."[220]

The Teacher

Description: Concept

The Teacher is the title of a proposed one act play for a longer piece called *IOU*, which Alan Ayckbourn eventually wrote as *Roundelay* in 2014. Although the concept of the play is the same - five inter-related plays whose order of performance are determined randomly by the audience - the plots of the one act plays as written are markedly different from those in the original synopsis for *IOU*.

The Teacher - as a title - doesn't exist in *Roundelay*, but the synopsis bears marked similarities to *The Star*. In this, the Reverend Russ Timms is rehearsing with a precocious girl named Roz, who has arranged a meeting with an agent, Gale. She is Russ's former lover and he believes she has returned to resume their relationship. But when she asks for £10,000 to pay off debts, Russ is left a broken man when she leaves.

In *The Teacher*, Russ is an English teacher and his student is called Rose. She is desperate for a quick route to fame and stardom and attempts to seduce Russ in order to get private tuition. A former pupil and now 'apparently' an agent, Gale, arrives and recounts how Russ and her nearly had an affair when she was 16. Needing money for an investment, she tries to blackmail a horrified Russ. Unsuccessful, she meets Rose and gives her a business card promising she can help her ambitions. Rose takes it and leaves Russ's rehearsals.[221]

Ten Times Table

Description: Abandoned

Ten Times Table is a rare example of Alan Ayckbourn writing a substantial amount of a play, before abandoning it and starting again.

Like *Absurd Person Singular* before it, the idea and the plot remained largely the same, it was just the structure which needed to be altered.

> "Last year, I broke down in the middle [of writing *Ten Times Table*]. I actually got to a point in the play when I had to admit "I simply can't go on, I don't know where we are." 48 hours before we started reading it. And we turned back, to do my other trick. I was on page 46, or something, and I want back to page 23. That's 23 pages thrown away, which is a hell of a lot of a play: it was a third or a quarter of the play."[222]

The problem to Alan's mind was originally the play had multiple locations set both in the Swan Hotel's dining room as well as the committee members' houses. A sketch of the set discovered in 2009 showed the original plan had a smaller committee table in the centre of the stage with other locations taking place in the four corners of the Stephen Joseph Theatre In The Round stage.

> "I once reached a giddy page 70 whilst writing *Ten Times Table*, before acknowledging I had become totally lost. My mistake, I discovered, had occurred on page seven, when I foolishly chose to leave the single location and take my characters out and about."[223]

Alan began writing the play during Christmas week and actually decided to scrap the original material he was dissatisfied with on Christmas Eve, writing through most of Christmas Day in order to meet the deadline for rehearsals.

One of the unfortunate casualties of the editing was Alan's partner, now wife, Heather Stoney, who prior to 1984 typed the scripts as Alan dictated them to her. Having realized there was a problem with the script, Alan worked on it alone before resuming dictation. At which point, he informed Heather the problem went back to the earliest pages of the script and would involve cutting a character Charlotte, who she was contracted to play![224]

Things That Go Bump
Description: Ephemera

Things That Go Bump was the title given to the 2008 summer season at the Stephen Joseph Theatre, Scarborough.

The season consisted of *Haunting Julia*, *Snake In The Grass* and *Life & Beth* and this was the first time these thematically-linked supernatural plays by Alan Ayckbourn had been performed together. Originally the season was to be called *Things That Go Bump In The Dark*, which was later shortened to *Things That Go Bump*.

An unintended consequence of giving the season an overarching title led to it being portrayed as the name for a trilogy of plays by some sections of the media. This was news to Alan Ayckbourn as he does not - nor has ever - considered the three plays to be a trilogy, despite acknowledging their thematic links.

It is important to note though *Things That Go Bump* is not the name of a trilogy of plays. Alan Ayckbourn has never referred to the plays with this title and does not regard the three plays as a trilogy as he does *The Norman Conquests* and *Damsels In Distress*. Unfortunately, certain publications - notably the website Wikipedia - insist on perpetuating the error by describing the plays as a trilogy despite nothing to support this but an erroneous article in The Independent newspaper in 2008.

This Is Where We Came In

Description: Variant

This Is Where We Came In originated as a Saturday morning matinee show at the Stephen Joseph Theatre In The Round in 1990. Split into two parts, the circular nature of the plot meant the audience - intended to be families - could see either part 1 or part 2 in any order.

The short six week run was extremely successful and the following year Alan Ayckbourn combined both parts to form a single full-length family show, which he went on to revive in 2001. The published edition of the play is the full-length version.

Time And Time Again

Description: Title - Discarded

The process by which Alan arrives at his play titles has rarely been discussed and by and large there survives relatively few examples of titles considered and then discarded by Alan Ayckbourn for his plays.

In the case of his 1971 play *Time And Time Again*, several early considered titles were discovered in 2011 amongst Alan's preliminary hand-written notes for the play. These titles included: *The Game's The Thing*; *Plays And Players*; *The Sporting Gnome* and *The Garden Pact*.

Todd on Ayckbourn On Song

Description: Ephemera

Todd On Ayckbourn On Song is not actually an Ayckbourn play, but a forerunner to the composer Paul Todd's 1992 revue *Between The Lines*, which features songs composed by both men with a book written by Todd.

Todd On Ayckbourn On Song - originally titled *Ayckbourn On Song* - was conceived as a small-scale touring show featuring some of the many songs written by Alan Ayckbourn and Paul Todd between 1978 and 1986. It was suggested to Paul Todd initially - with the idea he write the book for the musical - before Alan was approached to ask for permission to use his lyrics.

The plot was inspired by Paul Todd's experiences of working with Alan over the years and would have featured actors playing both men; during the refinement process, Alan suggested it would be better if the plot concentrated on Paul's experiences and had Alan as an off-stage presence.

Todd on Ayckbourn On Song went through at least two drafts before falling through; a planned tour in 1989 did not take place possibly because of difficulties writing the book. In 1991 the concept was revived by Paul and heavily reworked into a new revue *Between The Lines*.

A Trip To Scarborough

Description: Variant

A Trip To Scarborough was the first attempt by Alan Ayckbourn to adapt an existing play, in this case R.B. Sheridan's *A Trip To Scarborough* (which was itself an adaptation of John Vanbrugh's *The Relapse*, itself a sequel to Colley Cibber's *Love's Last Shift or The Fool In Fashion*).

It was premiered in 1982 and has three interwoven plot-lines set in different time-periods featuring variations on Sheridan's characters. Elements and scenes from Sheridan's original play are kept alongside Ayckbourn's own interwoven plots set in the 1940s and the present day. All the action is relocated to the foyer of the Royal Hotel, Scarborough, and the present day plot-strand revolves around someone trying to sell an illicit copy of R.B. Sheridan's original script for the play.

When Alan Ayckbourn revived the play in 2007 at the Stephen Joseph Theatre, he chose to revise elements of the contemporary plot, ostensibly to introduce mobile phones, which were not common in 1982 but would hardly be credible not to be present in the hands of businessmen in 2007. Small sections of dialogue were altered to allow for this and the 2007 version of the play is now considered the definitive version.

Although neither version of the script has been published, the 2007 version is available for production with one further alteration, the hotel featured in the play is now no longer specifically the Royal Hotel, but a generic hotel in the town.

True Life Fiction

Description: Title - Discarded

One of several titles Alan Ayckbourn considered for his 2005 play *Improbable Fiction*.

Unicorn children's play

Description: Concept

In 1971, the Unicorn Theatre for Children in London performed the first professional production of Alan Ayckbourn's short play for children *Ernie's Incredible Illucinations*. The success of the piece led Alan to agree to donate his royalties to the building fund for a permanent home for the company.

He also promised to write a full-length play for children for the venue, although this never actually came to fruition. No records exist in archive as to whether Alan actually began work on the play or just intended to write it.

> "When I first started as a playwright I wrote a play for children which was an absolute disaster, so I was encouraged by the success of *Ernie's Incredible Illucinations* to try my hand at children's writing again."[225]

Although Alan did not provide a full-length play specifically for the Unicorn, when he began writing for children again 17 years later, he gave permission for the venue to stage the London premiere of *Mr A's Amazing Maze Plays*. The company produced the play in 1989, four years before its generally acknowledged London premiere at the National Theatre in 1993.

Untitled 1974 play

Description: Concept

Very little is known about this proposed play from 1974, other than Alan had written notes regarding its characters and structure but did not progress to writing a script.

In 1974, Alan wrote *Absent Friends*, a play regarded as a significant turning point for the writer and very different to *The Norman Conquests* which had preceded it. His desire to write an a small, contained chamber piece which was almost the polar opposite of *The Norman Conquests*.

Although there is no context for this untitled idea, it's not hard to believe the discarded concept was one of Alan's first attempts to write a smaller scale play, but which was abandoned for a more promising idea.

The untitled play features a cast of six and appears to have been conceived as a relationship centered drama on three men and three women. From the existing notes, what can definitely be ascertained is it has nothing in common with *Absent Friends* and was not an earlier version of this play.[226]

Untitled Farce

Description: Grey Play

Untitled Farce is unique in Alan Ayckbourn's playwriting canon. It has received just one professional performance, directed by Alan Ayckbourn and featuring the Stephen Joseph Theatre company, and Alan has stated it will never be staged again.

The one-act farce was presented at the conclusion of the week long celebration of the Stephen Joseph Theatre's 50th anniversary in 2005, *Fifty Years New*. Billed as the 'big surprise!'[227], the play was presented on Saturday 13 August in the second half of the evening's entertainment and offered a unique end to the week's celebrations. It was written specifically for the event and performed from the book by Alan's resident company, having been rehearsed during the afternoon.

The farcical plot revolves around the recently married Sir Randolph who is preparing for an important dinner with a government minister. Matters are complicated by an incriminating letter, his wife dressed as a maid, the arrival of an old friend with problems of his own, a disastrously ill-conceived identity-change plan, the unexpected arrival of an old flame and a rather enthusiastic security officer.

> **Randolph:** D-I-C – one or two of those?
> **Sage:** One C, sir. L-O-U-S.
> **Randolph:** Nyyarr – Nyaarrr. How's that look?
> **Sage:** "Darling. Don't be so bloody ridiculous, Love Randy."
> **Randolph:** Think that'll tweak her heartstrings?
> **Sage:** Who can tell, sir?
> **Randolph:** With women? Precisely. Off you go then.[228]

Untitled television drama proposal

Description: Screenplay

This is a synopsis held in the Ayckbourn Archive which has little to identify either when it was written nor for whom. There is a precedent of Alan writing treatments for television dramas from a 1959 press cutting, but this synopsis seems almost certain to have been written several years later, possibly when Alan was working at the Victoria Theatre, Stoke-on-

Trent. The synopsis constantly refers to the year 1963 as a touchstone for the events and it seems a fair assumption this was due to it being the year the piece was written.

The untitled one hour programme proposal is set in the year 2025 in an overpopulated England where the percentage of over 65s has grown massively due to scientific advances; as a result, the young have given up caring for or about them. The action switches between an emergency body trying to deal with the elderly overpopulation and a church in the old folks' quarter of a county-sized city. The main characters are a group of elderly people, still dressed and acting as they did in the 1960s, and a vicar trying to keep his church alive in an increasingly secular society. The plot centres on a heli-coach trip to a local launch base with the elderly and explores how old age has affected the youth of the day: "The 1963 with it kid is the stick in the mud of tomorrow."[229]

When the group leaves the church for the trip, the emergency committee moves in to demolish the church. At the launch pad, the party find themselves aboard a rocket ship in what turns out to be an elaborate ruse to send the troublesome elderly into space. However the rocket fails to launch and the elderly abandon it and converge en mass towards the people trying to take away their livelihood: "the toothless mob, with vengeance in their eyes, bear down upon them, across the landing field."[230]

Virtual Reality

Description: Withdrawn

If one considers Ayckbourn's lost plays to be plays that have neither been published nor are available to produce, then *Virtual Reality* stands as the most recent 'lost' play. Written in 2000, the playwright's first play of the new millennium tackled many familiar Ayckbourn themes and laid the foundations for much that was to follow.

Having returned to Scarborough from directing the National Theatre's production of his plays *House & Garden*, Alan decided his next play would be an intimate, relationship based piece that would be staged in the Stephen Joseph Theatre's small, end-stage space The McCarthy. It was inspired by Alan's desire to investigate the devastating potential of relationships based on sexual attraction - a theme tackled previously in *Things We Do For Love* - and an incident Alan witnessed in a restaurant.

> "There were two young couples sitting at the table next to us, and all four of them were on their mobile phones. You could hear them saying to someone 'I'm with Tom, he's here now' and I just thought 'it's a curious way to have a meal, why don't you talk to each other?'"[231]

A lack of communication between people has been a frequent theme of the playwright's writing and here he explores it in relation to our increasing reliance on communication technology and how, despite this, we actually communicate with each other less and less.

The play is set in London, which began a cycle of four plays set in the capital (the other three being the *Damsels In Distress* trilogy). In contemporary interviews, Alan felt this was due to the increased amount of time he had spent in the city during the past few years. The play also deals with generation gaps in relationships and the different expectations and experiences each person brings to the relationship.

The plot revolves around Alex, undergoing a mid-life crisis, who has invented the Viewdow - a virtual window. His unsatisfactory life is summed up by a birthday meal where his wife, Penny, spends the meal on the phone while his best friend Barney tries to control his drunken wife, Beth. Alone at the end of the night, Alex goes home with the waitress Cassie, where he falls asleep. They continue to meet though with devastating effect: Penny's life collapses and Beth leaves Barney, who blames Alex. His new relationship is strained by differing expectations and Cassie's new friend, Lec, an avant-garde director who intends to record their lives. Isolated again, Alex returns to the restaurant, which has bought a knock-off malfunctioning Viewdow, which Alex apparently steps into.

> **Alex:** I used to find myself absolutely fascinating. I'd talk about me for hours on end, what I'd done, what I was doing, what I wanted to achieve. I used to sit at small tables in dark, smoky coffee bars and pubs, boring women senseless. Mostly women. Because at that time, I honestly believed every word I was saying, you see. Which at least made it sound vaguely interesting. Only, in the last few years... these days, I hear myself talking, saying much the same things I always have done, only now I no longer believe a word of it. Every time I speak I hear this little voice inside me saying, you bloody liar!
> 232

Although the original production toured, the play was withdrawn from production afterwards and has never been published. Several of the ideas and themes in the play have been used to better effect in subsequent plays such as the *Damsels In Distress* trilogy, *Sugar Daddies* and *Private Fears In Public Places*. In an interview in 2003, the playwright made it clear it is unlikely the play will see the light of day again.

> "Like doctors who bury their mistakes, he [Ayckbourn] makes sure his don't see the light of day either. *Virtual Reality*, for instance, will never be performed. 'I own it and can stop people performing it.'.... When he was writing it, he didn't know

if it was good or bad, but at the end of the process he knew it was not "quite a full meal.""[233]

The Waiter
Description: Miscellany

The Waiter is an incomplete lyric that is held in the Ayckbourn Archive attached to Alan Ayckbourn's notes for how to organise the curtain calls for *House & Garden* (1999). It is not known whether it was meant to be part of a larger piece or was just a song for another unspecified project.

It features a pianist, a waiter and two women - Dorothy and Isabel - discussing their friend Alice and the attractiveness of the Waiter of the song title.

> Waiter! I am over here!
> Waiter! No, don't disappear!
>
> When on my own, I have this sudden enviable ability
> To simply de-materialise, acquire invisibility -
> Could somebody explain it if they can -
> I'm sure I'd get some service if I'd only been a man.
> Beyond belief! Just see him stare
> Straight through me like I simply wasn't there.
>
> Waiter! Yes, it's me! I say!
> Waiter! Don't just run away!
>
> At times, I know, I'm criticised for lacking personality
> But nonetheless this eight stone six of feminine reality,
> Has got this sudden urge, I must confess
> To jump up on the table and rip off her bloody dress!
> But what if then -? - No wait! Dear lord!
> Suppose I did and still I got ignored?
>
> Waiter! Do you think I can - ?
> Waiter! Oh, you stupid man!
>
> If I was not expecting friends, I wouldn't be so lenient,
> But frankly, though, this place is cheap and thoroughly convenient
> For us to meet and share our mutual woes.
> Both Isabel and Alice have their ample share of those.
> Alice has been ditched - again -
> She doesn't have a lot of luck with men.
>
> Waiter! I was clearly first!

Waiter! No, it's true, I'm cursed -

As for my friend Isabel, I hope I don't sound critical -
Externally the journalist so chic and so political -
But underneath that gloss, that Gucci dress
There lurks a total insecure, neurotic, nervous mess.
Why we're friends - is far from clear -
We haven't got one single - Izzie dear! [234]

The Westwoods

Description: Concept

The Westwoods is a lunchtime revue written for the 1984 summer season at the Stephen Joseph Theatre In The Round. Performed in two parts, *His Side* and *Her Side*, it looks at a relationship from the perspective of both people over the course of four decades. It is not however the same unwritten revue which was initially advertised in the summer 1984 brochure:

> "The trouble, it's always seems to us, is that theatre has had to compete for far too long with these marathon, blockbusting, multi-million dollar TV series.
> Here, at last, is the first live theatre has to offer in the way of major competition. The enthralling, heart-wrenching story of The Westwood Family (or rather three specially chosen episodes from the 900 written and rejected).
> Described by the authors as a sort of musical Thorn Birds with just a dash of the Walton Family, it is designed to lure even the most hopelessly addicted from their TV sets.
> Please note, though, the convenient choice of playing time thereby ensuring that you do not miss your favourite evening TV series."[235]

The original concept, judging from the brochure, was a three-part satire on soap operas with individual 'episodes' (*Episode 36*; *Episode 12*; *Episode 105*). It is probable the earlier concept was also a musical, but there is no record of why the concept changed nor whether Alan actually began writing the revue that was originally advertised.

What The Devil!

Description: Grey Play

What The Devil! is a revue, largely conceived by Bob Eaton and Janet Dale, to which Alan Ayckbourn contributed.

Originally the show was developed for a company of three actors to tour to pubs in the Scarborough area. After the tour finished, the show was expanded for a short late night run at the Library Theatre.

Alan contributed two pieces to the revue, the one-act sketch *Dracula* and the song *The Ghost Of 'Enry Albert*. *Dracula* was specifically written for the expanded production at the Library Theatre as it featured five actors, but it is not known whether the song was featured in the touring revue or whether it was written specifically for the expanded version.

The revue has never been published and it does not appear to ever have been performed again.

Where's My Seat?

Description: Miscellany

In 2011, Alan Ayckbourn was asked to contribute towards an experimental production at the soon-to-open Bush Theatre in London. *Where's My Seat?* ran from 15 June - 3 July 2011 prior to the venue officially opening in the autumn.

It offered a chance for audiences to experience the new space and help offer suggestions towards its transformation from a library into a theatre. To that end, an evening featuring three short plays by Deidre Kinahan, Tom Wells and Jack Thorne was performed; each in a different staging configuration, utilising nine specially chosen props with each playwright given challenging stage directions by Michael Grandage, Alan Ayckbourn and Josie Rourke.

Alan provided ten detailed stage directions for Tom Wells' *Fossils* around which the playwright wrote his play. The first two of the stage directions are reprinted below. The highlighted words reflect Alan's choice of the nine props for the play.

Stage Direction 1.

At the start, we discover THE WOMAN busy in her sitting room tidying it ready for a visitor. She is anxious and excited, as she busies herself. Then room is simply furnished. Two chairs and a table. In the fireplace, a **coal scuttle**.

At present she is holding a large **strawberry**, trying to decide where best to display it. She first holds it here and then holds it there. Time is obviously getting short.

There is a knocking at the offstage front door. Discrete at first. THE WOMAN pauses and listens, making sure she has heard something.

In a moment, the same discrete knock is repeated.

She whimpers with anxiety and in panic renews her efforts to position the **strawberry**.

After a while, the knocking comes again, louder this time.
This spurs her on to still more frenzied efforts.
The knocking comes again. Loud and very insistent.
From another room, a dog starts muffled barking.
THE WOMAN in desperation goes to answer the door, putting down the **strawberry** on one of the chairs as she does so.
She goes off briefly. We hear the door opening and her crying out in surprise.
In a second, she returns leading her visitor into the room. It is THE MAN. He is wearing a primitive **mask**, probably the cause of her surprise.
He removes his **mask**, looking briefly for somewhere to hang it. She obligingly takes it from him and hangs it up like a hat on a hook on the wall.
She offers a chair to her visitor who sits. She goes to follow suit in the other chair, nearly sitting on the **strawberry**.
She hastily puts it on the table.

Stage Direction 2.

He breaks off in mid sentence. Distracted by the **strawberry** which is obviously disturbing his train of thought for a second. He continues as if nothing had occurred.[236]

Where Is Peter Rabbit?
Description: Miscellany

2016 marked the 150th anniversary of the birth of the author Beatrix Potter, renowned as the writer of the famed children's books based around Peter Rabbit and his friends. To mark the event, a live show was devised for *The Beatrix Potter Attraction* in Bowness-on-Windermere.

The attraction - which also celebrated its 25th anniversary that year - was created by Roger Glossop, one of Alan Ayckbourn's most prolific designers and found of The Old Laundry Theatre in Bowness. Roger was also responsible for devising the short musical play.

Alan Ayckbourn became involved when he was asked if he could provide lyrics for several songs after the original lyricist, the late Victoria Wood, had had to withdraw from the project. Despite not being a great fan of the *Peter Rabbit* books, Alan agreed as a favour to a friend and wrote the lyrics to music by Steven Edis.

Unfortunately, despite the limited extent of Alan's involvement being clearly marketed, it was repeatedly reported in the media that Alan had written the entire show and not just several songs. As the playwright did not want to draw attention away from the play, he declined to partake in

any interviews relating to the show in order that full attention was focused on whom he considered the show's true creators to be.

Who Do You Think?
Description: Concept

Another concept about which little is known nor whether Alan even began writing the play. *Who Do You Think?* is mentioned in correspondence to Sir Peter Hall, Artistic Director of the National Theatre, in January 1984 as a light piece destined to be the next play at the Stephen Joseph Theatre In The Round.

> "I have no clear ideas about the piece yet, other than the title of *Who Do You Think?* But it will have a smallish cast and be of a fairly light nature. Mind you, this is me speaking in January. It is likely to turn out to be a 28 hander of searing gloom."[237]

Ironically, the actual play he wrote that year turned out to be a massive undertaking with *A Chorus Of Disapproval*, which featured the largest cast - at that time - for an Ayckbourn play. This ambitious tale of rivalry amidst Pendon Amateur Light Operatic Society's production of *The Beggar's Opera* is patently not what Alan Ayckbourn had in mind when discussing *Who Do You Think?*.

Winnie's Wonderful Day
Description: Title - Discarded

On 27 March 2009, an informal event at the Stephen Joseph Theatre, Scarborough, saw Alan Ayckbourn officially step down as Artistic Director of the theatre. During his leaving speech he confirmed he had completed the first draft of his latest play that same morning and it was called *Winnie's Wonderful Day*.

As this wasn't an official announcement, the title was not made public by the Stephen Joseph Theatre. That would come in June during the Royal & Derngate theatre's *Ayckbourn At 70* celebration. Alan gave approval for the venue to make the first public mention of the title of his new play in the souvenir brochure produced for the event, followed by a confirmation of the title in an interview with Alan in Northampton's *Image* magazine

> "I've just finished play number 73, *Winnie's Wonderful Day*, which I'm directing in the autumn for the Stephen Joseph Theatre."[238]

Despite these announcements, by mid-June Alan had decided to alter the title - possibly because *Winnie's Wonderful Day* gave the impression

of being one of his 'family' plays rather than an adult play. On 19 June it was confirmed by the Stephen Joseph Theatre the title had been altered to *My Wonderful Day*.

As an interesting side-note, shortly after the original title was privately announced at the Stephen Joseph Theatre's company meeting, Alan's biographer Paul Allen was interviewed on BBC World Service's *The Strand*. There he inadvertently not only announced the title, but mistakenly called it *Millie's Wonderful Day*.

Withdrawn Plays

Description: Ephemera

There are currently considered to be eight plays which are part of the Ayckbourn canon (i.e. acknowledged full length plays), but which have been withdrawn, having never been published and not being available to produce. The majority of the withdrawn plays are drawn from early in Alan's writing career from a period he feels represent the very early steps of a writer and only reflect his inexperience at the time of their creation.

> "They [the early plays] are not producible pieces, they are are nothing more than my early jottings. My early plays are an object lesson in someone having confidence in someone - I was just delighted that someone would put my plays on."[239]

The withdrawn plays are currently considered to be: *The Square Cat* (1959); *Love After All* (1959); *Dad's Tale* (1960); *Standing Room Only* (1961); *Christmas V Mastermind* (1962); *The Sparrow* (1967); *Jeeves* (1975); *Virtual Reality* (2000).

There are also two plays which are considered to be in a slightly more grey area in that they have not been published and are not listed as being available, but under certain circumstances may be produced. These are *Making Tracks* (1981) and *The Musical Jigsaw Play* (1994).

Of the remaining as yet unpublished plays, all of them are either available to produce or will be made available to produce in due course. These plays - as of writing - are *Miss Yesterday* (2004), *Arrivals & Departures* (2013), *Roundelay* (2014), *Hero's Welcome* (2015) and *Consuming Passions* (2016).

The Wizard Of Oz

Description: Concept

This was an abandoned attempt to bring a live version of *The Wizard Of Oz* to the West End stage for Christmas 1969. The project involved Ray Cooney and Peter Mercier[240] and Alan was invited to write the script (it is

not known whether this would have been a play or a musical, although logic dictates it was probably a play as, at this stage in his career, Alan had had no experience of writing for musicals).

The production process appears to have been quite developed as a letter indicates Alan believed "Oz is definitely going on"[241] and after the project was abandoned Ray Cooney wrote to Alan that he hoped "all the effort of this year won't be wasted"[242] and that the project would be resurrected the following year. As surviving correspondence all comes from the September / October period of 1969, it would be fair to assume the production was quite advanced if it was to be staged for Christmas 1969 as Alan indicates.

It was not Alan's first experience of Frank L Baum's famous and popular fantasy tale as he did direct a family version of *The Wizard Of Oz*, written by Alfred Bradley, at York's Theatre Royal in 1968 and he would also go on to write *Whenever* in 2000. This time-traveling musical, with music by Denis King, features many nods to *The Wizard Of Oz*.

Woman In Mind

Description: Concept

The original concept for *Woman In Mind* was substantially different from the play Alan Ayckbourn eventually wrote, not least because it centered around a man.

As written, *Woman In Mind* is centred on the wife of a vicar who has invented an imaginary life and family in order to cope with her failing marriage and her abandonment by her son for a cult. Although the initial idea for the play shared the same core element of a play told from a subjective viewpoint, it was otherwise quite different.

> "Originally, I was going to write about a man who had a heart attack, could hear what was going on around him but who couldn't communicate. We would witness the play from the mind's eye. But then a woman experiencing a mental breakdown seemed so much more interesting that she gradually took over."[243]

A Word From Our Sponsor

Description: Concept

In 1994, Alan Ayckbourn's new play *Private Fears In Public Places* was announced; famously he was unable to write it and instead wrote *Communicating Doors*. However, between these two plays lies a mystery.

"Basically, I had two ideas bouncing around my head. So the final piece could have emerged from either one of them.... When I actually started to write the advertised play, *Private Fears In Public Places*, it all rather alarmingly began coming to pieces in my hands. It wasn't ready to be written.... So I turned to my second idea - which to my absolute horror suddenly began to look like another non-starter as well."[244]

At which point, fortunately, Alan had a third idea which became *Communicating Doors*. Of the second idea, nothing is known and Alan has never specifically spoken about the play. However, it is possible this is either *Schooldaze* or an earlier version of his musical *A Word From Our Sponsor*. Although this is far from certain, the intriguing possibility is raised by Alan Ayckbourn's programme note for *Communicating Doors* in which he mentions two titles in the same breath - bearing in mind that while *Private Fears In Public Places* had already been publicly announced, there had never been a previous public mention of a play called *A Word From Our Sponsor*.

"Thus I proudly unveil my 46th play entitled *A Word From Our Sponsor* - sorry - *Private Fears In Public Places* - no - *Communicating Doors*. That's the one. Well, it does have doors...."[245]

It does not seem implausible to suggest the second lost idea was *A Word From Our Sponsor*, particularly in light of an interview with the playwright in 1995.

"I had the idea for *Sponsor* about two years ago and I played around with it for a long time. I couldn't quite make it live because it has these exotic elements. It suddenly occurred to me it was a musical idea, by putting it to music, you could make it more credible and meet its exoticism."[246]

This timeline broadly correlates which could mean the second abandoned idea from 1994 was a non-musical version of *A Word From Our Sponsor*. This was not to say the original concept was entirely the same as the final product, minus music. In an interview in December 1992, Alan spoke about his gestating idea for a play which patently is the basis for *A Word From Our Sponsor*, despite differing in scope from the musical he would actually write three years later.

"The play I'm working on at the moment - it's still very embryonic - is as close to good and evil as I can get. It's about a man who, for the best intentions, chooses the wrong way. I originally wanted to write a play about sponsorship of the arts, but it's wider than that. It's really about how we get into bed

with the most extraordinary people. It's set in the middle of a recession, when the spirits are down, and concerns an enthusiastic vicar who decides to revive the mystery plays, to stage them on a huge scale. He's halfway through it when the sponsors drop out. This dark man turns up and offers him some sponsorship - he knows very well who it is! And the man starts altering the script, until you've got Arnold Schwarzenegger slicing people in half, because that's what would appeal to the young.

"That's a familiar theme of mine - that the wrong decision is almost right. Very rarely are we confronted with black-and-white choices; usually they're very difficult and demand a lot of thought. But I think in the end there is a way, and if we think about it for a minute we know which way we should go. The danger is that some part of our brain is always there telling us, 'Don't worry, it'll be all right, just this once. Take the £10 note, they're very rich people.' That's the real devil."[247]

That the idea had been long-gestating is given extra credence by correspondence in March 1995 in which Alan's wife writes:

"Alan has at last written *A Word From Our Sponsor* as a musical."[248]

Patently the idea was sound but it needed something extra which Alan found the solution to in 1995 when he premiered *A Word From Our Sponsor* at the Stephen Joseph Theatre In The Round with music by John Pattison, his final play to receive its premiere at this venue.

Work & Play

Category: Concept

Work & Play is little more than a title and handful of notes written by Alan Ayckbourn for an unwritten pair of plays, probably dating from 1994 judging from the other notes to which it is attached.

It is nonetheless an intriguing - if slightly mind-bending - concept for two plays set in two different auditoria - and could well be a precedent for *House & Garden*.

According to the brief handwritten notes, *Work* is set in an office and *Play* in a flat with both plays sharing the same cast. Whereas *House & Garden* was two plays running simultaneously in two spaces with the same cast, *Work & Play*'s conceit is the first act of *Work* is the second act of *Play* and the first act of *Play* is the second act of *Work*; this would necessitate audiences having to see both plays to comprehend the full

picture. Quite how - or even whether - this would have worked in practice is unknown as the plays were not taken any further than the notes.[249]

Into The Archive

These pages contain some of the items held in archive relating to some of the entries in *Unseen Ayckbourn*. These encompass Alan Ayckbourn's own hand-written notes, script extracts, early designs, production photographs and brochure / programme notes.

Absent Friends

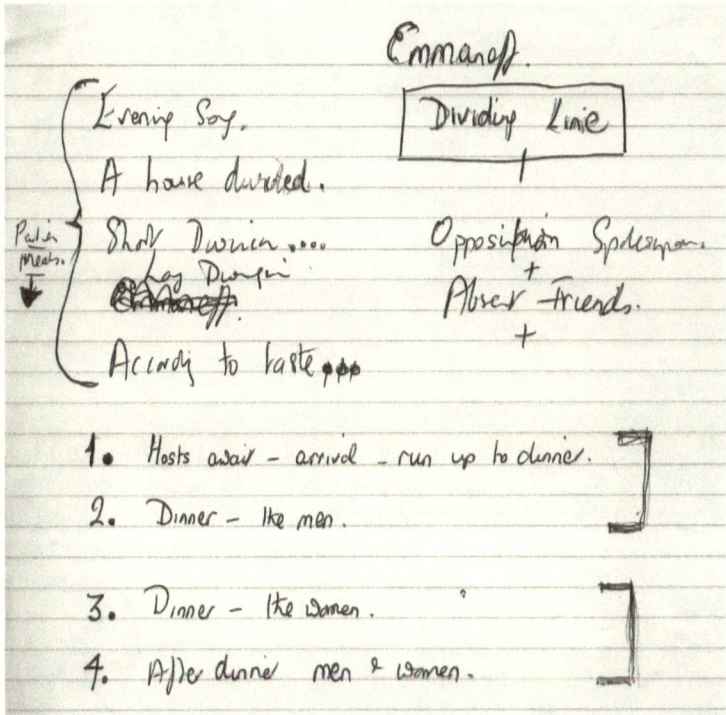

Early hand-written notes for Alan Ayckbourn's Absent Friends (1974) before the play became a two act, single location play set in real-time. The top-half features some of his early title ideas for the play, including the actual title.

The bottom half is the proposed structure for his original two-act, four-scene idea, centred around a dinner party viewed from the separate perspectives of the men and women.

Copyright: Alan Ayckbourn; held in the Ayckbourn Archive at the University of York

Bedroom Farce

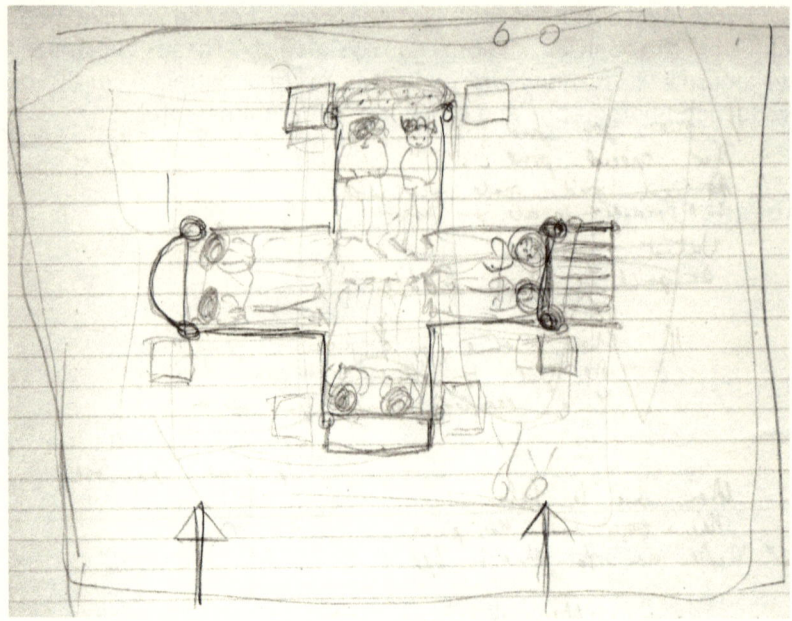

One of the earliest archival pieces relating to Alan Ayckbourn's 1975 play, Bedroom Farce. This sketch by the playwright illustrates his idea for how the stage would be laid out for its original production at the Library Theatre in Scarborough; although commissioned for the National Theatre, this is definitely a design for Scarborough as it is in-the-round rather than end-stage.

Of note is the fact the sketch features four beds and four couples rather than the three beds and four couples featured in the play as written. An earlier sketch of this stage layout - far simpler but still featuring the cruciform lay-out - can also be found on the back of a script page for the musical Jeeves held in the Ayckbourn Archive; Alan began working on Bedroom Farce during rehearsals for Jeeves.

Copyright: Alan Ayckbourn; held in the Ayckbourn Archive at the University of York.

A Chorus Of Disapproval

THE STEPHEN JOSEPH THEATRE IN THE ROUND
VALLEY BRIDGE PARADE
SCARBOROUGH
YO11 2PL

Alan Ayckbourn

Is writing a new play for the forthcoming professional Summer Season (Rehearsals commencing April 9th) Centred around a (Fictional!) Amateur Operatic Society.

He is anxious to meet AMATEUR SINGERS who would be interested in taking part in this venture. Some Soloing experience is required at least sufficient to cope with the demands of the average Light Opera Society Repertoire.

Although the scheduling will remain sufficiently flexible to accommodate certain prior engagements, applicants should be prepared to commit themselves for a number of Evenings between April and early September, 1984.

Please apply for Audition Details
either in writing or by phone
to the
Theatres Musical Director, Paul Todd.
Telephone (0723) 370540.

A published advert for the world premiere production of A Chorus Of Disapproval at the Stephen Joseph Theatre In The Round in 1984. Alan Ayckbourn's original idea for the play involved dozens of 'plants' in the audience, played by amateurs, who would unexpectedly join in the action as the play progressed. The auditions did go ahead, but the plans for amateur performers were dropped soon afterwards. Several of Alan's experiences at the auditions did apparently feed into the play though!

Copyright: Scarborough Theatre Trust; held in The Bob Watson Archive at the Stephen Joseph Theatre.

Confusions

1.	Bride and groom - Discovery.	2 1m 1f
2.	Marriage breaker - re-union & interruption.	3 2m 1f.
3.	Mother figure	3 2f 1m
4.	Man whose wife leaves him	5 3m 2f.
5	Reversals (1)	2m
6.	Reversals (2)	2f.

Alan Ayckbourn's original hand-written notes for an early idea for the structure of Confusions (1974).

The play, as written, features five short one act plays: Mother Figure, Drinking Companion, Between Mouthfuls, Gosforth's Fête & A Talk In The Park. As can be seen here, the original concept was for six one act plays, only one of which is present in the final play - Mother Figure; this being due to the fact Mother Figure was an existing play around which Confusions was built.

The other place-holder titles (Bride & Groom - Discovery, Marriage Breaker - Reunion & Interruption, Man Whose Wife Leaves Him, Reversals (1) and Reversals (2)) do not correspond with any of the actual plays within Confusions.

The right hand columns indicates the gender break-down of the characters in the plays and seems to indicate the piece would have featured five actors in total playing several roles each; the same configuration of three male and two female actors was used in the play as written.

Copyright: Alan Ayckbourn; held in the Ayckbourn Archive at the University of York.

Jeeves

> **DAHLIA'S SONG**
>
> There are two qualities
> A Frenchman has imbued
> One is for womankind
> The other is for food
> His - Je ne sais -
> Just the way
> He'll prepare them
> One he will sweeten
> One he will savour
> One he will flirt with
> One test for flavour
>
> It's all done with love - from the heart.
>
> There is such savoire faire
> Such a smooth technique
> He uses loving care
> To bring things to a peak.
> For at his wish -
> Every dish
> Turns to ambrosia
> Melts as you taste it
> Soft and fulfilling
> Fills men with ardour
> Makes women willing
>
> Yes. We're all in the hands of the chef.

A rare example of a surviving hand-written lyric for Alan Ayckbourn and Andrew Lloyd Webber's musical Jeeves (1975).

This is an extract from Alan Ayckbourn's notes for Aunt Dahlia's song, sung - briefly - by Betty Marsden in the original production. Briefly because Betty was fired from the play almost immediately after performances began in a desperate bid to reduce the play's running time. Her sub-plot and both her songs were dispensed with, including this one which was later re-titled Food's Old Sweet Song.

Given the song was cut after just one performance and did not feature on the original cast recording, this is a rare insight into a long-lost song.

Copyright: Alan Ayckbourn; held in the Ayckbourn Archive at the University Of York.

Joking Apart

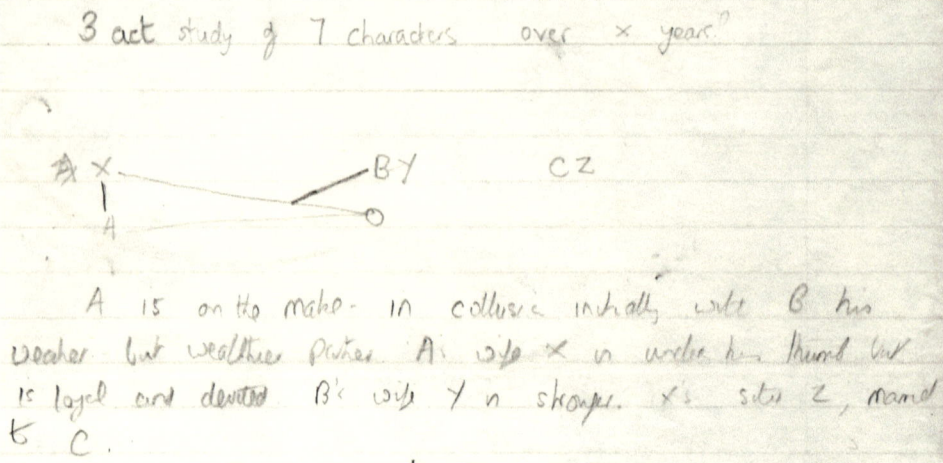

Alan Ayckbourn's notes pertaining to a very early concept for his 1978 play Joking Apart - including what looks like a scientific equation illustrating the relationships of the main characters, at this point only referred to by letters.

The faint notes beneath the diagram are a brief synopsis of the original idea and read: "A is on the make - in collusion initially with B his weaker but wealthier partner. A's wife X is under his thumb but is loyal and devoted. B's wife Y is stronger. X's sister Z, married to C."

The only aspect of the notes which survive in any meaningful way into the final play is the neurotic business partner and his strong wife, which become Sven and Olive.

Copyright: Alan Ayckbourn; held in the Ayckbourn Archive at the University of York.

The Jollies

A concept poster for the world premiere production of Alan Ayckbourn's The Jollies (2002).

The poster is unusual in that it is designed for Alan Ayckbourn's original brief for the play - a family whose life is lived unwittingly in the full glare of television - which was never used. After giving the Stephen Joseph Theatre details of the play, which were promptly used to advertise the play to school-parties, Alan announced he was not writing that play.

He proceeded to write a completely different play utilising the same title, but which rendered the concept poster redundant.

Copyright: Scarborough Theatre Trust; held in a private collection.

The Jubilee Show

THEATRE IN THE ROUND
AT WESTWOOD BOX OFFICE 70541

DON'T MISS THIS TOMORROW

JUBILEE DAY CELEBRATIONS 7 JUNE

12.00 noon — 1.00 p.m. Music from the Scarborough Town Band in Westwood playground free!

1.30 p.m. — 2.30 p.m. Free lunchtime show
"WESTWOOD CORONATION DAY STREET PARTY"
By Bob Eaton — Music, Magic and Mirth
Food and Drink will be available.

6.30 p.m. Free glass of Sherry in Theatre Bar

7.30 p.m. — 10.00 p.m. The Company in A Royal Tribute, a special entertainment for Jubilee Day with Guest Pianist Michael Garrick.

10.30 p.m. — 12.30 a.m. Jubilee Dance to the music of IMAGE

During the evening free soup and French bread will be available plus other low priced dishes from the Coffee Bar.

All this entertainment for only £2.00. Tickets and full details of the programme are available from the Box Office (70541) now. Tickets are limited to 250 so ring the Box Office A.S.A.P. to avoid disappointment.

Summer Season opens Wednesday 8 June, 7.45

FALLEN ANGELS

A delightful witty comedy by Noel Coward

All seats £1.30. O.A.Ps, Students and Children 80p. Party rates available.

This Company were formerly at the Library Theatre, Vernon Road

The Jubilee Show (1977) is one of the most unusual of Alan Ayckbourn's plays. It received only one performance, details of which were not recorded by the Stephen Joseph Theatre In The Round.

The play's existence was only discovered in 2007 when the sole-surviving copy of the manuscript was discovered at the back of a filing cabinet in the Stephen Joseph Theatre, which Alan Ayckbourn verified he had co-written with Mervyn Watson.

The only other material held in archive pertaining to the production are a flyer and this advert from the Scarborough Evening News which does not even list the final title of the play, noting instead it will be: "The company in a Royal Tribute, a special entertainment for Jubilee Day with Guest Pianist Michael Garrick."

Copyright: Scarborough Theatre Trust; held in The Bob Watson Archive at the Stephen Joseph Theatre.

Just Between Ourselves

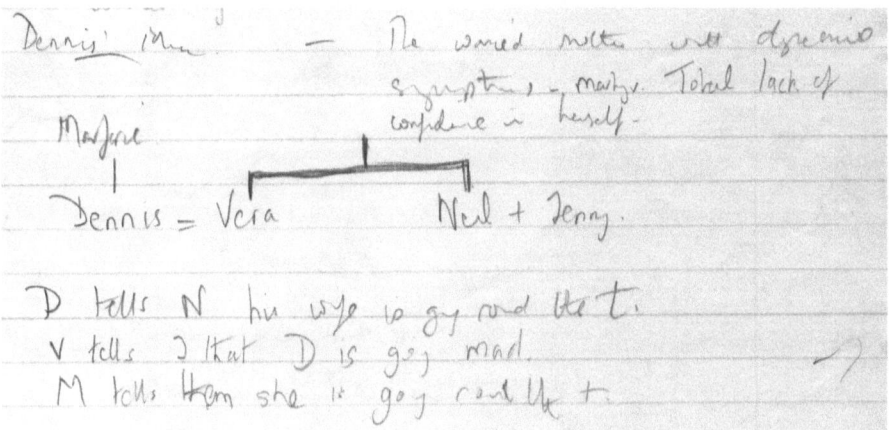

Just Between Ourselves is regarded as one of the darkest plays in the Ayckbourn play canon, ending with a birthday party for a comatose woman who has been driven to breakdown by her husband and his overbearing mother.

Extraordinarily, the play was conceived as being even darker as these early notes by Alan Ayckbourn demonstrate. They offer a brief description of the play's intended initial direction.

D [Dennis] tells N [Neil] his wife is going round the twist.

V [Vera] tells J [Jenny] that D [Dennis] is going mad.

M [Marjorie] tells them she is going round the twist.

If the play had continued down this path, then the implication is everyone in Dennis's household was suffering a breakdown or perceived as suffering one. Other notes held in archive suggest Dennis was conceived as a neurotic depressive which, combined with Vera's mental state, made for a very depressing play concept.

Copyright: Alan Ayckbourn; held in the Ayckbourn Archive at the University of York.

Neighbourhood Watch

Neighbourhood Watch

Occupants of The Glade

Occupying number 1
Graham, a factory manager
Anna, a housewife

Occupying number 2
Denzil Blaiser, an IT consultant, 30's
Elaine Blaiser, a receptionist, 30's

Occupying number 3 *a factory (hothouse)*
Martin Krark, ~~hdng spc~~ mngr, 40s
Hilda Krark, his sister, a ~~chiropodist~~, 40's *bookshop owner*
Perrie

Occupying number 4 *Dipett*
Dorothy ~~Beadle~~, 60's, widow, rtd p/a

Occupying number 5 *Bradley dry cleaner*
Larry ~~Bradwich~~, ~~are~~ ~~office director~~, 30's
Magda, his wife, music teacher 20's
Bradley

Occupying number 6
Donald Withersedge, traffic warden 30's
Daisy Withersedge, his wife, a nurse 30's

Occupying number 7
Brian Cable, a solicitor, 50's
Della Cable, manager of a health club 40's

Occupying number 8
Gareth Janner, unemployed engineer, 0's
Amy, his wife, call centre worker 40's

Occupying number 9
Rod Trusser, retired security man, 60's

Occupying number 10
Bill Bale, an accountant, 50's
Sheila Bale, local councillor, 50's

Occupying number 11
Lee Wrigley 50, garage owner
Maeve Wrigley, 50
Their sons Dirk & Doug, 20's

Occupying number 12
Derek Trace-Wallace, a salesman, 30's
Dinah Trace-Wallace, a surveyor, 30's

Occupying number 13
Ralph Ruderbeck, a physio, 40's
Divorced.

Occupying Number 14
Lucy Hooper, housewife, 30's
Susie, 12, Rupert, 7, Benbow 5

Occupying number 15
Micky Devise, a chef, 40's
Davey Choker, his partner, 30's

Occupying Number 16
Cissy Lipper, retired Wren, 60's
Sindy Mint, ex-wren judo instructor 40's

A page from Alan Ayckbourn's concept notes for his 2011 play Neighbourhood Watch. This lists the entire community of The Glade estate - later amended to Bluebell Hill estate.

The names in lighter type indicate the actual characters in the play, although several of the others are referred to within the final script. Alan's own written notes can also be seen, altering the names and details of the characters.

This page offers an idea of the background details for a play in which only eight characters actually appear, although references are made to the other residents of the estate.

Copyright: Alan Ayckbourn; held in the Ayckbourn Archive at the University of York.

Neighbourhood Watch

Martin Krark 40's, works for the council planning department. He is our chief protagonist. Initiates the fight back against incipient anarchy (as he sees it). Fiercely right wing, he is backed by his religious sister, Hilda Krark, 40's. Together they make a dangerous combination. They had a dark childhood with a domineering father and a submissive mother.

Larry Hunter, mid 30's, is an architect. He and his younger wife Magda Hunter, 20's, a music teacher, are Martin and Hilda's next door neighbours. Owing to an initial friction soon after the Krark's moved in, they become the chief opposition to the gradual take over of the estate. The nearest thing to an arranged marriage, Magda was more or less driven by her dominant parents to marry Larry. Whilst still uncertain about her own sexuality. Still very immature. As is Larry at heart.

Roddie Trusser, 60's represents the strong arm of the Krark's force. Allied with the Wrigley's, father Lee and two sons Dirk and Doug and the support of Cissy and Sindy, they are the enforcers. A widower and still massively fit.

Dorothy Beadie, 60's, also a strong supporter of the Krark's, the voice of middle Britain. Campagner for things as they were and still ought to be. Writes many letters. The gossip.

Gareth Mundle, 50's is an engineer, forced to take early retirement. He bears a huge grudge against a society who has treated him this way. He is a keen supporter of the Krark's. His wife, Amy Mundle, 30's finds herself a bit torn between her conscience and her loyalty to her dominant husband. She sleeps around a bit, currently having an affair with Ralph Ruderbeck at number 13.

A second page from Alan Ayckbourn's note for Neighbourhood Watch (2011) offering a look at Alan's early preparations for a play.

Here we have character descriptions of the protagonists within the play as well as short background descriptions about the characters and their relationships.

Although most of the notes do concur with the play as written, Martin and Hilda's background is darker than that actually featured in the play.

It is also worth noting most of the character names are later altered. Martin & Hilda Krark become Martin & Hilda Massie, Larry & Magda Hunter, become Luther & Magda Bradley, Roddie Trusser becomes Rod Trusser, Dorothy Beadie becomes Dorothy Doggett and Gareth & Amy Mundle become Gareth & Amy Tanner.

Copyright: Alan Ayckbourn; held in the Ayckbourn Archive at the University of York.

The Norman Conquests

Theatre in the round

(Founder Stephen Joseph)

Summer Season 1973

FANCY MEETING YOU

(A weekend view of the Norman Conquest)

by Alan Ayckbourn

Reg	**Stanley Page**
Sarah, his wife	**Alex Marshall**
Ruth, Reg's sister	**Janet Dale**
Norman, her husband	**Christopher Godwin**
Annie, Reg & Ruth's younger sister	**Rosalind Adams**
Tom	**Ronald Herdman**

Directed by Alan Ayckbourn

The action takes place in the dining room during a weekend

In proscenium arch theatre, an audience is often required to imagine that they are witnessing the action of a play through the 'fourth wall' of a room. Theatre-in-the-round, on the other hand, asks its audience, frequently, to become all four walls.

Tonight we see events in the lives of a family, from the point of view of the dining room, over a single weekend. Complementing this and running in repertoire with it, are different views of the same period of time seen from the living room **Make Yourself at Home** and the garden **Round and Round the Garden**. For me it is a new and, as far as I know, untried experiment in comedy. I hope you enjoy these three views of characters - from a choice of four directions. Which makes about 64 different ways of looking at it

Alan Ayckbourn

When Alan Ayckbourn unveiled his plans for the 1973 summer season at the Library Theatre, Scarborough, it included the world premiere of three inter-connected plays. We know them today as The Norman Conquests, but initially they were not known collectively by that name and were not even promoted as a trilogy as the playwright did not wish to put off tourists who might believe they had to book to see three plays.

The programmes for the original production were a single sheet of yellow double-side printed cardboard with one reproduced above. Of note is the title of the play - Fancy Meeting You was later retitled Table Manners - and the sub-title A weekend view of the Norman Conquest, which becomes The Norman Conquests for its transfer into London the following year.

Copyright: Scarborough Theatre Trust; held in The Bob Watson Archive at the Stephen Joseph Theatre.

Private Fears In Public Places

An unusual piece held in archive is this published page from the Stephen Joseph Theatre In The Round's 1991/2 winter season. It is unusual in advertising a play that was never written.

Alan told the theatre his next play would be called Private Fears In Public Places in 1991 with the brief: "At the airport, Jessica waves a fond farewell to her husband. Then a chance encounter changes her life. How well does she know, how far can she trust herself?"

When Alan hit a block when writing the piece, he contacted the theatre about writing an entirely different play. Unfortunately, the call came just hours after the press had begun printing the brochure and could not be stopped.

Alan wrote in its stead Communicating Doors and re-used the title Private Fears In Public Places in 2004, although it had nothing to do with the original premise.

Copyright: Scarborough Theatre trust; held in The Bob Watson Archive at the Stephen Joseph Theatre.

Sight Unseen

Sight Unseen was a play announced by Alan Ayckbourn to the media in 1980, which was intended to be a thriller - possibly with a randomly chosen murderer within it.

Alan didn't write the play though - despite the press coverage - and instead wrote *Season's Greetings*. Little was known about *Sight Unseen*, aside from the press cuttings, until two pages of hand-written notes were discovered in 2010. These show proposed plot ideas for the play as well as character names and relationships; most of the names were re-used for *Season's Greetings*.

Most notable with regard to these notes is Alan Ayckbourn's breakdown of the five possible killers and their reasons for killing Neville. If the idea of a random killer sounds familiar, Alan would return to it in 1983 when he wrote *It Could Be Any One Of Us*.

Copyright: Alan Ayckbourn; held in the Ayckbourn Archive at the University of York.

Sisterly Feelings

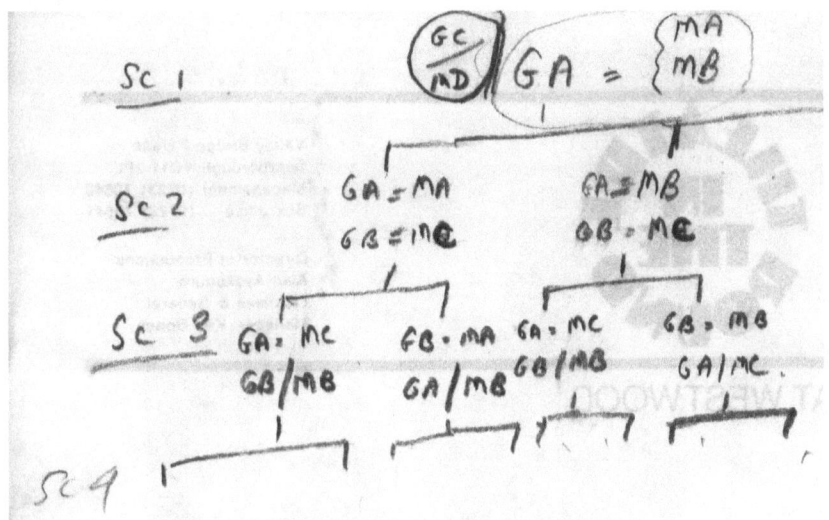

Sisterly Feelings is the first of Alan Ayckbourn's 'chance' plays in which an element of chance determines the outcome of the play. At the end of the first scene, a character tosses a coin which determines which of two second scenes are played. Later, another actor chooses which of two possible third scenes should be played.

The initial concept for the play was far more complex though with a common opening scene perpetually branching with two choices at the end of each scene, leading to a play with four scenes and eight possible permutations. The idea was scaled back for Sisterly Feelings but a similar structure was utilised for Intimate Exchanges in 1982.

That play though had 16 possible permutations, although it is not a 'chance' play as each night's permutation of the play is chosen in advance rather than being determined randomly on stage during the course of the action.

The hand-written notes by Alan Ayckbourn illustrate an early concept for Sisterly Feelings with the branching structure over four scenes and the initials of which relationship comes to the fore in each scene.

Copyright: Alan Ayckbourn; held in the Ayckbourn Archive at the University of York.

The Square Cat

The Square Cat marked Alan Ayckbourn's professional playwriting debut in 1959. He was encouraged by the Library Theatre's Artistic Director, Stephen Joseph, to write his own play after complaining about the quality of his roles.

This postcard is a rare promotional item for The Square Cat featuring Alan Ayckbourn in the lead role of the rock 'n' roll star, Jerry Wattis. It shows him 'playing' the guitar; ironically he wrote the play for himself in the lead role with the first act climaxing with the character breaking into song accompanying himself on a guitar - despite Alan having never played a guitar in his life!

Copyright: Scarborough Theatre Trust; held by The Bob Watson Archive at the Stephen Joseph Theatre.

Standing Room Only

New plays

WE put on three kinds of plays. First of all, new plays—written either by a member of the company or someone working closely with us. One of our leading actors, Alan Ayckbourn, is a playwright. His traffic-jam comedy "Standing Room Only" was last season's great popular success here. (It has been bought by ABC TV for Armchair Theatre). His next new play, a Chaplin-like farce called "Mr. Whatnot," will be shown in November.

Standing Room Only was Alan Ayckbourn's fourth play and premiered at the Library Theatre in Scarborough in 1961. It was also the first of his plays to be optioned for both the West End and for television.

Neither of which took place. Whilst the playwright has often spoken about his long and dis-spiriting West End experience with the play, very little is known about the proposed television adaptation.

All that is held in archive is a mention in a programme for his play Mr Whatnot at the Victoria Theatre, Stoke-on-Trent, and this newspaper article published in the Evening Sentinel on 10 October 1963 mentioning the piece had been bought for the popular series Armchair Theatre; the play was never produced for television.

Copyright: Local World; held in The Bob Watson Archive at the Stephen Joseph Theatre

Ten Times Table

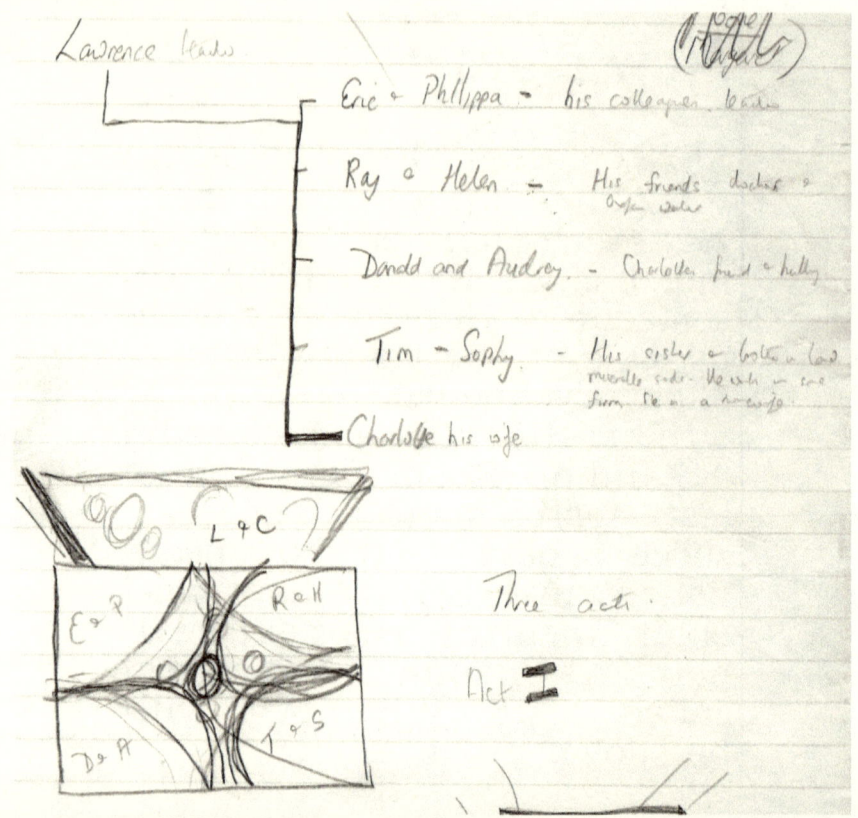

Ten Times Table (1977) is a play by Alan Ayckbourn which proved to be problematic in the writing. The playwright recalls he had written approximately 50 pages of the script before realising he had no idea where he was going and promptly discarded half of the script.

The hand-written notes above are for this original concept of the play showing a multi-location stage (bottom left) which apparently include the set expanded off-stage into one of the seating blocks. The play was later altered to a single location set.

Characters names and relationships are listed (top right), being most notable for including Charlotte, the character to be played by Alan Ayckbourn's then partner, Heather Stoney, but which was completely cut when he began re-writing.

Copyright: Alan Ayckbourn; held in the Ayckbourn Archive at the University of York.

The Westwoods

*And in the Bar!
Not only.*

Every Tuesday and Thursday from 24 May to 6 September (except 26 June and 21 August) in the **Studio Theatre** at 1.10pm

by Alan Ayckbourn with music by Paul Todd

The trouble, it's always seemed to us, is that theatre has had to compete for far too long with these marathon, blockbusting, multi-million dollar TV series.
Here, at last, is the first live theatre has to offer in the way of major competition. The enthralling, heart-wrenching story of

The Westwood Family

(Or rather three specially chosen episodes from the **900** written and rejected.)

Described by the authors as a sort of musical *Thorn Birds* with just a dash of the *Walton Family*, it is designed to lure even the most hopelessly addicted away from their TV sets.

Please note, though, the convenient choice of playing time thereby ensuring that you do not miss your favourite evening TV series.
All tickets £1.00

Diary/*Studio*

Thurs 24 May 1.10 Westwoods Episode 36 *opens*
Tues 29 May 1.10 Westwoods Episode 12 *opens*
Thur 31 May 1.10 Westwoods Episode 105 *opens*
Tues 5 June 1.10 Westwoods Episode 36
Thurs 7 June 1.10 Westwoods Episode 12
Tues 12 June 1.10 Westwoods Episode 105
Thur 14 June 1.10 Westwoods Episode 36
Tues 19 June 1.10 Westwoods Episode 12
Thur 21 June 1.10 Westwoods Episode 105
Thur 28 June 1.10 Westwoods Episode 36
Tues 3 July 1.10 Westwoods Episode 12
Thur 5 July 1.10 Westwoods Episode 105
Tues 10 July 1.10 Westwoods Episode 36
Thur 12 July 1.10 Westwoods Episode 12
Tues 17 July 1.10 Westwoods Episode 105
Thur 19 July 1.10 Westwoods Episode 36
Tues 24 July 1.10 Westwoods Episode 12
Thur 26 July 1.10 Westwoods Episode 105
Tues 31 July 1.10 Westwoods Episode 36
Thur 2 Aug 1.10 Westwoods Episode 12
Tues 7 Aug 1.10 Westwoods Episode 105
Thur 9 Aug 1.10 Westwoods Episode 36
Tues 14 Aug 1.10 Westwoods Episode 12
Thur 16 Aug 1.10 Westwoods Episode 105
Thur 23 Aug 1.10 Westwoods Episode 36
Tues 28 Aug 1.10 Westwoods Episode 12
Thur 30 Aug 1.10 Westwoods Episode 105 *Last perf*
Tues 4 Sept 1.10 Westwoods Episode 36 *Last perf*
Thur 6 Sept 1.10 Westwoods Episode 12 *Last perf*

The Westwoods (1984) was a two-part revue by Alan Ayckbourn with music by Paul Todd, which told the story of a long-term relationship from both the man and the woman's perspective.

However, this was not the original intent nor what was publicised. Instead The Westwoods was conceived as three revues inspired by popular soap operas of the period telling the story of the Westwood family; possibly a skit on the famed Sitwell family. It is not known why - or when - Alan decided to pursue a completely different show, but this is how the shows were advertised in the Stephen Joseph Theatre In The Round's summer 1994 brochure.

Copyright: Scarborough Theatre Trust; held in The Bob Watson Archive at the Stephen Joseph Theatre.

What The Devil

The one-sheet programme for the revue What The Devil! featuring Alan Ayckbourn's one-act Dracula and his song 'Enry Albert's Ghost.

Copyright: Scarborough Theatre Trust; held by The Bob Watson Archive at the Stephen Joseph Theatre.

Appendix I
Alan Ayckbourn: Definitive Play List (1959 – 2017)

Full Lengths Plays (The Canon)

	
1959	The Square Cat
1959	Love After All
1960	Dad's Tale
1961	Standing Room Only
1962	Christmas V Mastermind
1963	Mr Whatnot
1965	Relatively Speaking
1967	The Sparrow
1969	How The Other Half Loves
1970	Family Circles
1971	Time And Time Again
1972	Absurd Person Singular
1973	The Norman Conquests

comprising:
Table Manners
Living Together
Round And Round The Garden

Year	Title
1974	Absent Friends
1974	Confusions
1975	Jeeves (with Andrew Lloyd Webber)

subsequently:

Year	Title
1996	By Jeeves (with Andrew Lloyd Webber)
1975	Bedroom Farce
1976	Just Between Ourselves
1977	Ten Times Table
1978	Joking Apart
1979	Sisterly Feelings
1979	Taking Steps
1980	Suburban Strains (with Paul Todd)
1980	Season's Greetings
1981	Way Upstream
1981	Making Tracks (with Paul Todd)
1982	Intimate Exchanges

comprising:
Events On A Hotel Terrace
Affairs In A Tent
Love In The Mist
A Cricket Match
A Game Of Golf
A Pageant

	A Garden Fête
	A One Man Protest
1983	It Could Be Any One Of Us
1984	A Chorus Of Disapproval
1985	Woman In Mind
1987	A Small Family Business
1987	Henceforward...
1988	Man Of The Moment
1988	Mr. A's Amazing Maze Plays
1989	The Revengers' Comedies
1989	Invisible Friends
1990	Body Language
1990	This Is Where We Came In
1990	Callisto 5
	subsequently:
1999	Callisto #7
1991	Wildest Dreams
1991	My Very Own Story
1992	Time Of My Life
1992	Dreams From A Summer House (with John Pattison)
1994	Communicating Doors
1994	Haunting Julia
1994	The Musical Jigsaw Play (with John Pattison)
1995	A Word From Our Sponsor (with John Pattison)
1996	The Champion Of Paribanou
1997	Things We Do For Love
1998	Comic Potential
1998	The Boy Who Fell Into A Book
1999	House &
1999	Garden
2000	Virtual Reality
2000	Whenever (with Denis King)
2001	Damsels In Distress
	comprising:
	GamePlan
	FlatSpin
	RolePlay
2002	Snake In The Grass
2002	The Jollies
2003	Sugar Daddies
2003	Orvin: Champion Of Champions (with Denis King)
2003	My Sister Sadie
2004	Drowning On Dry Land
2004	Private Fears In Public Places

2004	Miss Yesterday
2005	Improbable Fiction
2006	If I Were You
2008	Life & Beth
2008	Awaking Beauty (with Denis King)
2009	My Wonderful Day
2010	Life Of Riley
2011	Neighbourhood Watch
2012	Surprises
2013	Arrivals & Departures
2014	Roundelay
2015	Hero's Welcome
2016	Consuming Passions
2017	A Brief History Of Women

Revues and Musical Entertainments

1978	Men On Women On Men (with Paul Todd)
1980	First Course (with Paul Todd)
1980	Second Helping (with Paul Todd)
1981	Me, Myself & I (with Paul Todd)
1983	Incidental Music (with Paul Todd)
1984	The 7 Deadly Virtues (with Paul Todd)
1984	The Westwoods (with Paul Todd)
1985	Boy Meets Girl (with Paul Todd)
1985	Girl Meets Boy (with Paul Todd)
1986	Mere Soup Songs (with Paul Todd)
1998	Cheap And Cheerful (with Denis King)

One Act Plays

1962	Countdown
1984	A Cut In The Rates
2013	Chloë With Love (Farcicals)
2013	The Kidderminster Affair (Farcicals)
2016	No Knowing

Plays For Children And Young People

1969	Ernie's Incredible Illucinations
1989	The Inside Outside Slide Show
1999	Gizmo
2002	The Princess And The Mouse
2003	The Ten Magic Bridges
2004	Miranda's Magic Mirror
2005	The Girl Who Lost Her Voice

Other Works
2015	The Divide
2016	The Karaoke Theatre Company

Adaptations
1982 A Trip To Scarborough
(Original: *A Trip To Scarborough* by R.B. Sheridan)
1985 Tons Of Money
(Original: *Tons Of Money* by Will Evans & Valentine)
1989 Wolf At The Door
(Original: *Les Corbeaux* by Henry Becque; translation by Professor David Walker)
1999 The Forest
(Original: *The Forest* by Ostrovsky; translation by Vera Liber)
2011 Dear Uncle
(Original: *Uncle Vanya* by Anton Chekhov; translation by Vera Liber)

Plays For Television
1974 Service Not Included

Books
2002 The Crafty Art Of Playmaking

Miscellaneous Contributions
1974 What The Devil! (lyricist / writer)
2011 Where's My Seat? (contributor)
2016 Where's Peter Rabbit? (lyricist)

The Grey Plays
Performed but not part of the official canon and which have never been published nor made available for further performance.

1960 Double Hitch
1961 Love Undertaken
1962 Follow The Lover
1975 Dracula
1977 The Jubilee Show
1983 Backnumbers (with Paul Todd)
1987 An Evening With PALOS
1992 Between The Lines (lyrics by Alan Ayckbourn)
2005 Untitled Farce

Early Plays
Acknowledged but not part of the official canon and which have never been performed or published (all dates approximate).

1957	The Season
1958	The Party Game
1958	Relative Values
1959	Mind Over Murder

Books

2002	The Crafty Art Of Playmaking

Authorized stage adaptations Of Alan Ayckbourn's Plays

2014 The Boy Who Fell Into A Book (musical)
 (book & lyrics by Paul James with music by Cathy Shostak & Eric Angus)

Appendix II

People & Places

A guide to some of the people and locations mentioned in *Unseen Ayckbourn*

Paul Allen: Alan Ayckbourn's biographer.

Roland Allen: Alan Ayckbourn's writing pseudonym between 1959 and 1961. The name is a combination of his own name and his first wife, Christine Roland.

The Ayckbourn Archive: Alan Ayckbourn's personal archive and the world's single largest physical Ayckbourn collection. Held at the Borthwick Institute For Archives at the University Of York.

The Ayckbourn Digital Archive: Held by Alan Ayckbourn's Official Website www.alanayckbourn.net, this digital archive holds thousands of items relating to all of Alan Ayckbourn's career in the theatre.

The Bob Watson Archive: The Stephen Joseph Theatre's Archive which contains cuttings and material on all of Alan Ayckbourn's productions in Scarborough.

Ken Boden: Amateur theatrical closely involved with the Library Theatre, Scarborough, from its opening. Ken was largely responsible for keeping the venue running after Stephen Joseph's death in 1967 until Alan Ayckbourn became the Artistic Director in 1972.

Peter Bridge: Alan Ayckbourn's first London producer who was responsible for producing *Mr Whatnot*, *Relatively Speaking* and *How The Other Half Loves* in the West End.

British Library: The British Library holds one of the world's largest collection of Alan Ayckbourn's plays in the world. It holds manuscripts for every professionally produced play and other notable Ayckbourn ephemera.

Michael Codron: Producer who was responsible for producing the majority of Alan Ayckbourn's plays in London's West End between 1971 and 2002.

Tom Erhardt: Alan Ayckbourn's agent from 1992 until his retirement in 2013.

Richard Eyre: Former Artistic Director of the National Theatre from 1988 to 1997, who was responsible for bringing Alan Ayckbourn's early family plays to the venue.

Roger Glossop: Frequent designer for Alan Ayckbourn's plays since 1986. Founder of the Old Laundry Theatre, Bowness-on-Windermere, an in-the-round venue inspired by the Stephen Joseph Theatre In The Round.

Grey Plays: A number of acknowledged plays by Alan Ayckbourn which have been produced but not published, are not available for production and are not considered part of the official Ayckbourn play canon.

Sir Peter Hall: Former Artistic Director of the National Theatre from 1973 to 1988, who commissioned Alan's first play for the venue (*Bedroom Farce*) and who was instrumental in persuading Alan to take a two year sabbatical from Scarborough to work at the National Theatre between 1986 and 1988.

Robin Herford: Prolific Ayckbourn actor and director who was also the Artistic Director (alongside Alan Ayckbourn) of the Stephen Joseph Theatre In The Round, when Alan took his sabbatical at the National Theatre between 1986 and 1988.

Stephen Joseph: Alan Ayckbourn's mentor and founder of both the first professional theatre in the round company (Scarborough) and theatre (Stoke-on-Trent) in the UK. Stephen was a passionate advocate of supporting new writing and new theatre forms. He encouraged Alan to both write and direct and was a major influence in Alan's life until his death in 1967

Mel Kenyon: Alan Ayckbourn's agent.

Denis King: Composer and musical collaborator with Alan Ayckbourn.

The Library Theatre: The home of England's first professional theatre-in-the-round company, founded by Stephen Joseph. It was based on the first floor of Scarborough's public library between 1955 and 1976 and the original home of the Scarborough company of which Alan Ayckbourn would be Artistic Director between 1972 and 2009.

Lord Chamberlain's Collection: Until 1968, every play produced in the UK had to be officially approved and licensed by the Lord Chamberlain's office. This procedure ceased in 1968 and the extensive collection of plays was given to the British Library. As a result, the British Library has copies of all of Alan Ayckbourn's plays between 1959 and 1968 including the only existing copy of his second play *Love After All* as well as 'Grey plays' such as *Double Hitch* and *Love Undertaken*.

The McCarthy: The end-stage space at the Stephen Joseph Theatre, Scarborough. Alan Ayckbourn premiered *Things We Do For Love*, *House*, *Virtual Reality* and *Farcicals* in this space as well as revivals of *Haunting Julia* and *Bedroom Farce*.

The Michael T. Mooney Archive: The largest known private collection of Ayckbourn-related material which became part of the Ayckbourn Archive in 2016.

Simon Murgatroyd: Alan Ayckbourn's Archivist and the founder and administrator of his official website www.alanayckbourn.net.

National Theatre: The National Theatre on London's South Bank has staged many of Alan Ayckbourn's plays including the world premiere of *A Small Family Business*. It has also staged *Bedroom Farce*, *Sisterly Feelings*, *Way Upstream*, *A Chorus Of Disapproval*, *Invisible Friends*, *Mr A's Amazing Maze Plays*, *House & Garden* and *Season's Greetings*. Between 1986 and 1988, Alan Ayckbourn was a company director at the

National, having taken a sabbatical from the Stephen Joseph Theatre In The Round.

John Pattison: Composer and musical collaborator with Alan Ayckbourn.

Peggy: See Margaret Ramsay

Margaret Ramsay: Noted literary agent and Alan Ayckbourn's first agent who took him on in 1964 and represented him until her death in 1992.

Alain Resnais: Noted and award-winning French film director who adapted Alan Ayckbourn's plays *Intimate Exchanges*, *Private Fears In Public Places* and *Life Of Riley* into the films *Smoking / No Smoking*, *Coeurs* and *Aimer, Boire et Chanter*. At the time of his death in March 2014, he was working on *Arrivées et Départs*, an adaptation of Alan Ayckbourn's *Arrivals & Departures*.

Stephen Joseph Theatre: The present home of the Scarborough company since 1996. A former Odeon cinema converted to a state-of-the-art venue with an in-the-round space (The Round) and end-stage space (The McCarthy).

Stephen Joseph Theatre In The Round: The Scarborough company's second home on the ground floor of a converted boys' high school. The company was based there between 1976 and 1996.

Christine Roland: Alan Ayckbourn's first wife.

The Round: The auditorium at the Stephen Joseph Theatre, Scarborough, where Alan Ayckbourn premieres the vast majority of his plays.

Heather Stoney: Alan Ayckbourn's second wife and personal assistant.

Eric Thompson: Director who was responsible for the West End premieres of *Time And Time Again*, *Absurd Person Singular*, *The Norman Conquests*, *Jeeves* and *Absent Friends*. Also directed *Absurd Person Singular* and *The Norman Conquests* on Broadway.

Paul Todd: Composer and musical collaborator with Alan Ayckbourn.

University Of Manchester: University which holds the papers of Alan Ayckbourn's mentor Stephen Joseph - including one of the few extant copies of Alan Ayckbourn's first play *The Square Cat*.

University Of York: University which has held the Ayckbourn Archive (Alan Ayckbourn's personal archive and the single largest physical Ayckbourn resource in existence) since 2011.

Victoria Theatre: The first professional theatre in the round venue in the United Kingdom (the Library Theatre, Scarborough, was the first professional round company). Founded in 1962 in Stoke-on-Trent, the current home of the company is the New Vic Theatre, Newcastle-under-Lyme.

Lord Andrew Lloyd Webber: One of the world's most successful living composers, who collaborated with Alan Ayckbourn on the flop musical *Jeeves* and its successful revision *By Jeeves*.

Acknowledgements

Given there have been four editions of this book now, I think I must have thanked nearly everyone I know!

There are always far too many people to mention who have supported and guided me through the writing of this and previous volumes. I'm confident they know who they are and that they have my greatest thanks, even if I haven't mentioned them here.

This volume is dedicated to Mo Thwaites who has changed my life beyond belief. I have no words which adequately convey how much I love her and how much I treasure our relationship.

As always, my thanks go out to my two wonderful girls Kate and Sarah for all their love and support. I can never state enough how proud I am of them.

This book would also not be possible without the support of Sir Alan and Lady Ayckbourn.

A special thanks to Albert-Reiner Glaap and Stephanie Tucker for being inspirations and for their always welcome advice and encouragement.

Lizzie Glazier is a wonderful friend and has put up with so much of my stressing over the years, she gets a special point out!

And for everyone else who helped, contributed or just kept me sane working on *Unseen Ayckbourn*, thank you. Special mention though to John Cotgrave & Richard McArtney, Paul Elsam, Martin Hyde & Stephen Dinardo, Jaye Lewis, Mike Linham, Ed & Greg Martin, Michael T. Mooney, Ian & Jean Murgatroyd, Rob Shearman, Jeannie Swales, Lee & Dawn Dyson-Threadgold, Sue Warren and Rebecca Winder.

Simon Murgatroyd, December 2016

Footnotes

1 Plays And Players, September 1975

2 Preliminary notes regarding *Absent Friends* held in the Ayckbourn Archive

3 Preliminary notes regarding *Absent Friends* held in the Ayckbourn Archive

4 Preface to *Three Plays* (Chatto & Windus, 1977, ISBN 070112203X)

5 Alan Ayckbourn, *Tea For Two*, Stephen Joseph Theatre, 24 July 2008

6 Municipal Entertainment, May 1978

7 Scarborough Evening News, 13 December 1989

8 Preface to *Three Plays*

9 Preface to *Three Plays*

10 *Bedroom Farce*, Alan Ayckbourn, pp.8 (Samuel French, 1977)

11 Yorkshire Post, 26 April 2004

12 Preface to *Alan Ayckbourn: Plays 3* (Faber & Faber, 2005, ISBN 0571226884)

13 *Barnstairs Sydrome* synopsis, date unknown circa 2008, held in the Ayckbourn Archive

14 Weekend Post, 11 July 1981

15 Preliminary set design sketches for Bedroom Farce from the second draft *Jeeves* manuscript held in the Ayckbourn Archive

16 Sunday Times, 30 June 1974

17 *Countdown* was first produced as part of *If Love Decay...* in September 1962; *If Love Decay...* would eventually become *Mixed Doubles* in 1969. Alan was writing under the pseudonym Roland Allen until at the latest March 1962 when he was first represented by the Literary agent Margaret Ramsay.

18 Extract from *Bedside Manners*, held in the Ayckbourn Archive

19 Extract from Paul Todd's show breakdown for *Between The Lines*, held in the Ayckbourn Archive

20 Alan Ayckbourn interview, *Private Fears In Public Places* region 2 DVD

21 The Guardian, 6 July 2007

22 Positif magazine, July / August 2015

23 Extract from *Board Game*, held in the Ayckbourn Archive

24 Yorkshire Post, 20 August 1999

25 Scarborough Evening News, 22 September 1999

26 *By Jeeves* first draft workshop script, 1995, held in the Ayckbourn Archive

27 A Guided Tour Through Ayckbourn Country (second edition), Albert-Reiner Glaap, pp.138-140 (Wissenschaftlicher Verlag Trier, 2004, ISBN 3884766783)

28 Provisional performance schedule for summer 2017 at the Stephen Joseph Theatre, autumn 2016

29 Conversations With Ayckbourn, Ian Watson, pp.138 (Faber, 1988, ISBN 0571151922)

30 Grinning At The Edge, Paul Allen, pp.207 (Methuen, 2001, ISBN 0413771369)

31 Watson, pp.138

32 Correspondence between Alan Ayckbourn and Peter Hall, 14 April 1984

33 Watson, pp.43

34 Interview with Peter Cheeseman, date unknown

35 Extract from *Christmas V Mastermind*, held in the Ayckbourn Archive

36 Evening Sentinel, 1 January 1963

37 Watson, pp.43

38 Transcript from *Cinderella's Star Night* album, 1983 (transcription by Michael Mooney)

39 Notes for *The Circle*, held in the Ayckbourn Digital Archive, date unknown

40 Correspondence between Margaret Ramsay and Lynda Obst, 13 January 1981

41 Correspondence between Alan Ayckbourn and Margaret Ramsay, 31 January 1981

42 Correspondence between Alan Ayckbourn and Margaret Ramsay, 16 February 1981

43 www.imdb.com (International Movie Database)

44 The Press, 22 August 2013

45 Hand-written note regarding *Confusions* held in the Ayckbourn archive

46 Extract from *A Cut In The Rates* (Samuel French, 1991, ISBN0573120846)

47 Ayckbourn At 50 (Stephen Joseph Theatre souvenir programme)

48 Watson, pp.33

49 Allen, pp.80

50 Extract from *Dad's Tale*, held in the Ayckbourn Archive

51 Ayckbourn At 50 (Stephen Joseph Theatre In The Round, 1989)

52 'Modern Dramatists: Alan Ayckbourn', Michael Billington, pp.7 (Grove Press, 1983, ISBN 0394620518)

53 Extract from first read-through draft of *The Divide*, held in the Ayckbourn Archive

54 Allen, pp.82

55 Lord Chamberlain's Collection card index, British Library

56 Extract from *Double Hitch*, held in the Ayckbourn Archive

57 The Stage, 16 January 1992

58 Extract from *Dracula*, held in the Ayckbourn Archive

59 Correspondence between Alan Ayckbourn and John Pattison, circa 1991

60 Watson, pp.4

61 Watson, pp.6-7

62 Alan Ayckbourn personal correspondence, 14 July 1990

63 The Times, 4 July 1973

64 Denver Post, 03 March 2003

65 Correspondence between Alan Ayckbourn and Philip Jones (director of light entertainment, Thames TV), 30 November 1981

66 Correspondence between Alan Ayckbourn and Philip Jones, 30 November 1981

67 Correspondence between Margaret Ramsay and Alan Ayckbourn, 18 January 1982

68 Correspondence between Peter Tinniswood and Alan Ayckbourn, 8 February 1982

69 Correspondence between Philip Jones and Alan Ayckbourn, 4 August 1982

70 There have been several proposals for spin-offs from Alan's plays, mostly centred around *The Norman Conquests*, but *Ernest & Delia* is unique in being the only one to get further than a proposal.

71 Extract from *An Evening With PALOS*, held in the Ayckbourn Archive

72 *Theatre In The Round Takes Root In The Potteries*, The Times, 3 December 1962

73 *Relatively Speaking* programme note, 1968

74 Correspondence Between Michael Codron and Alan Ayckbourn, 27 September 1974

75 Artscene, June 2001

76 *Floor 71* synopsis held in the Ayckbourn Archive

77 Extract from *Floor 71* synopsis held in the Ayckbourn Archive

78 *Folk From T'Smoke* notes held in the Ayckbourn Archive

79 Extract from *Follow The Lover*, held in the Ayckbourn Archive

80 *In Future* draft manuscript, held in the Ayckbourn Archive

81 Artscene, June 2001

82 Extract from *What The Devil!* script (two act version), held in the Ayckbourn Archive

83 Personal correspondence, 5 November 2001

84 Watson, pp.10

85 The Authorised Biography of Ronnie Barker, Bob McCabe, (BBC Books, 2005, ISBN 978-0563522461)

86 Interview with Simon Murgatroyd, May 2008

87 Interview with Simon Murgatroyd, May 2008

88 Correspondence between Alan Ayckbourn and Michael Codron, 15 January 1994

89 Northwest Portfolio, March 1989

90 Watson, pp.143

91 Interview with Susan Lowenberg, first streamed at www.latw.org on 1 January 2011.

92 Christine Roland quoted in Allen, pp.66

93 The Stage, 22 March 2007

94 *Tea Time Talk* between Alan Ayckbourn and Kate Fenton, 29 September 2016

95 Los Angeles Times, 5 October 1975

96 Interview with Eric Thompson, The Times, 27 July 1974

97 Correspondence from Alan Ayckbourn to Rob Walker, 2 October 1994

98 *How The Other Half Loves* follow up talk with Alan Ayckbourn, Stephen Joseph Theatre, Scarborough, 18 June 2009

99 Watson, pp.58

100 *How The Other Half Loves* programme, 1973

101 Extract from *If I Were You* (first draft), held in the Ayckbourn Archive

102 *Communicating Doors* initial design sketch, circa January 1994, held in the Ayckbourn Archive

103 *Intimate Exchanges* script notes from correspondence between Alan Ayckbourn & Gordon House, 13 July 1986

104 Wigan Evening Post, 1 July 1980

105 Watson, pp.52

106 *Isn't It Romantic* synopsis, July 2008, held in the Ayckbourn Archive

107 *Isn't It Romantic* Synopsis, July 2008, held in the Ayckbourn Archive

108 Scarborough Evening News, August 1996

109 Correspondence between Alan Ayckbourn and Amanda Saunders, 16 February 2006

110 Various company memos, Stephen Joseph Theatre, Spring 2006

111 The Guardian, 24 June 1996

112 Bristol Evening Post, 22 March 1975

113 Allen, pp.148

114 The Sentinel, July 2001

115 Alan Ayckbourn, 26 February 1995

116 *With Great Pleasure*, BBC Radio 3, 2 April 2009

117 The Guardian, 5 October 2010

118 *Joking Apart* notes held in the Ayckbourn Archive

119 *Joking Apart* notes held in the Ayckbourn Archive

120 *Joking Apart* notes held in the Ayckbourn Archive

121 The Guardian, 4 September 2002

122 Extract from *The Jubilee Show*, held in the Ayckbourn Archive

123 Preliminary notes regarding *Just Between Ourselves*, held in the Ayckbourn Archive

124 Preliminary notes regarding *Just Between Ourselves*, held in the Ayckbourn Archive

125 Preliminary notes regarding *Just Between Ourselves*, held in the Ayckbourn Archive

126 Adrian McLoughlin quoting Alan Ayckbourn in the *Two For Tea*, Stephen Joseph Theatre, 30 July 2008

127 Extract from *The Karaoke Theatre Company*, held in the Ayckbourn Archive

128 http://chrisboyd.blogspot.com/2008/04/alan-ayckbourn-by-request-or-one-more.html

129 Alan Ayckbourn, *Tea For Two*, Stephen Joseph Theatre, 24 July 2008

130 Ayckbourn at 50 (Stephen Joseph Theatre In The Round, 1989)

131 Watson, pp.37-42

132 Extract from *Love After All*, held in the Ayckbourn Archive

133 Watson, pp.42

134 Lord Chamberlain's Collection card index, British Library

135 Alan Ayckbourn personal correspondence, July 2008

136 Extract from *Love Undertaken*, held in the Ayckbourn Archive

137 Extract from *Making Tracks*, held in the Ayckbourn Archive

138 Watson, pp.130

139 Watson, pp.143

140 Ayckbourn at 50

141 Alan Ayckbourn, *Tea For Two*, Stephen Joseph Theatre, 24 July 2008

142 *Relatively Speaking* programme, 1968

143 Ayckbourn At 50 (Stephen Joseph Theatre In The Round, 1989)

144 Extract from *Millennium* sketches, held in the Ayckbourn Archive

145 *Mind Over Murder* manuscript, held in the Ayckbourn Archive

146 Extract from *Mind Over Murder* screenplay, held in the Ayckbourn Archive

147 *Modern Love* manuscript, held in the Ayckbourn Archive

148 Various correspondence, 1992-1993, held in Alan Ayckbourn's personal archive

149 Extract from *The Musical Jigsaw Play*, held in the Ayckbourn Archive

150 *Neighbourhood Watch* notes held in the Ayckbourn Archive

151 Synopsis for *IOU: The Nightclub*, March 2013, held in the Ayckbourn Archive

152 Evening Standard, 6 June 1974

153 The Stage, 4 April 1974

154 *Round And Round The Garden* programme, 1973

155 Synopsis for *IOU: The Novelist*, held in the Ayckbourn Archive

156 *One Day In Spring* synopsis, November 2009, held in the Ayckbourn Archive

157 Extract from *The Party Game*, held in the Ayckbourn Archive

158 Extract from *The Party Game*, held in the Ayckbourn Archive

159 *Past Tense* synopsis, October 2012, held in the Ayckbourn Archive

160 Watson, pp.52

161 Correspondence between Ben Travers, BBC Assistant Head Of Copyright, and Margaret Ramsay, 2 June 1975 and other personal correspondence, 31 July 1974

162 Yorkshire Post, 1 February 1994

163 Yorkshire Post, 1 February 1994

164 Correspondence between Alan Ayckbourn and Jeannie Swales, 20 June 1993

165 Brochure copy from the Stephen Joseph Theatre In The Round winter 1993/94 brochure

166 *Relatively Speaking* screenplay, held in private collection

167 Extract from *Relatively Speaking* screenplay, held in private collection

168 Sunday Times, 3 June 1973

169 Correspondence with John Cleese, 25 October 1984

170 Extract from *Relative Values*, held in the Ayckbourn Archive

171 Correspondence between Alan Ayckbourn and Margaret Ramsay, 2 April 1989

172 Unknown publication, 1991

173 Peggy: The Life Of Margaret Ramsay Literary Agent, Colin Chambers, pp.143 (Nick Hearn Books, 1997, ISBN 978-0413728005)

174 *Love After All* programme, The Library Theatre, Scarborough, 1959

175 *Satisfaction Guaranteed* synopsis, October 2008, held in the Ayckbourn Archive

176 Note from *The Season*, held in the Ayckbourn Archive

177 Watson, pp.52

178 Extract from *The Season*, held in the Ayckbourn Archive

179 Alan Ayckbourn personal correspondence, 25 February 1985

180 Extract from *Season's Greetings* original production manuscript, held in the Ayckbourn Archive

181 Correspondence between Robert Buckler, script editor for the BBC, and Alan Ayckbourn, 11 July 1973

182 Correspondence between Alan Ayckbourn and Margaret Ramsay, 1 December 1973

183 Correspondence between Alan Ayckbourn and Christopher Morahan, 12 August 1980

184 Watson, pp.169-70

185 Watson, pp.169-70

186 Preliminary notes regarding *Sight Unseen* held in Alan Ayckbourn's personal archive

187 *Relatively Speaking* programme, 1968

188 Scarborough Evening News, 25 August 1980

189 *Someone Watching* treatment, held in the Ayckbourn Archive

190 Scarborough Evening News, July 1967

191 Correspondence between Alan Ayckbourn and Margaret Ramsay, 1969 – 1970

192 Extract from *The Sparrow*, held in the Ayckbourn Archive

193 Scarborough Evening News, 13 August 1971

194 Municipal Entertainment, May 1978

195 Daily Telegraph, July 1967

196 Plays And Players, September 1972

197 Yorkshire Post, 02 March 2005

198 The Independent, 24 August 2009

199 www.time.com, 17 September 2009

200 Sunday Times, 1 June 1986

201 Sunday Times, 1 June 1986

202 Watson, pp.36

203 Yorkshire Post, 18 November 2005

204 Extract from *The Square Cat*, held in the Ayckbourn Archive

205 Extract from *The Square Cat*, held in the Ayckbourn Archive

206 Interview with Simon Murgatroyd, 2000

207 The Stage, July 1961

208 Extract from *Standing Room Only*, held in the Ayckbourn Archive

209 Ayckbourn At 50

210 Watson, pp.46-47

211 *Mr Whatnot* programme, Victoria Theatre, Stoke On Trent, 1963

212 Synopsis for *IOU: The Star*, held in the Ayckbourn Archive

213 Scarborough Evening News, January 1980

214 Crosscut, 3 October 2013

215 Extract from revised version of *Sugar Daddies* (2013), held in the Ayckbourn Archive

216 Interview with Simon Murgatroyd, 14 February 2012

217 Interview with Simon Murgatroyd, 14 February 2012

218 Correspondence between Tom Erhardt and Alan Ayckbourn, 4 April 1986

219 Correspondence between Heather Stoney and Tom Erhardt, 6 April 1996

220 *Relatively Speaking* programme, 1968

221 Synopsis for *IOU: The Teacher*, held in the Ayckbourn Archive

222 Municipal Entertainment, May 1978

223 The Crafty Art Of Playmaking, Alan Ayckbourn, pp.46 (Faber, 2004, ISBN 0571215106)

224 Conversation with Heather Stoney, 13 July 2010

225 The Times, 25 October 1971

226 Notes from *Untitled 1974 Play*, held in the Ayckbourn Archive

227 *50 Years New* flyer / programme, 13 August 2005

228 Extract from *Untitled Farce*, held in the Ayckbourn Archive

229 Extract from untitled television synopsis, held in the Ayckbourn Archive

230 Extract from untitled television synopsis, held in the Ayckbourn Archive

231 Unknown publication, 28 January 2000

232 Extract from *Virtual Reality*, held in the Ayckbourn Archive

233 Yorkshire Post, 14 June 2003

234 Extract from *The Waiter*, held in the Ayckbourn Archive

235 Stephen Joseph Theatre summer brochure 1994

236 *Where's My Seat?* stage directions, 2011, held in Alan Ayckbourn's personal archive

237 Correspondence between Alan Ayckbourn and Sir Peter Hall, 14 April 1984

238 Image Magazine, June 2009

239 Yorkshire Post, 18 November 2005

240 Correspondence between Ray Cooney and Alan Ayckbourn, 27 November 1969

241 Correspondence between Alan Ayckbourn and Peter Mercier, 1 October 1969

242 Correspondence between Ray Cooney and Alan Ayckbourn, 27 November 1969

243 Alan Ayckbourn personal correspondence, 22 February 1984

244 Yorkshire Post, 1 February 1994

245 *Communicating Doors* programme, Stephen Joseph Theatre In The Round, 1994

246 Interview with Simon Murgatroyd, 1995

247 Six Contemporary Dramatists, Duncan Wu, pp.154 (St Martin's Press, 1996, ISBN 0312165676)

248 Heather Stoney personal correspondence, 5 March 1995

249 Notes from *Work & Play*, held in the Ayckbourn Archive

www.ingramcontent.com/pod-product-compliance
Lightning Source LLC
Chambersburg PA
CBHW032014170526
45157CB00002B/696